D1595392

Decorating the Lord's Table

On the Dynamics between Image and Altar in the Middle Ages

THE UNITED LIBRARY
2121 Sheridan Road
Evanston, IL 60201

DECORATING THE LORD'S TABLE

On the Dynamics between
Image and Altar in the Middle Ages

Edited by
Søren Kaspersen & Erik Thunø

NA
5060
.D33
2001
us

MUSEUM TUSCULANUM PRESS
University of Copenhagen
2006

Decorating the Lord's Table.
On the Dynamics between Image and Altar in the Middle Ages

Edited by Søren Kaspersen and Erik Thunø

© 2006, Museum Tusculanum Press and the authors
Copy edited by Birgit Tang and Pernille Flensted-Jensen
Cover design by Pernille Sys Hansen
Set and printed in Denmark by Narayana Press
www.narayana.dk
Set in Adobe Garamond Pro

ISBN 87 635 0133 3

Cover illustrations:
The 'Nativity'. Detail from Odder frontal. Cf. fig. 6, p. 157.
The 'Visitation'. Detail from Odder frontal. Cf. fig. 11, p. 98.
The 'Visitation'. Detail from Ølst frontal. Cf. fig. 9, p. 96.
Golden frontal from Ølst Church. Cf. fig. 1, p. 130.
The 'Annunciation to the Shepherds'. Detail from Ølst frontal.
Cf. fig. 18, p. 109.

All photos: John Lee, National Museum, Copenhagen.

Published with support from

The New Carlsberg Foundation

Museum Tusculanum Press
Njalsgade 94
DK – 2300 Copenhagen S
www.mtp.dk

Contents

Introduction

Erik Thunø and Søren Kaspersen

The Middle Ages witnessed a profusion of sumptously decorated altars throughout Europe. As the chief locus of Christian worship, the altar has always been subject to pictorial decoration. Many of the medieval altars discussed here were covered with images of Christ, the saints and Biblical personages, often in conjunction with narrative cycles depicting the life of Christ or of various saints. Why were these altars decorated with images and precious materials? What role did the Eucharist play in the program? Were pictures included simply to remind viewers of the story of Christ and the saints, or did they have other functions? What precisely did the narratives relate? The contributors to this volume discuss these and other questions by focusing on material remains from Italy, Germany, and Scandinavia that range in time from the early eighth to the thirteenth century.

Not until the Early Middle Ages do the sources provide a more consistent pattern as to how the altars were decorated. The *Liber pontificalis* is by far the most informative document in this regard. It mentions, for example, that many papal donations to Roman churches included silk cloths for altars. Although these precious textiles have not survived, it is known from verbal descriptions that they were often decorated with scenes from the life of Christ.[1] In some cases, altars were provided with frontals made of wood, stone, or metal. Like the cloths hanging from the altar, the frontals displayed Biblical scenes or personages, often flanked by colorful ornaments studded with gems. Several of the essays in this book deal with these frontals, which have received less scholarly attention than have later medieval altarpieces, which were placed *over* altars. The relationship between image and altar extends well beyond the *mensa* to include the adjacent area, invariably decorated with hanging crucifixes, ciboria, curtains, and frescoes or mosaics on walls, niches and apses.[2] The authors of this volume have therefore focused not only on the ornaments affixed to the altar but also those relegated to the surrounding area.

The essays published here are based on papers presented during the 36th International Congress on Medieval Studies in Kalamazoo, Michigan, at a double

session entitled "Image and Altar: Interrelationships," organized by the editors of this volume.[3] The motive behind this initiative was twofold. On the one hand, it granted the contributors an opportunity to probe deeper into the relationship between altar and image; on the other, it allowed them to make the Scandinavian material more accessible to an international and interdisciplinary audience.[4] Although most surviving medieval altar frontals are from Scandinavia, the fact that they are geographically isolated and that the last comprehensive study on them was published in Danish eight decades ago, has prevented them from receiving the attention they deserve.[5] It is important to remember, however, that medieval Europe was not partitioned into nations and was unified by a common church and its official language. The plane on which medieval art should be discovered and investigated, therefore, is larger than is generally assumed.

As a singularly well-preserved visual treasure, produced within a relatively short time frame and in some cases still *in situ*, Scandinavian altar frontals are valuable sources of information on medieval altar decor. In fact, without them we would have a rather incomplete and fragmented picture of the relationship between image and altar in the Middle Ages. Aside from simply presenting and interpreting the Scandinavian pieces, the essays in this volume deal with both this relatively obscure material and with more well known medieval monuments from other areas in Europe. All in all, the aim has been to achieve a more comprehensive and balanced understanding of altar décor in the period under investigation.

This investigation of the relationship between image and altar should be viewed in light of recent methodological developments in medieval art history. Among these is the ever-growing emphasis on liturgy as the key to understanding how images interacted with the performance of divine services for which they served as visual settings.[6] More careful attention paid to the role of space, time and text in narrative programs has also given rise to new questions concerning the audience and setting of these images.[7] The analysis of non-narrative images, too, has benefited from current concepts of materiality, the visualization of the invisible, and the relationship of artifacts to relics and the human body.[8] In sum, new methodologies have succeeded in liberating the image from its iconographic and stylistic straitjacket, thereby activating it in a ritual set before an audience within a visual and spatial context.

The contributions are arranged according to theme not chronology. The anthology begins with Ann van Dijk's essay on the interaction between the altar and its decorated setting. In it she claims that the typological connection between sacred history and eucharistic ritual had already affected the choice and placement of imagery in Early Christian churches. She argues that Middle Byzantine frescoes and mosaics depicting the narrative of Christ's life reinforced the ritual

re-enactment of His life during the celebration of the Eucharist. Such a link between sacred history and its liturgical representation is evident even earlier in the burial chapel of Pope John VII (705-707) in Old St. Peter's in Rome, where mosaics displaying episodes of Christ's infancy and passion appeared directly above the altar. Here, as van Dijk demonstrates, each of the events shown in the Passion cycle was evoked verbally during the performance of the Mass. The structure of the infancy narrative, on the other hand, served to create a close bond between the Nativity and the altar, which, in turn, established an additional connection to the Eucharist since each enactment of the latter causes Christ's body and blood to reappear on the altar in the form of consecrated bread and wine.

Annika Elisabeth Fisher is equally concerned with the liturgical re-enactment of sacred history in her analysis of yet another image in its context: the Ottonian Gero Crucifix suspended above the altar in the Cathedral of Cologne. Relying on the writings of the Carolingian theologians Amalarius of Metz and Paschasius Radbertus, Fisher reveals how the Mass was transformed into an allegorical drama of the events leading up to salvation. In this scenario, the Gero Cross became Golgotha, while the crucified Christ, and the congregation, stood in for the crowd of Jerusalemites which had witnessed the spectacle. Assisting in this transformation was the piece of the True Cross inside the Gero Crucifix, as well as a fragment of the Host, which was identified as Christ's historical body at the time. As Fisher explains, the sculpture gave concrete form to the concept of the Eucharist, which was only a cloak – a *figura* – for the actual body and blood. Since the sculpture contained the host, it too was a *figura*, whose wooden surface hid an inner essence. The Gero Crucifix, she concludes, explained rather than revealed the host. Fisher also contends that the crucified body of Christ, which symbolizes the Church, functioned as a metaphor for the bishop's care of his flock as he distributed the sacrament.

In Erik Thunø's essay, the focus shifts from the precinct of the altar to the altar itself. Thunø argues that the narrative mode of the frontal of the golden altar of Milan has so many features in common with later European altar frontals, especially those of Scandinavian origin (which are treated in the next three essays), that one can speak of a shared conceptual framework? Unlike the highly visible medieval mosaics in Rome or the Gero Crucifix, the Milanese narratives could hardly be seen since they were overshadowed by the glitter and reflections of precious materials. The materials are also mentioned in an inscription on the altar that reminds the reader to subordinate the shimmering gold of the altar to the potency of the relics placed beneath it. Thunø roots this hierarchical organization in medieval aesthetics; the materiality is but an external form of beauty that denotes the invisible reality – true beauty – which exists in the relics inside

the altar. The altar thus becomes a point of encounter between earth and heaven, a bridge that is crossed with the assistance of the altar's explicit materiality and the Eucharist, the body of Christ, whose mediating power is explained and authorized by the Christological narratives that the viewer reads upon reaching the altar.

The three remaining essays all deal with Scandinavian frontals. Søren Kaspersen presents a survey of the Christological cycles depicted on these frontals and discusses their fundamental structure as well as other aspects of their narrativity. The series of events depicted on the golden altars clearly conforms to a cyclical model even if its scope is somewhat limited and lapses in chronology are evident. In his analysis of a single motif, the *Visitation*, Kaspersen demonstrates how an individual episode may be narrated in different ways; 'modes' vary according to the ordering (*dispositio*) and ornamentation (*elocutio*) of the formal language. He also discusses style, mimesis, and reception as elements of the character of narrativity, and shows that the 'staging' of a narrative can be carried by different kinds of signs – mimetic, stylized, abstract, and metaphorical. All the same, he notes that the extent to which these signs may be understood as meaning-bearing components is a matter of interpretation.

Kaspersen also maintains that in the Middle Ages, Christian narratives were conceived according to three different views of time. Christological series on frontals, therefore, reflected not only the *continuum* of the story of salvation, but also the cyclical dimension of time as it occurs in the liturgy's annual commemoration of Christ's act of redemption. At the same time they referred to the annulment of time and space that took place through the intervention of the divine at every Mass. These varying concepts of time are apparent in the diverse relations between the *historiae* and the central image, i.e. Christ in Majesty. Finally, the frontals were endowed with special status by the gilding, which elevated their *elocutio* to a higher level and transformed them into an *ornatus* that alluded to an even greater radiance – that of the spiritual light radiating from the divine mysteries related by the narratives.

Lena Liepe, in turn, stresses the importance of the human body in Christian thought and art, thereby the importance of 'reading' medieval images through their phenomenological appearance and analyzing how they communicate through their formal properties, including 'body language.' She interprets the narrative sequence of Christ's childhood and passion in the Ølst frontal on this 'pre-iconographic' level, and investigates a type of visual communication that is not bound by textual sources. Conceiving ground and space according to Jean-Claude Bonnes' interpretation of Romanesque art, she focuses on aspects of 'body language.' Like Meyer Shapiro and Norbert H. Ott, she considers the different positions and parts of the body as systems of signification that work

contextually and relationally, and concludes that relational variables are strong carriers of meaning in the narrative of the Ølst frontal. She also applies Birgitte Buettner's three factors – namely, repetition, contrast, and variation – to her analysis of the pictorial, self-referential articulation of meaning in the pictorial program of the frontal.

In the final essay, Harriet M. Sonne de Torrens's analyses a single motif – a Nativity on the altar frontal in Stadil Church in Jutland (Denmark) – in light of both its unusual iconography and the singular gestures of the Virgin and the Child. She relates the composition to the Johannine reading for the third Mass on Christmas Day (John 1:1-14) and other relevant texts. At the same time, she examines the uncommon relationship between the Virgin and her Child in the context of a broader 'intertextuality' that includes such motifs as the Deposition of Christ, the Doubting Thomas, and the arms of Moses held up by Aaron and Hur at the battle of Amalek. Sonne de Torrens claims that the composition alludes to the advent of the Church, personified here by the Virgin, who is both the mother and *sponsa* of Christ. She situates this work within a distinct phase of the rise and establishment of the Church, and its triumphant dissemination of the New Law – an idea often represented in images of Christ's childhood on liturgical objects such as frontals and baptismal fonts.

Notes

1 *Liber Pontificalis*, ed. L. Duchesne (Paris, 1955), 1: 363, 432, 500, etc. For an overview from the Early Christian period to the Late Middle Ages, see Joseph Braun, *Der christliche Altar in seiner geschichtlichen Entwicklung* (München, 1924), 2: 9-27.

2 Omitted in both groups are objects of a less 'permanent' nature, that is, liturgical utensils, reliquaries and icons that only occupy the altar during mass and on other liturgical occasions.

3 Held on 4 May 2001.

4 The same idea lies behind a current preparation for an up-to-date publication on the Danish golden altars supported by Novo Nordisk, Denmark.

5 Poul Nørlund, *Gyldne altre. Jysk Metalkunst fra Valdemarstiden* (København, 1926 / Århus 1968²); only recently Nørlunds volume has been complemented by Poul Grinder Hansen, Gérard Franceschi and Asger Jorn, *Nordens gyldne billeder fra ældre middelalder* (København, 1999), with a fine introduction to the material and a large and very valuable body of photographs. Joseph Braun, however, did include several of the Scandinavian frontals in his majestic overview, see Braun, *Christliche Altar*, 98ff.

6 Staale Sinding Larsen, *Iconography and Ritual* (Oslo, 1984); *Heiliger Raum – Architektur, Kunst und Liturgie in mittelalterlichen Kathedralen und Stiftskirchen*, ed. Franz Kohlschein & Peter Wünsche (Münster, 1998), with an extensive bibliography on the subject (pp. 243-360); *Art, cérémonial et liturgie au Moyen Age*, ed. Nicolas Bock et al. (Rome, 2002).

7 *Pictorial Narrative in Antiquity and the Middle Ages*, ed. Herbert L. Kessler and Marianna Shreeve Simpson, *Studies in the History of Art* 16 (Washington DC, 1985); Marcia Kupfer, *Romanesque Wall Painting in Central France: The Politics of Narrative* (New Haven/Conn., 1993);

Wolfgang Kemp, *Christliche Kunst: Ihre Anfänge, ihre Strukturen* (München, Paris, London, 1994).

8 Hans Belting, *Bild und Kult – Eine Geschichte des Bildes vor dem Zeitalter der Kunst* (München, 1990); *L'image: fonctions et usages des images dans l'Occident medieval,* ed. Jérôme Baschet & Jean-Claude Schmitt (Paris, 1996); *Les images dans les sociétés médiévales: Pour une histoire comparée,* ed. Jean-Marie Sansterre & Jean-Claude Schmitt (Bruxelles, 1999); Herbert L. Kessler, *Seeing Medieval Art* (Peterborough, 2004).

'Domus Sanctae Dei Genetricis Mariae'

Art and Liturgy in the Oratory of Pope John VII

Ann van Dijk

The Middle Byzantine feast cycle

In his classic study, *Byzantine Mosaic Decoration*, Otto Demus incorporated the christological narrative scenes decorating the naos of Middle Byzantine churches into the three interlinked interpretive systems he distinguished underlying the choice and arrangement of imagery (Fig. 1).[1] In what he termed the hierarchical cosmic system, the narrative images represent the Holy Land, situated half way between the terrestrial zone in the lower part of the church, and the celestial realms symbolized by the dome. In the topographical system, viewing the narrative scenes enables the worshipper in the church to make a symbolic pilgrimage to the sites sanctified by the events of Christ's life. And in the liturgico-chronological system, the narrative images function as a monumental calendar of liturgical feasts celebrated throughout the church year. The common designation of these images as the Festival or Feast Cycle refers to this last aspect of Demus' interpretation and indicates the broad acceptance it found.[2]

However, several scholars have challenged the notion that the christological cycle in Middle Byzantine churches represents a monumental feast calendar, pointing out that the scenes are not arranged in the order that they fall in the liturgical calendar, but in the narrative order of the Gospels. Moreover, these cycles frequently include episodes that were not celebrated as liturgical feasts, and leave out others that were. André Grabar, Hans Joachim Schulz, and Jean-Michel Spieser in particular have argued that the narrative imagery in Middle Byzantine churches should be termed liturgical less because it depicts events of Christ's life commemorated at the major feasts of the liturgical year than because these same events were represented sacramentally at every celebration of the eucharist.[3] Their arguments are convincing and worth sketching out here briefly.

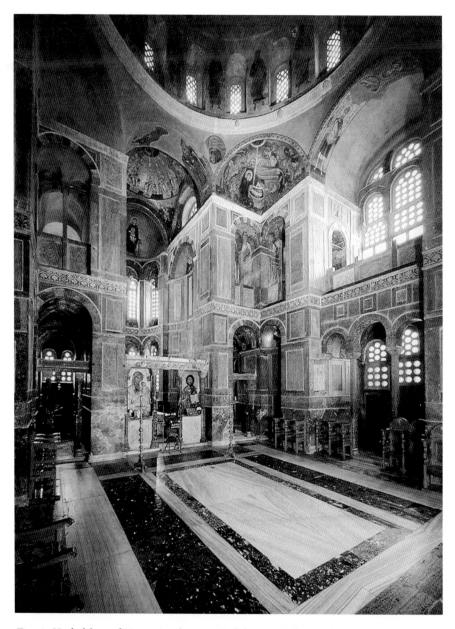

Fig. 1. Katholikon of Hosios Loukas, view of the naos. Photo: after Bruce White, in The Glory of Byzantium: art and culture of the Middle Byzantine era, A.D. 843-1261, *ed. H. Evans and W. Wixom, 20. New York: Metropolitan Museum of Art, 1997.*

The conception of the church as an image of the Holy Land and the eucharistic liturgy as a symbolic re-enactment of Christ's life are ideas clearly expressed in Byzantine liturgical commentaries. Writing in the eleventh century and thus contemporary with the earliest of the surviving examples of Middle Byzantine church decoration, Nicholas of Andida set out to provide a comprehensive interpretation of the eucharistic liturgy that identified each of its rituals with a different event of Christ's life.[4] He states his project clearly at the outset:

> Many who exercise the priestly office know and profess that what is accomplished in the Divine Liturgy is a copy of the passion, burial and resurrection of Christ our Lord. I am unable to say, however, why they are ignorant (or so they seem to me) that the liturgy also denotes all the manifestations which accompanied his entire saving life among us in the flesh: his conception, his birth, his life in the first thirty years, the activity of his precursor, his public debut at his baptism, the choice of the apostles, and the three-year period of miracles which roused envy and led to his crucifixion.[5]

In the commentary that follows the author elaborates on these statements. He interprets the preparation of the gifts in the *skeuophylakion* as a representation of the birth of Christ and the first thirty years of his life.[6] The Little Entrance is an image of the manifestation of Christ at his Baptism.[7] The Great Entrance represents the Entrance into Jerusalem.[8] The elevation of the host "images forth the elevation on the cross, the death on the cross, and also the resurrection" of Christ.[9] After the communion, the removal of the remaining consecrated species back to the *skeuophylakion* signifies the Ascension.[10]

André Grabar pointed out that a very similar conception of the liturgy appears to have motivated the juxtaposition of text and *painted* image in an illuminated liturgical scroll in Jerusalem (Library of the Greek Patriarchate, MS Staurou 109) also dating to the eleventh century.[11] The scroll contains the text of the prayers spoken by the priest during the Liturgy of John Chrysostom and is illustrated by a series of ten Gospel narrative scenes placed in the margins – largely the same choice of scenes that appears in contemporary Middle Byzantine churches.[12] The images function as a pictorial commentary on the liturgy, illuminating the significance of the prayers and rites they accompany in a manner highly reminiscent of, although not identical to, the written commentary of Nicholas of Andida. For example, the Presentation in the Temple appears alongside the prayer immediately preceding the Cherubikon hymn of the Great Entrance, a prayer that petitions God to purify the souls and body of those who approach the altar (Fig. 2). The image underlines the meaning of the prayer by reference to the Purification of Mary.[13] Moreover, it elucidates the

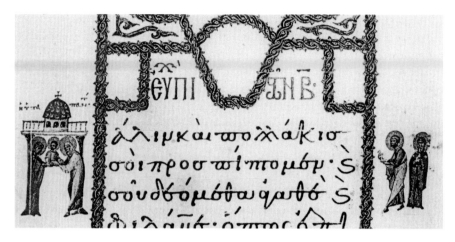

Fig. 2. The Presentation in the Temple. Jerusalem, Library of the Greek Patriarchate, Ms. Staurou 109. Photo: after Grabar, "Rouleau liturgique," (as in note 3), fig. 8.

significance of the procession of the gifts at the Great Entrance; to the right of the text column, Mary and Joseph bring their sacrificial offering to the temple whereas to the left, Christ, the true offering, appears already inside the temple in the hands of Symeon and Anna.[14]

Created at the same time and in the same intellectual climate that produced Nicholas of Andida's *Protheoria* and the illuminated liturgical scroll, the narrative imagery in Middle Byzantine churches surely shared the same interpretive emphasis. Like the illuminations, the mosaics and frescoes depict major events from the life of Christ. Adorning walls that enclose a liturgical space, moreover, the monumental narratives display a spatial relationship to the liturgical celebration in the church analogous to that of the marginal illuminations to the liturgical text they bracket in Staurou 109. Together this suggests that the narrative images in the church, like those in the manuscript, functioned as a pictorial reinforcement of the liturgy's representational character by illustrating the sacred history underlying the ritual re-enactment that was regularly performed below them during the celebration of the eucharist.

Art and liturgy before the Middle Byzantine period: The Oratory of Pope John VII

When did this approach to church decoration originate? Based on the evidence of the liturgical commentaries alone, Spieser suggested its origins in the change of interpretive emphasis that occurred between the *Mystagogy* of Maximos the

Confessor, written in the first half of the seventh century, and the liturgical commentary composed by Patriarch Germanos I of Constantinople shortly before the outbreak of Iconoclasm in 726.[15] While Maximos the Confessor's work follows in the spiritualizing and anagogical tradition of Dionysios the Pseudo-Areopagite and the Alexandrian exegetical school, that of Germanos in many ways turns back to the more historicizing tendencies associated with the school of Antioch, exemplified by the writings of Theodore of Mopsuestia and John Chrysostom.[16] Germanos' text remained widely read throughout the Middle Byzantine period, as its manuscript tradition attests, and it set the interpretive course for later centuries, directly influencing such later writers as Nicholas of Andida, discussed above.[17] In this paper I shall examine what our knowledge of some pre-Iconoclastic examples of church decoration can bring to bear on the question, focusing on the mosaic christological cycle that once adorned the Oratory of Pope John VII (705-707) in Old St. Peter's.

In the history of church decoration, expressing a typological connection between sacred history and the eucharistic ritual appears to have been a motivating factor in the choice and placement of at least some of the imagery in the church already in the Early Christian period. Old Testament types of the eucharist occur as early as the Abraham and Melchizedek panel positioned adjacent to the apse in the nave of Sta. Maria Maggiore in Rome, whose decoration dates to the pontificate of Sixtus III (432-440).[18] Gospel imagery with eucharistic significance occupies a comparable position in the early sixth-century decoration of S. Apollinare Nuovo in Ravenna; adjoining the apse on the left nave wall, scenes of the Wedding at Cana and the Miracle of the Loaves and Fishes illustrate New Testament types of the eucharist, while facing them, on the right wall, the Last Supper represents the institution of the sacrament.[19] In both churches, however, the scenes just enumerated form part of a vast narrative cycle adorning the full length of the nave, and it is only these few scenes, the ones closest to the apse, whose full significance emerges only through reference to the eucharistic ritual performed there.

Changes in the choice and arrangement of narrative imagery decorating the church in the following centuries suggest parallel changes in meaning and emphasis. In the church of S. Maria Antiqua in Rome, the presbyterium was selected as the site of a relatively concise fresco cycle of christological scenes under Pope Martin I (649-653) and again under John VII (705-707), even though more spacious expanses of wall were available in the main body of the church.[20] The latter pope, John VII, was also responsible for constructing an oratory in the northeast corner of Old St. Peter's, where a mosaic christological cycle adorned the wall directly above the altar.[21] Common characteristics of all three of these decorations are the inclusion of a series of images illus-

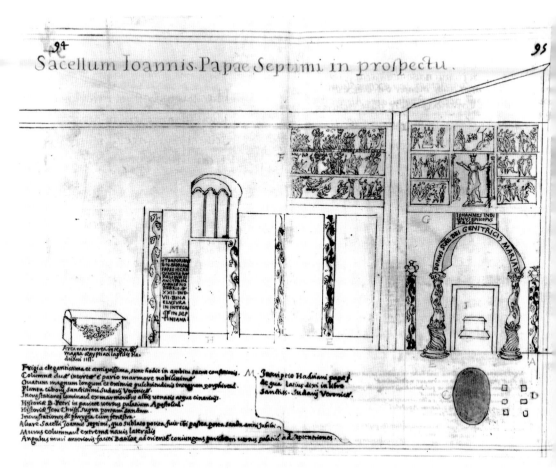

Fig. 3. The Oratory of Pope John VII, Rome. Vatican Library, Ms. Barb. lat. 2733, fol. 94v–95r. Photo: © Biblioteca Apostolica Vaticana.

trating the life of Christ and their position in close physical proximity to the altar.[22]

The last named example of this trend, the Oratory of Pope John VII, exists today only as a handful of mosaic and sculptural fragments that were preserved when the chapel was destroyed along with the last remaining section of Old St. Peter's at the beginning of the seventeenth century (Figs. 5–7).[23] While caution is required when discussing the decoration of a monument that no longer exists, the surviving fragments along with drawings and descriptions dating both before and shortly after the oratory was destroyed do allow a fairly detailed recon-

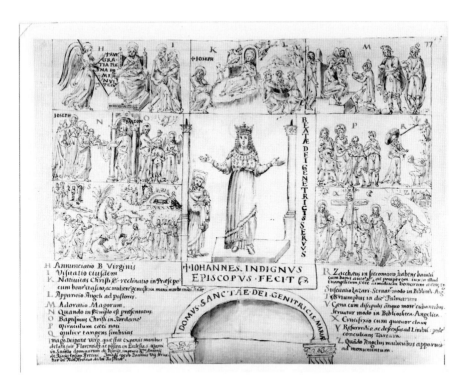

Fig. 4. Christological cycle in the Oratory of Pope John VII. Vatican Library, Ms. Barb. lat. 2732, fol. 76v-77r. Photo: © Biblioteca Apostolica Vaticana.

struction of many aspects of the chapel's appearance.[24] In particular, Giacomo Grimaldi's illustrated descriptions of the oratory, which document the chapel's appearance just prior to its destruction, are invaluable for understanding the decorative program (Figs. 3, 4).[25] This material shows that the focus of the decoration was a large mosaic image directly above the altar on the east wall, depicting a majestic Maria Regina in orant pose while a substantially smaller image of the pope, standing to one side, offered her the oratory.[26] Framing this pair on three sides was a series of seven mosaic fields, comprising imagery from the life of Christ, from the Annunciation and Visitation in the upper left corner, to the Crucifixion, Anastasis, and Women at the Tomb in the lower right.[27]

Considered in isolation, the choice and arrangement of imagery above the altar on the east wall suggest certain readings to the viewer. In the central panel, the actions of the two figures defined their relationship; the papal patron, John VII, offered the oratory to the Virgin Mary, to whom it was dedicated, and in return, so it would seem, Mary raised her arms in prayer, interceding on his

behalf. The narrative imagery arranged around this central image provided its foundation and justification. John VII's presentation of the oratory to Mary was made to follow a biblically sanctioned tradition of gifts to the Virgin represented in the scenes of the top register where the angel Gabriel and Elizabeth offered her gifts of praise, the midwives gifts of service, and the magi physical gifts of gold, frankincense and myrrh.[28] The scenes of the top register also provided the basis for Mary's depicted regal status and intercessory power in the central image; all devoted to the events surrounding the birth of Christ, they emphasized Mary's role in the Incarnation.[29] Within these scenes, Mary was prominent, the object of most of the other figures' gestures and gaze, and twice she appeared seated on a jewel-encrusted throne. Particularly significant was the placement of the Nativity directly above the focal central Mary Regina; the juxtaposition set up a direct relationship between Mary's historical role as the Mother of God and her resulting regal status and power to mediate.[30]

In the middle register, the narrative emphasis shifted from Mary to Christ, and the opening scene, the Presentation in the Temple, marked the transition. As in the earlier narrative scenes, Mary was the central figure, but in a reversal of roles she no longer appeared as the recipient of gifts. Instead, she herself of-fered the Christ child to the aged Simeon, who recognized him as the Messiah, as indicated by the words with which he received the Child, "Lord, now lettest thy servant depart in peace, according to thy word: For my eyes have seen thy salvation…."[31] The arch denoting the Temple at the far right of the scene acted as a visual boundary, signaling the passage to a new chapter in the narrative; in the following scene of the Baptism, another image of epiphany, the adult figure of Christ took center stage for the first time, a position he retained from this point onward. Yet, reading this register from left to right, the viewer's eyes were brought back the central image of Mary, whose large figure interrupted the nar-rative between the Baptism and the miracle scenes that followed, including the Woman with the Issue of Blood and the Healing of the Man Born Blind. If the Presentation and Baptism represented manifestations of Christ as divine saviour, the subsequent miracle scenes showed the first demonstrations of Christ's saving power in action. Positioned between the Baptism and the miracle scenes, the figure of Mary visually interjected the necessity of the Incarnation in bringing Christ's salvation to humankind.[32]

Mary served a similar function in the bottom register, devoted to the Passion. Much like the Presentation above, the dominating scene in the left field of the lowest register, the Entry into Jerusalem, served a transitional function, mark-ing the progression from Christ's ministry during his life on earth to his saving death on the cross and resurrection. In both registers the concept of passage was expressed through reference to a gate or archway. However, as Anna Kartsonis

observed, contrary to expectation, the Entry procession led not to the gates of Jerusalem, which did not appear in the scene, but to the central figure of Mary, the closed gate of Ezekiel's prophecy.[33] When the narrative resumed in the right panel, it jumped immediately to the Crucifixion and Anastasis. Bridging the transition between life and death in the narrative, the figure of Mary served a liminal function in this register as well, declaring once more the centrality of the Incarnation to humankind's redemption illustrated in the final scenes of the cycle.[34]

Such a reading of the imagery on the oratory's east wall takes on additional levels of meaning when the chapel's original function is taken into account. In constructing his oratory, John VII participated in a broader trend, the proliferation of chapels and secondary altars in Roman churches during the early Middle Ages, a phenomenon that coincides with a comparable rise in the number of special, votive masses of various types included in Roman sacramentaries.[35] According to the *Liber pontificalis*, John VII was buried in the oratory, his tomb placed under the pavement in front of the altar, which in turn was positioned directly below the christological cycle.[36] The inclusion of an altar, the location of the pope's tomb in front of it, and the prominence of John VII's image, clearly identified by inscription, in the decoration all suggest that the oratory was originally constructed as a burial chapel for the performance of private masses to benefit John VII's soul, a liturgical practice that had been growing in popularity since the early seventh century.[37] When the oratory's pictorial decoration is considered together with the liturgical ritual performed there, a rich and complex relationship emerges, suggesting that John VII enlisted the power of images to reinforce the meaning of the eucharistic celebration in ways that strongly evoke the later tradition of Byzantine church decoration discussed above.

Closest in position to the altar below, the Passion scenes in the bottom register of the christological cycle were most obviously related to the ritual activity that took place in the oratory, and each one of these events was evoked verbally during the performance of the mass.[38] At the far left, the Raising of Lazarus corresponded to one of the Gospel readings during masses for the dead listed in the Roman lectionaries of the time.[39] The words chanted by the crowd during Christ's Entry into Jerusalem, "Blessed is he who cometh in the name of the Lord: Hosanna in the highest," form the text of the Benedictus, recited near the beginning of the canon of the mass.[40] Christ's words and actions at the Last Supper – his blessing of the bread and wine, his statement that they are his body and blood, and his command that the disciples do this in remembrance of him – are recited by the priest at the consecration.[41] And the Crucifixion, Anastasis, and Women at the Tomb formed a visual counterpart to the prayer of anamnesis that follows immediately after the account of the institution during the consecration:

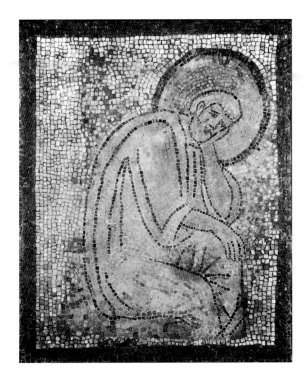

Fig. 5. Joseph. Mosaic fragment from the Oratory of Pope John VII. Moscow, Pushkin Museum. Photo: after Etinhof, "Mosaici di Roma" (as in note 23).

Wherefore, O Lord, we, thy servants…, calling to mind the blessed passion of the same Christ, Thy Son, our Lord, His resurrection from the grave, and his glorious Ascension into heaven, offer up to Thy most excellent majesty of Thine own gifts bestowed upon us, a victim which is pure, a victim which is holy, a victim which is stainless, the holy bread of life everlasting, and the chalice of eternal salvation.[42]

Read from left to right, therefore, the scenes of the bottom register corresponded to the order in which they were alluded to in the text of the mass. Viewed in conjunction with their evocation in the liturgy, these images synchronized the eucharistic celebration with the final events of Christ's redemptive mission. In so doing, they emphasized the liturgy's significance not only as the commemoration, but also as the representation of those events and, therefore, the extension of the history of salvation into the present ritual.

Domus sanctae Dei genetricis Mariae

As one of the central texts of the consecration, the account of the institution has an importance in the Roman mass that is not, however, reflected in the oratory's

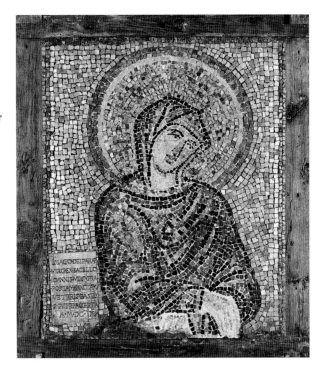

Fig. 6. Mary. Mosaic fragment from the Oratory of Pope John VII. Orte, Diocesan Museum. Photo: Archivio Fotografico Soprintendenza Speciale per il Polo Museale Romano.

decoration. The small size of the Last Supper image and its awkward positioning in the upper right corner of the bottom register's left field de-emphasize its importance in favour of the large, central image of Mary it adjoins. Conversely, the emphasis on the figure of Mary in the oratory's decoration has no parallel in the text of the mass in use in early eighth-century Rome, where her presence is minimal. Her name appears only twice, in the *Communicantes* and in a supplement to the Lord's prayer, the *Embolism,* both prayers invoking Mary's intercession.[43] During the celebration of the mass, the large Maria Orans would have acted as a focus for these prayers of intercession, as well as a reassurance that they would be answered. However, the positioning of Mary's dominating figure in relation to the surrounding narrative scenes and to the altar below suggests that she was intended to play a more integral role. Bisecting the narrative, the image of Mary created a strong vertical axis in the decoration that extended both down to the altar and up to the image of the Nativity. This arrangement set up a direct visual connection between the representation of Christ's human birth by means of Mary, and the celebration of the eucharist, during which another incarnation is effected when Christ's body and blood are made present again on the altar in the consecrated bread and wine.

Both the iconography of the Nativity and the architecture of the altar en-

Fig. 7. Miracle of the midwife with the withered hand. Watercolour of a mosaic fragment from the Oratory of Pope John VII. Vatican Library, Ms. Barb. lat. 4410, n. 12. Photo: © Biblioteca Apostolica Vaticana.

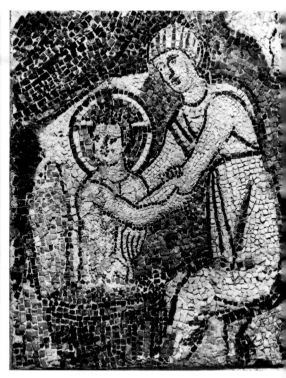

Fig. 8. Midwife bathing Christ. Mosaic fragment from the Oratory of Pope John VII. Vatican grottoes. Photo: Reverenda Fabbrica di S. Pietro in Vaticano.

semble seem to have been designed to reinforce this connection visually. The Nativity is one of the best preserved and documented scenes of the christological cycle, with the result that we are quite well informed about its iconography. Three mosaic fragments survive, showing Joseph, the bust of Mary, and one of the midwives bathing the Christ child (Figs. 5-6, 8).[44] Another, showing a midwife stretching out her withered hand to Christ in the manger for healing, was evidently preserved as well when the oratory was torn down since it is recorded in a watercolour dating to the 1630s, but the fragment itself no longer survives (Fig. 7).[45] Representations of the full scene are preserved in a number of drawings, also dating to the seventeenth century: the illustrations to the Grimaldi manuscripts, of which the earliest (Vatican, MS Barb. lat. 2732, fol. 76v-77r)

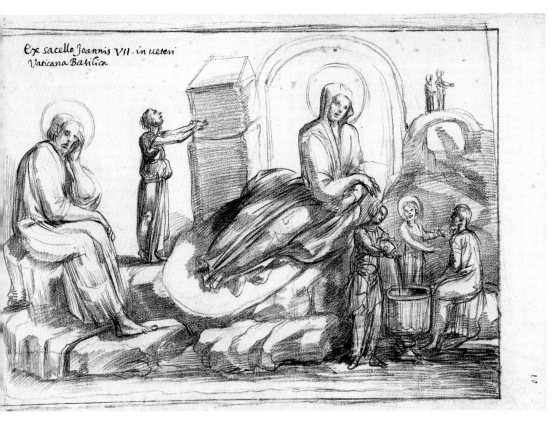

Fig. 9. The Nativity. Drawing of a mosaic in the Oratory of Pope John VII. Vatican, Ms. Archivio di S. Pietro A64 ter, fol. 45r. Photo: © Biblioteca Apostolica Vaticana).

is reproduced here as Fig. 4, and one of the large studies thought to have been made before the oratory was torn down in 1609 and included in the volume of drawings known as the Album (Vatican, MS Archivio di S. Pietro, A64 ter, fol. 45r: Fig. 9).[46] With the exception of the drawing in the Album, to be discussed below, this material presents a largely consistent view of the Nativity that allows one to reconstruct its iconography as follows: In the bottom left corner sat the melancholy figure of Joseph. Grey-haired and bearded in the surviving fragment, he wears a grey garment and encircling his head is a two-tone nimbus, half turquoise and half grey, outlined in blue (Fig. 5). The Grimaldi drawing preserves the inscription above his head: "+IOSEPH" (Fig. 4). Facing him, the figure of Mary occupied the centre of the composition. In the preserved frag-

ment of this figure, Mary's nimbus is gold, outlined with blue, and she wears a blue *palla* and *maphorion* decorated with gold emblems at the shoulders, breast, and forehead (Fig. 6). Underneath these garments she wore a purple tunic, and she lay on a yellow mattress; parts of both tunic and mattress are visible in the upper left corner of the surviving fragment of the midwife bathing the Christ child (Fig. 8). Mary's hands are crossed at the waist, and her head is turned to the right and inclined, so that she gazed at the washing scene in the mosaic's bottom right corner. Between Mary and Joseph, the infant Christ, nimbed and swathed in white cloths, lay on top of a block-like manger, from behind which emerged the heads of the ox and the ass, as shown in the watercolour of the destroyed fragment (Fig. 7). Above the manger, a gold star emitted three rays, while below, to the left, knelt the apocryphal midwife with the withered hand, wearing a sleeveless white or yellow tunic with a red belt, and a red and white striped cap. In the bottom right corner of the composition, two more midwives flanked an older Christ child. In the fragment surviving from this part of the scene, Christ's head is encircled by a nimbus with a blue and white cross, and he stands in a gold basin with red and blue vertical highlights, filled with turquoise water (Fig. 8). The midwife on the right sits facing Christ, dressed in identical fashion to the midwife with the withered hand. The midwife on the left stood pouring water into the basin. In the upper right corner of the composition there seems to have been a small representation of the Annunciation to the Shepherds (Fig. 4).[47]

While the Album drawing corresponds in general layout and many details to the description above, it disagrees with the reconstruction on a number of points (Fig. 9). In it, for example, the figure to the right of the Christ child in the washing scene is not a midwife, but a man with a beard. Since this is clearly contradicted by one of the surviving fragments (Fig. 8), the drawing is evidently in error. The Album drawing also shows the woman between Joseph and Mary stretching out her limp hand to a block-like structure, but no trace of the infant Christ is seen lying on it, and neither ox nor ass appears. This is in disagreement with the watercolour of the destroyed fragment (Fig. 7), which is surely the more trustworthy representation since the figure grouping it records has parallels in other representations of the midwife with the withered hand, a group of ivories ranging in date from the sixth to the eighth or ninth centuries (Fig. 10) and the frescoes of the S. Valentino catacomb in Rome.[48] By contrast, the same passage in the Album drawing would not only be unique, it would make no narrative sense.[49] These aberrations in the Album drawing are disturbing, because the group of drawings to which it belongs is generally recognized as the most accurate documentation of the oratory mosaics. However, as Nordhagen pointed out long ago, there are reasons to believe that this particular mosaic field was

Fig. 10. The Adoration of the Magi and the Nativity with miracle of the midwife with the withered hand. Ivory relief, 6th cent. London, British Museum. Photo: British Museum.

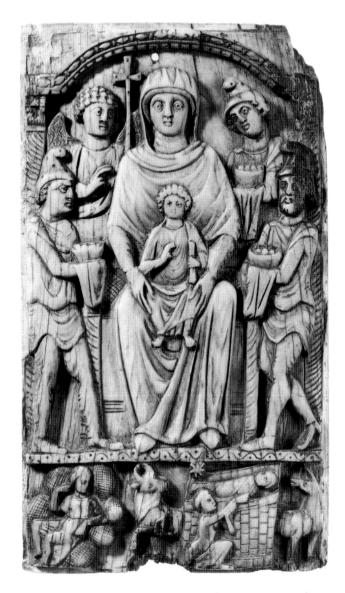

partially obscured by candle soot and grease when the drawing was made, resulting in the artist's confusion and errors.[50]

While the drawing of the Nativity in the Album is evidently untrustworthy on several counts, it does preserve a number of important iconographic features that will be critical to the argument presented here. The first is the generally block-like form of the altar to which the midwife stretches out her withered hand. This feature is corroborated both by the watercolour of the destroyed fragment

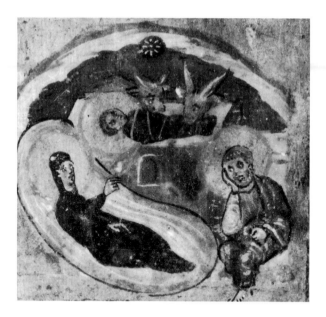

Fig. 11. Nativity. Detail of painted reliquary box with Christological scenes, 6th cent. Vatican Museum. Photo: Monumenti, Musei e Gallerie Pontificie.

and the illustrations to the Grimaldi manuscript. It is also a common element of Nativity iconography in the general period to which the oratory mosaics belong and can be found in works of art in a variety of media produced in different centers, including the sixth-century painted pilgrim's reliquary box from the Holy Land in the Vatican Museum (Fig. 11), the Rabbula Gospels of 586, and a number of ivories, among which are those discussed above in connection with the midwife with the withered hand (Fig. 10).[51] The second iconographic feature of note in the Album study is the form of the basin in which the Christ child stands. In the drawing it is represented as a chalice-like vessel: a deep, fluted cup on a relatively short stem with a knop and a splayed base. The fluted surface of the cup in the drawing corresponds closely with the surviving fragment of the vessel in the washing scene (Fig. 8), suggesting that the basin as a whole is accurately recorded in the Album drawing. The last feature is the lightly sketched arch around the figure of Mary in the Album drawing. The same feature appears in the earliest of the Grimaldi illustrations (Fig. 4)), but it disappears in the later versions, and there is no indication of it in the surviving fragment with the bust of Mary, which shows a plain gold background (Fig. 6). In this case, however, the evidence of the surviving fragment does not settle the matter, as the large size, regular shape, and close setting of the gold tesserae clearly indicate that they are later than the figure they surround, substituted for the original background when the mosaic was cut from the wall in order to make an icon out of the bust of Mary.[52] That leaves the graphic evidence, which tips the balance in favour

of the existence of the arched form outlining the top half of Mary's body, as it appears in the earliest of the drawings to record the oratory mosaics, drawings that, in the case of the Album, were made while the mosaic was still attached to the wall of the oratory, or, in the case of the earliest Grimaldi illustration, may have been created before the surviving fragment was altered.[53]

What was this arched form? While it may only indicate the outline of the yellow mattress on which Mary lay, it seems more likely that in the mosaic Mary was positioned in front of the cave specified as the site of Christ's birth in apocryphal accounts of the Nativity and venerated as a *locus sanctus* in Bethlehem.[54] The cave of the Nativity was frequently represented in art; the painted reliquary box from the Holy Land shares this feature with the oratory mosaic as well (Fig. 11).[55] Even more striking, however, is the ninth-century fresco in the crypt of San Vincenzo al Volturno (Fig. 12).[56] Lying on a mattress as in the oratory mosaic, Mary here appears in front of a cave very close in form to the structure that frames the upper part of her body in the drawings of the Nativity.

Having established the likelihood that the Nativity mosaic in the oratory contained two images of Christ, one lying on a block-like manger and the other standing in a chalice-like basin, and that Mary was represented reclining in front of a cave that framed the upper part of her body, let us consider the altar ensemble that stood below. The altar in front of which John VII was buried no longer existed when Grimaldi documented the oratory; the altar he included in his illustration of the chapel, hovering beneath the christological mosaics, is his reconstruction of the original, and the rectangle that frames it is an indication of the *Porta Santa*, the holy door opened only during Jubilee Years, a feature that belongs to the oratory's later history (Fig. 3).[57] Nothing can be known for certain about the original altar's appearance. It was probably made of stone and generally square or rectangular in shape, but it may have been any of the three types of altar common in this period, a table altar, a chest altar, or a block altar.[58] The drawings and description in the Grimaldi manuscripts indicate that the altar's placement was marked by an elaborate setting: two twisted vine scroll columns supporting a semicircular arch inscribed with the words DOMUS SANCTAE DEI GENETRICIS MARIAE in mosaic (Fig. 3).[59] According to Grimaldi's description, but not included in the illustrations, a mosaic representation of the Madonna and Child flanked by Peter and Paul adorned the lunette under the canopy; however, while possible, it is not certain that this mosaic was part of the oratory's original decoration as no part of it has survived.[60] In fact, of the elements of the altar ensemble, only the twisted vine scroll columns may be preserved, as it seems likely that they are to be identified with the pair of columns currently flanking the altar of St. Francis in the Chapel of the Sacrament at St. Peter's.[61]

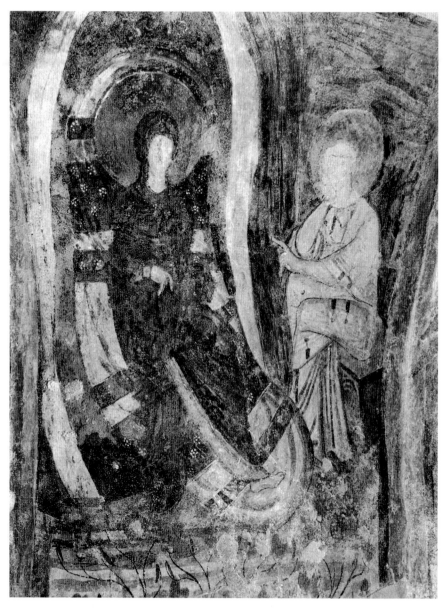

Fig. 12. The Nativity – Mary and Joseph. Fresco in the crypt of San Vincenzo al Volturno, 9th cent. Photo: John Mitchell.

With the exception of the lunette mosaic, there seems no reason to doubt that the altar canopy was part of the oratory's original decoration. Both textual evidence preserved in the *Liber pontificalis* and surviving fragments attest to the practice of sheltering altars under ciboria of various types in Roman churches around the time that John VII was pope.[62] These structures tended to be free-standing with canopies of a somewhat different form from the simple round arch recorded in the drawings of John VII's oratory. However, half-ciboria attached to a wall and supported on two columns only are not unheard of; archeological evidence suggests that such a structure appeared in the chapel of Leo IV (847-855) at S. Clemente.[63] Ward Perkins' contention that the twisted vine scroll columns were only brought to the oratory after 1507, when six of the twelve spiral columns adorning the main altar of St. Peter's were taken down, is unfounded, because Nikolaus Muffel recorded seeing the columns in the chapel during his visit to Rome in 1452.[64] While rare, such columns were very conceivably available to John VII at the beginning of the eighth century because the *Liber pontificalis* records that Pope Gregory III (731-741) was able to obtain six of them to decorate the main altar only a few decades later.[65] The columns in the oratory supported what was undoubtedly an original part of the decoration. Simple round arches survive among the fragments of early medieval liturgical furnishings in Rome.[66] Moreover, the term "domus" in the inscription adorning the front face of the arch is specific to the oratory's early history, occurring otherwise only in its dedication inscription but not in any of the later textual references to the chapel.[67]

When the Nativity mosaic and the altar structure that stood below it are now considered in relation to each other, the visual connections created between the two suggest that the juxtaposition was both deliberate and meaningful. The two images of Christ in the Nativity, one lying on a block-like manger and the other standing in a cup-like basin, take on eucharistic overtones. As Weitzmann discussed, the depiction of Christ's manger as a block-like altar originated in the art of the Holy Land, where it referred to and fused both the altar marking the site of Christ's birth in the grotto beneath the Church of the Nativity in Bethlehem, and the actual crib, which was also preserved there (Fig. 11).[68] The subsequent popularity of this iconography weakened the association with the specific *locus sanctus* that gave rise to it, diminishing the image's original significance in many cases (Fig. 10). However, in the Oratory of John VII, the appearance of the Nativity directly above the altar reactivated its latent liturgical connotations, identifying the historical newborn Christ in the manger with the Christ made newly present again on the altar in the eucharistic species.[69] On the other hand, the origins of the iconography of the bathing of the Christ child in pagan and secular images of the birth of gods and heroes make it unlikely that the motif

was intended to carry a eucharistic meaning when first taken over into Christian imagery.[70] As Kitzinger observed, the appearances of this motif in images of the Nativity was probably intended to indicate Christ's humanity and thus the reality of the Incarnation.[71] In the particular context of the oratory, however, the conjunction of this scene with the image of Christ on the altar-like manger suggests the possibility that it was also meant to make a eucharistic allusion, to the transformation of the consecrated wine into Christ's blood.[72] Finally, the arch of the cave framing the upper half of the figure of Mary in the Nativity mosaic would have echoed the arch of the canopy vault sheltering the altar which carried the inscription DOMUS SANCTAE DEI GENETRICIS MARIAE, House of Mary, the holy mother of God, and which may have contained an image of Mary in its lunette. Reflecting the Nativity image above, therefore, the altar ensemble seems to have been intended to identify the setting of the eucharistic celebration with the site of Christ's birth.

The concept of the eucharist as an incarnation of Christ has a long history in patristic thought.[73] It has a biblical basis in the text of John 6:51-54 where Christ presented himself as the antitype of the manna that God sent to feed the Jews in the wilderness, saying:

> I am the living bread which came down from heaven; if any man eat of this bread, he shall live forever; and the bread that I will give is my flesh, which I will give for the life of the world.

Among the many writers who used this text as a foundation for exegesis, John Chrysostom was exceptional in discerning a typological relationship between Christ's historical Incarnation at his birth and the sacramental incarnation that occurs during the eucharist.[74] Chrysostom's use of typology is characteristic of the exegetical school of his native Antioch which, as already mentioned above, emphasized the liturgy's commemorative aspect, interpreting the individual eucharistic rites as images of the various stages of Christ's historical work of redemption during his life on earth.[75] Writers of this school made frequent reference to the events surrounding Christ's death and resurrection when interpreting the liturgy, and John Chrysostom was no exception. However, he also evoked Christ's birth in this connection and so closely identified the historical with the eucharistic incarnation that the latter functioned for him as a transparency through which the former became visible. For example, in his homily *In beato Philogono*, he states:

> If we approach [the altar] with believing hearts, we will undoubtedly see the Lord lying in the manger, for the Supper table takes the place of the manger. Here too

the body of the Lord will lie, not wrapped in swaddling clothes as it was then, but surrounded on every side by the Holy Spirit.[76]

Elsewhere he makes use of the etymological interpretation of Bethlehem as "house of bread" when he adjures his listeners to follow the example of the Magi and "hurry to Bethlehem, where the house of spiritual bread is," where one "sees the Saviour lying in his spiritual manger."[77]

John Chrysostom's vision of the eucharistic Nativity has a parallel in the more elaborate vision of Paula, inspired by the sight of the *locus sanctus* in Bethlehem during her pilgrimage to the Holy Land in 385. Jerome recorded this vision in a letter, recording that upon entering the "cave of the Saviour:"

> [Paula] solemnly declared in my own hearing that, with the eye of faith, she saw a child wrapped in swaddling clothes, weeping in the Lord's manger, the Magi worshiping, the star shining above, the Virgin Mother, the attentive fosterfather, and the shepherds coming by night....[78]

Indeed, it is thought that Jerusalem, with its stational liturgy determined by the city's sacred topography, gave rise to the type of liturgical symbolism characteristic of the school of Antioch.[79] In the following passage of the same letter, the etymological interpretation of Bethlehem appears again, this time followed by an allusion to the text of John cited above:

> Then, her joy mixed with tears, she began to say: "Blessed Bethlehem, 'House of Bread,' birthplace of the bread that came down from heaven."

The etymological interpretation of the name of Christ's birthplace and the eucharistic implications that result from associating it with John 6:51ff became standard exegesis in the West, reappearing, for example in Pope Gregory I's Christmas homily:

> It was fitting too that he was born in Bethlehem. Bethlehem is translated "house of bread," and it is he who said: I am the living bread who came down from heaven. The place in which the Lord was born was called the "house of bread" because it was truly going to come to pass that he would appear there in a material body who would nourish the hearts of his chosen ones by an interior food.[80]

In the East, on the contrary, beginning in the fifth century, there was a shift away from the type of liturgical interpretation associated with the school of Antioch toward the more spiritualizing, anagogical tendencies of the Alexandrian school,

epitomized by the writings of Dionysios the Pseudo-Areopagite and Maximos the Confessor.[81] By the early eighth century, however, there is evidence to believe that the tide was again turning. As Taft and Meyendorff discussed, the liturgical commentary of Patriarch Germanos I of Constantinople, already mentioned above, represents a synthesis of these two schools of thought.[82] More important, in places Germanos' work recalls the writings of John Chrysostom and revives his identification of the eucharistic celebration at the altar with the Nativity. For example, in the interpretation of the various parts of the church and its furnishings at the beginning of the work, Germanos stated that "the apse corresponds to the cave in Bethlehem where Christ was born, as well as the cave in which he was buried."[83] Furthermore, while the altar was identified both with "the spot in the tomb where Christ was placed" and the table at which the Last Supper was eaten, it was also "prefigured by the table of the Old Law upon which the manna, which was Christ, descended from heaven," alluding again to the text of John 6:51f.[84]

In the oratory, therefore, the placement of the image of the Nativity over the altar drew on an established exegetical tradition that linked Christ's birth with the eucharist. The direct visual correspondence that existed between individual elements of the Nativity's iconography and the altar ensemble below finds a parallel in the writings of school of Antioch and, later, Germanos. Like them, it posited a typological connection between Christ's historical Incarnation and the sacramental incarnation of his body and blood in the eucharistic bread and wine. The importance of the text of John 6:51f, "I am the living bread which came down from heaven…," to this tradition is also significant in the context of the oratory's liturgical function; in the Roman lectionaries of the time it is listed as one of the gospel readings during masses for the dead.[85] During the celebration of the mass in the oratory, therefore, the spoken word, the visual image, and even architecture worked together to express the link between sacred history and its liturgical representation in a way that conceptually foreshadows the later history of Byzantine church decoration.[86]

Frequently cited sources

Bornert, René. *Les commentaires byzantins de la divine liturgie du VIIe au XVe siècle.* Paris, 1966.

Deshman, Robert. "Servants of the Mother of God in Byzantine and Medieval Art." *Word & Image* 5 (1989): 33-70.

Germanus. *On the Divine Liturgy.* Introd., ed., and trans. P. Meyendorff. Crestwood, 1984.

Grimaldi, Giacomo. *Descrizione della Basilica Antica di S. Pietro in Vaticano: Codice Barberini Latino 2733.* Ed. R. Niggl. Vatican City, 1972.

Jungmann, Joseph. *The Mass of the Roman Rite: Its Origins and Development.* Trans. F. A. Brunner. 2 vols. New York, 1951-1955.

Nordhagen, Per Jonas. "The Mosaics of John VII (705-707 A.D.)." *Acta ad archaeologiam et artium historiam pertinentia* 2 (1965): 121-166.

Schulz, Hans Joachim. *Die Byzantinische Liturgie: Glaubenszeugnis und Symbolgestalt.* Trier, 1980. Published in English as *The Byzantine Liturgy: Symbolic Structure and Faith Expression.* Trans. M. J. O'Connell. New York, 1986. (Citations are to the English edition.)

Spieser, Jean-Michel. "Liturgie et programmes iconographiques." *Travaux et memoires* 11 (1991): 575-590.

Taft, Robert "The Liturgy of the Great Church: an Initial Synthesis of Structure and Interpretation on the Eve of Iconoclasm." *Dumbarton Oaks Papers* 34-35 (1980-1981): 45-75

Van Dijk, Ann. "The Oratory of Pope John VII (705-707) in Old St. Peter's." Ph.D. diss., Johns Hopkins University, 1995.

Notes

* This article reworks material found in my doctoral dissertation, "The Oratory of Pope John VII (705-707) in Old St. Peter's" (Johns Hopkins University, 1995), the research for which was funded by the Johns Hopkins University, the Social Sciences and Humanities Research Council of Canada, and the Samuel H. Kress Foundation. Earlier versions of different parts of this article were presented as papers at the 21st Annual Byzantine Studies Conference, 1995, in New York and the 36th International Congress on Medieval Studies, 2001, in Kalamazoo. For their generosity at different stages during the development of this material I am especially grateful to: Herbert Kessler, John Mitchell, Valentino Pace, and Erik Thunø.

1 Otto Demus, *Byzantine Mosaic Decoration: Aspects of Monumental Art in Byzantium* (London, 1948), 15-25.

2 The terminology is Byzantine in origin, as pointed out by Henry Maguire, "The Mosaics of Nea Moni: An Imperial Reading," *Dumbarton Oaks Papers* 46 (1992): 205-214, esp. 205, n. 2.

3 André Grabar, "Un rouleau liturgique constantinopolitain et ses peintures," *Dumbarton Oaks Papers* 8 (1954): 161-199; Hans Joachim Schulz, *Die Byzantinische Liturgie: Glaubenszeugnis und Symbolgestalt* (Trier, 1980), published in English as *The Byzantine Liturgy: Symbolic Structure and Faith Expression*, trans. M. J. O'Connell (New York, 1986), 77-80 (subsequent citations are to English edition); Jean-Michel Spieser, "Liturgie et programmes iconographiques," *Travaux et memoires* 11 (1991): 575-590. See also Ernst Kitzinger, "Reflections on the Feast Cycle in Byzantine Art," *Cahiers archéologiques* 36 (1988): 51-73; Thomas Mathews, "The Sequel to Nicaea II in Byzantine Church Decoration," *Perkins Journal* (July, 1988), 14-17; Maguire, "Mosaics of Nea Moni," 205-214.

4 Nicholas of Andida, *Protheoria* (PG 140:413-468). On the work and its author, see also René Bornert, *Les commentaires byzantins de la divine liturgie du VIIe au XVe siècle* (Paris, 1966), 181-206; Schulz, *Byzantine Liturgy*, 89-98.

5 Nicholas of Andida, *Protheoria* 1 (PG 140: 417); translation from Schulz, *Byzantine Liturgy*, 89f.

6 Nicholas of Andida, *Protheoria* 9f (PG 140: 429B-D).

7 Ibid., 14 (PG 140: 436CD).

8 Ibid., 18 (PG 140: 441AB).

9 Ibid., (PG 140: 464D); translation from Schulz, *Byzantine Liturgy*, 97.

10 Nicholas of Andida, *Protheoria* 38 (PG 140: 465A).

11 Grabar, "Rouleau liturgique," esp. 182-186. See also Schulz, *Byzantine Liturgy* 80-89; Spieser, "Liturgie et programmes iconographiques," 579f.

12 Illustrated are the Annunciation, Nativity, Presentation in the Temple, Baptism, Transfiguration, Raising of Lazarus, Entry into Jerusalem, Prayer at Gethsemene, Crucifixion, and Anastasis.

13 Grabar, "Rouleau liturgique," 182f.

14 Schulz, *Byzantine Liturgy*, 83f; Spieser, "Liturgie et programmes iconographiques," 580. Both these authors reject Grabar's interpretation; however, the two interpretations do not seem to be mutually exclusive.

15 Spieser, "Liturgie et programmes iconographiques," 589. See also Bornert, *Commentaires byzantins*, 178-180.

16 On the commentaries of Maximos and Germanos and the interpretive traditions to which they belong, see Bornert, *Commentaires byzantins*, 52-180; Schulz, *Byzantine Liturgy*, 3-67 passim; Robert Taft, "The Liturgy of the Great Church: an Initial Synthesis of Structure and Interpretation on the Eve of Iconoclasm," *Dumbarton Oaks Papers* 34-35 (1980-1981): 45-75; Paul Meyendorff, introduction to his edition and translation of Germanus, *On the Divine Liturgy* (Crestwood, 1984), 23-52.

17 Bornert, *Commentaires byzantins*, 130-146.

18 Beat Brenk, *Die frühchristlichen Mosaiken in S. Maria Maggiore zu Rom* (Wiesbaden, 1975), 113f. For a different interpretation of this image, however, see Wolfgang Kemp, *Christliche Kunst: Ihre Anfänge, ihre Strukturen* (Munich, 1994), 151-154.

19 Friedrich Deichmann, *Ravenna: Haupstadt der spätantiken Abendlandes* (Wiesbaden, 1969-1989), 1:176-197; 2, pt. 1:129. The Miracle at Cana has been restored incorrectly.

20 On the earlier cycle created under Martin I, see Per Jonas Nordhagen, "The Earliest Decorations in Santa Maria Antiqua and Their Date," *Acta ad archaeologiam et artium historiam pertinentia* 1 (1962): 60; idem, "The Frescoes of the Seventh Century," *Acta ad archaeologiam et artium historiam pertinentia* 8 (1978): 101-103. On the cycle dating to John VII see idem, "The Frescoes of John VII (A.D. 705-707) in S. Maria Antiqua in Rome," *Acta ad archaeologiam et artium historiam pertinentia* 3 (1968): 22-38, 43-54.

21 Van Dijk, "Oratory of John VII;" Maria Andaloro, "I mosaici dell'Oratorio di Giovanni VII," in *Fragmenta Picta: Affreschi e mosaici staccati del medioevo romano* (Rome, 1989), 169-177; Per Jonas Nordhagen, "The Mosaics of John VII (705-707 A.D.)," *Acta ad archaeologiam et artium historiam pertinentia* 2 (1965): 121-166.

22 William Tronzo, "The Prestige of St. Peter's: Observations on the Function of Monumental Narrative Cycles in Italy," in *Pictorial Narrative in Antiquity and the Middle Ages*, ed. H. Kessler and M. Simpson, Studies in the History of Art 16 (Washington, 1985), 98f discussed this issue in connection with John VII's frescoes in S. Maria Antiqua, as did Stephen Lucey in a

paper delivered at the 37th International Congress on Medieval Studies, May 2-5, 2002, entitled "Picturing Ritual: Narrative Cycles at Santa Maria Antiqua, Rome" and in his doctoral dissertation, "The Church of Santa Maria Antiqua, Rome: Context, Continuity, Change" (Rutgers University, 1999).

23 The largest number of surviving fragments are under the current St. Peter's, in the Vatican Grottoes. Other fragments are preserved in the sacristy of S. Maria in Cosmedin in Rome, in the church of S. Marco in Florence, in the diocesan museum in Orte, and in the Pushkin Museum in Moscow. In addition to the literature cited above in n. 21, see Olga Etinhof, "I mosaici di Roma nella raccolta di P. Sevastjanov," *Bollettino d'arte* 76, n. 66 (1991): 29-38; Per Jonas Nordhagen, "A carved marble pilaster in the Vatican Grottoes: some remarks on the sculptural techniques of the Early Middle Ages," *Acta ad archaeologiam et artium historiam pertinentia* 4 (1969): 113-119.

24 Van Dijk, "Oratory of John VII," 34-120.

25 Giacomo Grimaldi, *Descrizione della Basilica Antica di S. Pietro in Vaticano: Codice Barberini Latino 2733*, ed. R. Niggl (Vatican City, 1972), 105-113, 117-128, 257-259. On the author and his writings, see Reto Niggl, "Giacomo Grimaldi (1568-1623): Leben und Werk des römischen Archäologen und Historikers" (Ph.D. diss., Ludwig-Maximilians Universität, 1971). For a detailed assessment of the Grimaldi material's trustworthiness, see van Dijk, "Oratory of John VII," 6-34, 41-77.

26 Grimaldi records that in 1609, Cardinal Giovanni Evangelista Pallotta gave the fragment with the Maria Regina to the Archbishop of Arrezzo, Antonio di Ricci, for use in decorating his family chapel in S. Marco in Florence, where it remains to this day. The bust of John VII is in the Vatican Grottoes. See Grimaldi, *Descrizione*, 119, 257ff; Andaloro, "Mosaici dell'Oratorio," 169, 173; Nordhagen, "Mosaics of John VII," 124ff.

27 A second narrative cycle of Peter imagery decorated the adjacent north wall; however, its function within the oratory's decoration is beyond the scope of this article. For a discussion of this component of the decorative program, see Ann van Dijk, "Jerusalem, Antioch, Rome, and Constantinople: The Peter Cycle in the Oratory of Pope John VII (705-707)," *Dumbarton Oaks Papers* 55 (2001): 305-328; William Tronzo, "Setting and Structure in Two Roman Wall Decorations of the Early Middle Ages, *Dumbarton Oaks Papers* 41 (1987): 477-492.

28 On the function of the Annunciation scene within the cycle see Ann van Dijk, "The Angelic Salutation in Early Byzantine and Medieval Annunciation Imagery," *Art Bulletin* 81 (1999): 423-429, 432-433. On the significance of the midwives in the Nativity scene, see Robert Deshman, "Servants of the Mother of God in Byzantine and Medieval Art," *Word & Image* 5 (1989): 36-42. See also Natalia Teteriatnikov, "The 'Gift Giving' Image: The Case of the Adoration of the Magi," *Visual Resources* 13 (1998): 381-391.

29 This was discussed by Deshman, "Servants," 42; Anna Kartsonis, *Anastasis: The Making of an Image* (Princeton, 1986), 79-80.

30 Deshman, "Servants," 39. On Maria Regina imagery, see John Osborne, "Images of the Mother of God in Early Medieval Rome," in *Icon and Word: the Power of Images in Byzantium. Studies presented to Robin Cormack*, ed. A. Eastmond and L. James (Aldershot, 2003), 135-156, esp. 136-141. While the choice of Maria Regina for the central image may have been politically motivated, discussion of this aspect of the decoration is beyond the scope of this paper. In this connection, however, see Gerhard Ladner, *I ritratti dei papi nell'antichità e nel medioevo*, 3 vols. (Vatican City, 1941-1984), 1:92f and, most recently, Thomas F. X. Noble, "Topography, Celebration and Power: The Making of Papal Rome in the Eighth and Ninth Centuries," in

Topographies of Power in the Early Middle Ages, ed. M. de Jong et al. (Leiden, 2001), 45-91, esp. 61-67.

31 Luke 2:29ff.

32 For a more detailed discussion of the scenes in the middle register, see van Dijk, "Oratory of John VII," 234-252.

33 Kartsonis, *Anastasis*, 79; Ezekiel 44:2.

34 For a more detailed discussion of the scenes in the bottom register, see van Dijk, "Oratory of John VII," 252-257.

35 Arnold Angenendt, "Missa specialis: Zugleich ein Beitrag zur Entstehung der Privat Messen," *Frühmittelalterliche Studien* 17 (1983): 153-221; Franz Alto Bauer, "The Liturgical Arrangement of Early Medieval Roman Church Buildings," *Mededelingen van het Nederlands Instituut te Rome* 59 (2000): 101-28, esp. 114-117.

36 *Le Liber Pontificalis*, ed. L. Duchesne and C. Vogel, 2nd ed. (Paris, 1955-57), 1:385f.

37 Arnold Angenendt, "Missa specialis," 198-203; Frederick Paxton, *Christianizing Death: The Creation of a Ritual Process in Early Medieval Europe* (Ithaca and London, 1990), 66-69; Cyrille Vogel, "Deux conséquences de l'eschatologie grégorienne: la multiplication des messes privées et les moines-prêtres," in *Grégoire le Grand*, ed. J. Fontaine et al. (Paris, 1986), 268-276; van Dijk, "Oratory of John VII," 193-205.

38 In Rome, the text of the mass had been largely fixed by the late 6th century, and only a few alterations were made between that time and the early 8th century, when John VII's oratory was constructed. Masses for the dead were distinguished only through their readings and the inclusion of a few special prayers. For the history of the mass, see Joseph Jungmann, *The Mass of the Roman Rite: Its Origins and Development*, trans. F. A. Brunner, 2 vols. (New York, 1951-1955); Salvatore Marsili et al., *La Liturgia, eucharistia: teologia e storia della celebrazione*, vol. 3, pt. 2 of *Anàmnesis: introduzione storico-teologica alla Liturgia*, ed. S. Marsili (Casale Monferrato, 1983), 225-245; Robert Cabié, *The Eucharist*, trans. M. J. O'Connell, vol. 2 of *The Church at Prayer*, ed. A. G. Martimort, new ed. (London, 1986); Roger E. Reynolds, "Mass, Liturgy of the," *Dictionary of the Middle Ages*, 8:181-197. For the text, see Anton Hänggi and Irmgard Pahl, eds., *Prex Eucharistica: Textus e variis liturgiis antiquioribus selecti*, Spicilegium Friburgense 12 (Fribourg, 1968), 426-437; Bernard Botte and Christine Mohrmann, *L'ordinaire de la messe: texte critique, traduction et études* (Paris, 1953), 58-91. For the prayers specific to masses for the dead around the time of John VII, see Leo C. Mohlberg, ed., *Liber sacramentorum Romanae aeclesiae ordinis anni circuli (Sacramentorum Gelasianum)*, Rerum Ecclesiasticarum Documenta, series maior, Fontes 4 (Rome, 1968), 236-247; Jean Deshusses, *Le sacramentaire grégorien: ses principales formes d'après les plus anciens manuscrits*, 2nd ed., Spicilegium Friburgense 24 (Fribourg, 1988), 2:198-232. For the readings during masses for the dead, see Theodor Klauser, *Das Römische Capitulare Evangeliorum: Texte und Untersuchungen zu seiner ältesten Geschichte* (Münster, 1935), 1:45f, 92, 129f.

39 Klauser, *Römische Capitulare Evangeliorum*, 1:45, 92. The text is John 11:21-27. Although not the account of the raising itself, this passage records the conversation between Martha and Christ immediately before, both alluding to the miracle to come and explaining its significance.

40 Matthew 21:9. On the Benedictus, see Jungmann, *Mass of the Roman Rite*, 2:136-138.

41 Hänggi and Pahl, *Prex Eucharistica*, 433f; see also Jungmann, *Mass of the Roman Rite*, 2:194-201.

42 Hänggi and Pahl, *Prex Eucharistica*, 434; trans. from *The New Roman Missal in Latin and English* (New York, 1945), 784. See also Jungmann, *Mass of the Roman Rite*, 2:218-226; Marsili et al., *Liturgia, eucharistia*, 231, 240.

43 On these prayers, see Jungmann, *Mass of the Roman Rite*, 1:170-179; 2:284f. All other references to Mary in the ordinary of the mass are later additions.

44 The fragment of Joseph is in the collection of the Pushkin Museum in Moscow: see Etinhof, "Mosaici di Roma." The bust of Mary is in the diocesan museum of Orte, and the midwife bathing the Christ child is in the Vatican Grottoes: see Nordhagen, "Mosaics of John VII," 130-134; Andaloro, "Mosaici dell'Oratorio," 170-173, 174; Tommaso Strinati, "Vergine (particolare della Natività)," *Romei e Giubilei: Il pellegrinaggio medievale a San Pietro (350-1350)*, ed. M. D'Onofrio (Milan, 1999), 443.

45 "Altaria, sepulcra, vetera monumenta, quae olim in templo vel atrio Vaticano extabant...," Vatican, MS Barb. lat. 4410, n. 12; see also Nordhagen, "Mosaics of John VII," 142f.

46 On the Grimaldi manuscripts, see above, n. 25. With the exception of the bifolium containing the dedication and title pages, Barb. lat. 2732 dates to 1612: see van Dijk, "Oratory of John VII," 14, n. 38. Grimaldi probably commissioned the drawings in the Album as each bears an inscription in his hand identifying it as being "ex sacello Joannis VII. in veteri Vaticana Basilica." On the creation of the Album, see Niggl, "Giacomo Grimaldi," 308ff.

47 Per Jonas Nordhagen, "The Integration of the Nativity and the Annunciation to the Shepherds in Byzantine Art," in *Acts of the Twenty-Second International Congress on the History of Art, Budapest, 1969* (Budapest, 1972), 1:253-257.

48 Representations of the midwife with the withered hand closely related to the watercolour of the oratory fragment appear on two plaques, one in the British Museum and the other in the John Rylands Library in Manchester, and on an ivory pyxis in Berlin: see *Age of Spirituality: Late Antique and Early Christian Art, Third to Seventh Century*, ed. K. Weitzmann (New York, 1979), 497, cat. 447; 509f, cat. 457; 531f, cat. 476. A second, closely related pyxis in Vienna with the same scene is thought to be a Carolingian copy: see Wolfgang Volbach, *Elfenbeinarbeiten der Spätantike und des frühen Mittelalters*, 3rd ed. (Mainz, 1976), 120, cat. 199. The frescoes in the S. Valentino catacomb are very deteriorated but their iconography is recorded in an engraving in Bosio's *Roma sotterranea*. Traditionally they have been associated with Pope Theodore (642-649) who, according to the *Liber pontificalis*, restored the church above them: see LP, 1:332f. However, John Osborne, "Early Medieval Wall Paintings in the Catacomb of San Valentino, Rome," *Papers of the British School at Rome* 49 (1981): 82ff argued that the catacomb frescoes should associated with the patronage of John VII.

49 Both the Greek *Protoevangelium of James* 19:3-20:4 and its Latin descendent, the *Gospel of Pseudo-Matthew* 13, recount the miracle of the midwife whose hand withered when she insisted on testing Mary's virginity following the birth of Christ but was miraculously healed when, instructed by an angel, she touched the Christ child with it: see J. K. Elliot, *The Apocryphal New Testament* (Oxford, 1993), 64f, 93f.

50 Nordhagen, "Integration of the Nativity."

51 On the painted reliquary box in Vatican, see Charles R. Morey, "The Painted Panel from the Sancta Sanctorum," in *Festschrift zum sechzigsten Geburtstag von Paul Clemen* (Düsseldorf, 1926), 150-167, esp. 156f. On the Rabbula Gospels, see Carlo Cecchelli et al., *The Rabbula Gospels (Florence, Laurenziana, Plut. I, 56)* (Olten and Lausanne, 1959), 55. On the ivories, see above, n. 48. For a discussion of this iconography, with additional examples, see Kurt Weitzmann, "Loca Sancta and the Representational Arts of Palestine," *Dumbarton Oaks Papers* 28 (1974): 31-55, esp. 36-39.

52 Nordhagen, "Mosaics of John VII," 130f.

53 The oratory was destroyed in 1609, and according to Nordhagen, ibid., the restoration of the fragment of the Virgin probably took place shortly thereafter, but precisely when is not known. The drawing in the earliest Grimaldi manuscript dates 1612: see above, n. 46.

54 Christ's birth in a cave is mentioned in both the *Protoevangelium of James* 18:1, 19:1-3 and the *Gospel of Pseudo-Matthew* 13: see Elliot, *Apocryphal New Testament*, 64, 93. On the grotto of the Nativity in Bethlehem, see John Wilkinson, *Jerusalem Pilgrims before the Crusades* (Warminster, 1977), 151f; Weitzmann, "Loca Sancta," 36f; Jack Finegan, *The Archeology of the New Testament: The Life of Jesus and the Beginning of the Early Church*, rev. ed. (Princeton, 1992), 30-32.

55 On the painted reliquary box, see the bibliography cited in n. 51 above.

56 John Mitchell, "The Crypt Reappraised," in *San Vincenzo al Volturno*, ed. R. Hodges, Archeological Monographs of the British School at Rome 7 (London, 1993), 76-81.

57 The oratory's original altar seems to have disappeared sometime between the end of the 15th century, when the German pilgrim Arnold von Harff saw it, and the second half of the 16th century, when Onofrio Panvinio omits it from his description of the chapel: see Arnold von Harff, *The Pilgrimage of Arnold von Harff Knight from Cologne...in the Years 1496-1499*, ed. and trans. M. Letts (London, 1946), 27; Onofrio Panvinio, *De rebus antiquis memorabilibus et praestantia basilicae Sancti Petri apostolorum principis vaticanae libri septem*, ed. A. Mai, *Spicilegium Romanum*, vol. 9 (Rome, 1843), 244. On the origins of the *Porta Santa*, see: Genoveffa Palumbo, *Giubileo giubilei: pellegrini e pellegrine, riti, santi, immagini per una stroria dei sacri itinerari* (Rome, 1999), 192-194, with further bibliography; Eva-Maria Jung-Iglessis, "La porta santa," *Studi romani* 23 (1975): 473-485; Carlo Cecchelli, "Origini della porta santa," *Capitolium* 25 (1950): 229-238.

58 Joseph Braun, *Der christliche Altar in seiner geschichtlichen Entwicklung*, 2 vols. (Munich, 1924); Sible de Blaauw, "L'altare nelle chiese di Roma come centro di culto e della committenza papale," in *Roma nell'alto medioevo*, Settimane di studi sull'alto medioevo 48 (Spoleto, 2001), 2:969-994. A chest altar presupposes the presence of a relic. Sible de Blaauw has suggested that the oratory may have housed a relic of the manger: see idem, *Cultus et Decor: Liturgia e architettura nella Roma tardoantica e medievale*, trans. M. B. Annis, 2 vols., Studi e testi 356 (Vatican City, 1994), 573. Relics of Christ's manger had been kept at S. Maria Maggiore, probably since the mid-7th century, after which time the church was regularly referred to as "ad presepe," and by the end of the 8th century it had a chapel "quod presepe dicitur," presumably constructed to house the relic. The same terminology is used in connection with the oratory of John VII in the mid- to late-8th century pilgrims' guide to St. Peter's chapels and altars, where the chapel is referred to as "presepe sanctae Mariae," suggesting that John VII may have placed part of S. Maria Maggiore's manger relic in the altar of his own chapel: see Giovanni Battista De Rossi, ed., *Inscriptiones christianae urbis Romae septimo saeculo antiquiores* (Rome, 1857-1888), 2:224-228, esp. 227.

59 Grimaldi, *Descrizione*, 106. The information that the inscription was in mosaic, however, comes from Pietro Sabino, who recorded the oratory's inscriptions in the late 15th century. He includes the canopy inscription with all those on the oratory's east wall under the heading, "Ibidem super columnas duas ex opere vermiculato ubi est imago Virginis:" see De Rossi, *Inscriptiones*, 2:418. The information is confirmed by Tiberio Alfarano, who describes the inscription as "al musivo" in his "Additione overo supplimento al libro di Maffeo Vegio e Petro Mallio," Vatican, Archivio di S. Pietro, cod. G.5., p. 159.

60 The only other reference to this mosaic is in Pompeo Ugonio's draft for his unfinished "Theatrum Urbis Romae," Vatican, MS Barb. lat. 1994, fol.311r. His description, however, adds no new information, and the sketch with which he accompanies it is disappointingly summary: an arch with "Maria" inscribed vertically down its central axis, flanked by "S. Paolo" inscribed to the left and "S. Pietro" to the right.

61 The suggestion was first made by D. M. Cerrati in his edition of Tiberius Alpharanus, *De Basilicae Vaticanae Antiquissima et Nova Structura*, Studi e Testi 26 (Rome, 1914), 55. See also van Dijk, "Oratory of John VII," 110-115.

62 A. M. D'Acchille, "Ciborio," in *Enciclopedia dell'arte medievale* 4 (Rome, 1993), 718-735, esp. 718-725; Federico Guidobaldi, "I *cyboria* d'altare a Roma fino al IX secolo," *Mededelingen van het Nederlands Instituut te Rome* 59 (2000): 55-69.

63 William Tronzo, "Setting and Structure," 477-488.

64 J. B. Ward Perkins, "The Shrine of St. Peter's and its Twelve Spiral Columns," *Journal of Roman Studies* 42 (1952): 21-33, esp. 24; Nikolaus Muffel, *Beschriebung der Stadt Rom*, ed. W. Vogt (Tübingen, 1876), 21: "Item auch sind do [in St. Peter's] XIIII seulen, die im tempel Salomonis gestanden sind, die al einer arbeit sein und sten zwu bey der Fronicka altar, do die gulden porten vermaurt is und die andern zwelf seulen sind im kor...." In the 15th century, the twisted vine scroll columns in St. Peter's were popularly believed to have come from the Temple of Solomon. Muffel does not mention the oratory by name; however, his reference to the "golden door" (i.e. the Porta Santa) and the Veronica altar, which by then stood inside the oratory, clearly identify the location of the two columns.

65 LP 1:417, 422, n. 11.

66 Guidobaldi, "*Cyboria* d'altare," 56f.

67 The dedication inscription read: + DEDICATIO DOMUS HUIUS SCAE DI GENITRICIS DIE XXI M MARC. IND IIII: see Grimaldi, *Descrizione*, 106; De Rossi, *Inscriptiones*, 2:418, n. 15; idem, *Musaici cristiani e saggi dei pavimenti delle chiese di Roma anteriori al sec. XV.* (Rome, 1899), commentary to pl. 20; van Dijk, "Oratory of John VII," 108.

68 Weitzmann, "Loca Sancta," 36-39. On the Church of the Nativity in the early period see also Wilkinson, *Jerusalem Pilgrims*, 151f; R. W. Hamilton, *The Church of the Nativity, Bethlehem: A Guide* (Jerusalem, 1947).

69 If the altar contained a relic of the manger, as discussed above in n. 58, the identification between manger and altar and, by extension, between the infant Christ depicted in the mosaic and the eucharistic species, would have been all the stronger.

70 Per Jonas Nordhagen, "The Origin of the Washing of the Child in the Nativity Scene," *Byzantinische Zeitschrift* 54 (1961): 333-337; Marian Lawrence, "Three Pagan Themes in Christian Art," in *De Artibus Opuscula XL. Essays in Honor of Erwin Panofsky*, ed. M. Meiss (New York, 1961), 329f; Ernst Kitzinger, "The Hellenistic Heritage of Byzantine Art," *Dumbarton Oaks Papers* 17 (1963): 101-104; Alfred Hermann, "Das erste Bad des Heilands und des Helden in spätantiker Kunst und Legende," *Jahrbuch für Antike und Christentum* 10 (1967): 60-81.

71 Kitzinger, "Hellenistic Heritage," 104, n. 39.

72 It has been suggested that the scene has baptismal significance since Christ's birth was regarded as an antitype of liturgical baptism, through which the new Christian is born, and Tertullian described the baptismal waters in terms of the purifying bath of the newborn Christian: see Deshman, "Servants," 34f; Pamela A. Patton, "Et Partu Fontis Exceptum: The Typology of Birth and Baptism in an Unusual Spanish Image of Jesus Baptized in a Font," *Gesta* 33 (1994): 84-88. This is certainly true in cases where the iconography of Christ's bath is reflected in images of his baptism, and vice versa. Although both scenes appeared in the oratory cycle,

they were not visually related through placement or iconography, making it unlikely that the creators of the oratory intended to emphasize the typological link between them.

73 Johannes Betz, *Die Eucharistie in der Zeit der griechischen Väter*, vol. 1, pt. 1, *Die Aktualpräsenz der Person und des Heilswerkes Jesu im Abendmahl nach der vorephesinischen Patristik* (Freiburg, 1955), 262-300. For the expression of this concept in medieval images of the Adoration of the Magi see Ursula Nilgen, "The Epiphany and the Eucharist: On the Interpretation of Eucharistic Motifs in Mediaeval Epiphany Scenes," *Art Bulletin* 49 (1967): 311-316.

74 Betz, *Eucharistie*, 1, pt. 1, 294-296.

75 Bornert, *Commentaires byzantins*, 72-82; Taft, "Liturgy of the Great Church," 62-70.

76 PG 48:753; translation from Schulz, *Byzantine Liturgy*, 15.

77 *Homilia in Mattheum 7*, 5 (PG 57:78f).

78 Jerome, *Letter 108 to Eustochium*, 10:2, in *Lettres*, ed. and trans. J. Labout (Paris: Les Belles Lettres, 1955), 5:159-201; English trans. from Wilkinson, *Jerusalem Pilgrims*, 49.

79 Taft, "Liturgy of the Great Church," 65f.

80 Gregory I, *Homily 8* (PL 76:1103); trans. D. Hurst in Gregory the Great, *Forty Gospel Homilies* (Kalamazoo, 1991), 50-53, where it is Homily 7.

81 Writers of the Alexandrian school conceived of the liturgy primarily as a reflection and means of access to spiritual realities and make little reference to the events of Christ's earthly life, although they did stress the importance of the Incarnation as the source and model of mankind's union with God: see Bornert, *Commentaires byzantins*, 66-72, 83-124; Schulz, *Byzantine Liturgy*, 25-28, 43-49; Taft, "Liturgy of the Great Church," 61f, 70f.

82 Taft, "Liturgy of the Great Church," 70-75; Paul Meyendorff, introduction to his edition and translation of Germanus, *On the Divine Liturgy*, 42-47.

83 Germanus, *On the Divine Liturgy*, 3f; ed. and trans. Meyendorff, 58f.

84 Ibid.

85 Klauser, *Capitulare Evangeliorum*, 1:45f, 92, 129f.

86 In particular, the relationship between the altar and the image of the Nativity as discussed here seems to furnish an important precedent for the *melismos* image that begins to appear in the apses of Byzantine churches from the late 12th century on: see Sharon Gerstel, *Beholding the Sacred Mysteries: programs of the Byzantine Sanctuary* (Seattle, 1999), 40-47.

Cross Altar and Crucifix in Ottonian Cologne

Past Narrative, Present Ritual, Future Resurrection[1]

Annika Elisabeth Fisher

The Christian altar is a place of various temporal evocations. In the case of the early medieval cross altar, the only early altar dedicated to a specific moment in the salvation story, the Biblical past was linked to the hope for future resurrection through the liturgy that was enacted there in the present.[2] In the cathedral of Cologne, the site of the cross altar – together with the miraculous crucifix erected above it and the Eucharist performed upon its *mensa* – formed a particularly powerful ritual center within the church.

Although evidence for altars dedicated specifically to the Crucifixion can be traced back to the Early Christian period, they first became standard features of medieval churches following the Carolingian multiplication of altars in the ninth century.[3] Many written accounts of the building, dedication, and liturgical use of cross altars remain from the Ottonian period, attesting to their former prevalence and importance.[4] The surviving documentation usually refers to the location of the cross altar with the phrase: "in medio ecclesiae."[5] This position "in the middle of the church" implies either that the altar stood in the middle of the nave as on the Carolingian plan of St. Gall or the Ottonian church in Essen, or that it stood in the middle of the transept, bisecting the choir screen as in the cathedral of Halberstadt.[6] The main function generally ascribed to the cross altar was that of *Volksaltar*; it was the site in the church where the Eucharist was consecrated and distributed to the laity on the high feast days.[7] Some sources indicate that is was also used as a key processional site in Paschal ceremonies and for the celebration the Mass of the Dead, particularly for honored members of the laity.[8]

The image associated with the cross altar is, not surprisingly, that of the cross or Crucifixion, which visually proclaims the altar's special dedication. Even on the plan of St. Gall, the altar labeled "altare sancti salvatoris ad crucem" is visually differentiated from the many altars lining the nave by the double-outline of

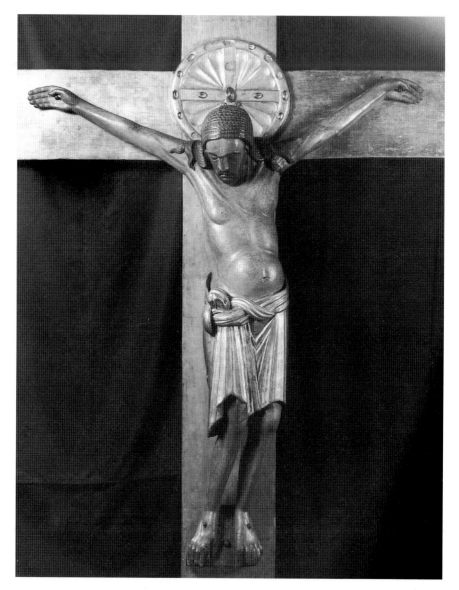

Fig. 1. Gero Cross. Cathedral of Cologne. Photo: Rheinisches Bildarchiv.

a large cross, indicating the fundamental importance of this image to the cross altar. The image could take the form of a jeweled cross, echoing the one Constantine erected on Golgotha, or a large crucifix, depicting the historical moment of humankind's redemption.[9] Most references to monumental crucifixes

*Fig. 2. Gero Cross,
detail. Cathedral
of Cologne. Photo:
Bildarchiv Foto
Marburg.*

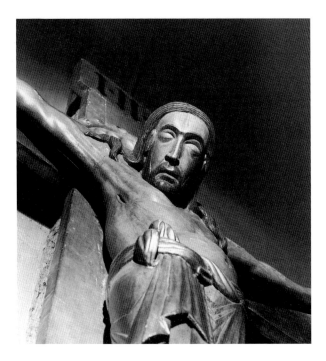

throughout the Middle Ages point to the cross altar as their original location.[10]
The crosses and sculptures either stood behind the altar on a support, such as
the columns remaining in Essen and Hildesheim, or they were suspended from
the ceiling above the altar.[11]

A number of the potential meanings of the altar/image relationship at the
cross altar are exemplified in the case of the Ottonian cathedral of Cologne, for
which a particularly fortuitous source survives even though the altar itself does
not. The early eleventh century *Chronicon* of Thietmar of Merseburg contains
a miracle story involving Gero of Cologne, who served as archbishop from 969
to 976. The passage in Chapter Two of Book Three reads:

> Meanwhile, Archbishop Gero of the see of Cologne died. As I have only spoken
> briefly about him, I will now relate a few things which I previously held back.
> He had a crucifix artfully made out of wood, which now stands above his grave,
> in the middle of the church. When he noticed a fissure in the crucifix's head, he
> healed it, trusting not in himself, but rather in the healthy remedy of the high-
> est artisan. He took a portion of the body of the Lord, our unique comfort in
> every necessity, and part of the health-bringing cross, and placed them together
> in the crack. Then, prostrating himself, he tearfully invoked the name of the

Fig. 3. Floor plan of the Cathedral of Cologne in the twelfth century. Photo: after A. Wolff, "Der Alte Dom", 150. Relevant locations on the plan are #10: the possible position of the cross altar in the Staufer period; #11: Gero's sarcophagus, to the east of the circle in the square (the cross altar was most likely to the west and Gero's cross may have stood in the middle of the circle); #12: rectangular field surrounded by a metal grill where Doppelfeld and Weyres position the cross altar.

Lord. When he arose, he found that the damage had been healed through his humble benediction.[12]

The crucifix in the account is probably the so-called Gero Cross that still today hangs in the cathedral of Cologne, though the church has been rebuilt and the cross is now located to the north of the high altar framed in a Baroque shrine (Figs. 1 and 2).[13]

The phrase describing the Gero Cross's original location, "in medio ecclesia," indicates that the miraculous cross was originally associated with the cathedral's cross altar. Since the early medieval cathedral that preceded the current Gothic structure greatly resembled the idealized plan of St. Gall, Weyres and Wolff position the cross altar in the very center of the nave (Fig. 3).[14] Doppelfeld and Kier support this proposed location through their analyses of the Carolingian marble floor patterns found in excavations beneath the current cathedral.[15] In the precise center of the nave was a perfect square of marble inscribed by a rosette, at

the middle of which Gero's crucifix may have stood (Fig. 3; #11). Abutting this square to the east are the remains of an empty grave from which only the black and white marble band that framed the sarcophagus lid remains. This was the site of Gero's grave, below his cross as per Thietmar's account. His sarcophagus, transferred from this spot to the Stephanus Chapel in the new Gothic choir, retains a lid encrusted with marble mosaic work that fits within the preserved frame and would have been at floor level in its original location.

To the east of Gero's tomb was another marble rectangle within the Carolingian floor, around which eleven stones bear small, rectangular impressions and the traces of a metal grill (Fig. 3; #12). Doppelfeld and Weyres maintain that this was the site of the cross altar.[16] Kier however convincingly argues the altar stood on the opposite side of Gero's tomb, directly west of the rosette. She contends that due to the cross altar's central importance to the laity as the site of their Communion celebration, it could not have stood behind Gero's tomb since this would have necessitated treading on the grave to attain the Eucharist. Furthermore, directly to the west of her proposed position of the cross, the large marble trachyte plates covering the ground show signs of heavy wear, possibly indicating the repeated kneeling of many people at precisely this spot. The crucifix would have stood on a firm support as indicated by a peg that extends from the base of the vertical cross shaft.[17]

The majority of scholarship on the Gero Cross has been concerned with the question of its dating and whether or not it can be identified as the cross in Thietmar's *Chronicon*; the paragraph has been employed primarily as a reference against which the surviving cross is compared. The further implications of the text itself, however, have not been adequately examined. My approach shall leave aside this issue of the correspondence between the cross in Cologne and the cross in the *Chronicon* by addressing primarily the latter.

By positing Ottonian spectators for the cross that Thietmar describes who were cognizant of the miracle tale, I shall propose a theoretical framework for the crucifix's reception and its association with the cross altar above which it stood. In light of the particular situation in Cologne recounted in the *Chronicon*, I shall examine three points: first, the multiple presence of the Eucharist at the site of the cross altar; second, the sacramental nature of the crucifix; and third, the affect of the cross altar and its image upon their intended medieval viewers.

The presence within in the cross, the altar, and the ritual

As Thietmar's miracle account reports, a piece of the True Cross and a consecrated Host were sealed within a crack in the wood of the crucifix, effecting the "heal-

Fig. 4. Back of the Cross from St. George, Cologne, with reliquary openings in the back and head. Cologne, Schnütgen-Museum. Photo: Rheinisches Bildarchiv.

ing" of the fissure.[18] In the early Middle Ages, independently holy substances like relics were frequently inserted within three-dimensional sculptures. The golden majesty of Ste. Foy in Conques is a prime example. The sculpture gave the relics, which were usually the corporeal remains of saints, an optically recognizable form – in effect, placing a body once again around the holy bones.[19] In return, the relics, which merited devotion on their own, helped to justify the sculpture's existence by allowing it to avoid any suspicion of being an idol.[20]

Three-dimensional images of Christ on the cross also often had reliquaries within their heads or chests (cf. Fig. 4). But, since Christ had ascended bodily to

heaven, these relics could not be fragments of his body, but were rather *brandea*, or touch relics, that had been sanctified by his contact during his brief tenure on earth.[21] The most common relic of this type was the marvelously prolific wood of the True Cross. This divine splinter was the traditional insertion within many medieval crucifixes, processional crosses, and pectoral amulets since it bestowed an immediate identification between the medieval creation and its holy prototype.[22] The inclusion of the Host was not unprecedented, but was far less common. A lost Carolingian cross from the Palatine Chapel in Aachen had a receptacle for the Eucharist in its head, as does the Ottonian crucifix in Werden (which also hung above a cross altar) and the Romanesque cross of Bishop Hermann II of Münster.[23]

The Eucharist, in addition to being permanently enshrined within the *corpus* of the crucifix in Cologne, would have also very likely been present within the altar itself. According to the *Ordo Romanus* of the eighth century and other early pontificals and sacramentaries, three particles of the Host together with three grains of incense should be placed together with the relics inside an altar during its consecration ceremony.[24] This practice was standard throughout Europe until the thirteenth century and was particularly appropriate for the cross altar. Finally, the Eucharist was again present at the cross altar when Mass was celebrated upon its *mensa* and Communion was distributed to the laity. In 966, Rather of Verona dictated that this should occur at least four times a year: at Christmas, the Lord's Supper, Easter, and Pentecost.[25]

Thus, at the center of the cathedral in Cologne, the Eucharist was present in the cross, in the altar, and during the ritual. The writings of two Carolingian theologians help us to interpret this situation: Amalarius of Metz and Paschasius Radbertus, whose theories about the liturgy and the Eucharist were widely dispersed and accepted in the Ottonian period.

Amalarius put forth a new interpretation of the western liturgy in the ninth century that had profound repercussions for Christian devotion. He viewed the liturgy as more than a mnemonic aid and rather as an elaborate allegory that enacts the events of salvation history and renews them in the present. Accordingly, he believed that each element of the liturgy symbolically evokes a specific aspect of the Passion narrative. For example, during the Offertorium which enacts the Crucifixion in the Mass, the bowed head of the priest symbolizes Christ's death, the supine subdeacons around the altar represent the women around the cross, the altar stands for the cross on Golgotha, and the congregation, as the audience of this drama, becomes the crowds in Jerusalem watching the spectacle of the Crucifixion.[26] The Mass is thus an intimate and inclusive mimetic renewal of the historical sacrifice in the Biblical narrative.

This conception of the liturgy as a performance of the Bible story is closely

associated with Paschasius's theory of the Real Presence of the Eucharist. In his tract *De corpore et sanguine Domini*, Paschasius asserts that after the consecration, the Host actually becomes the body of Christ. It retains only the physical attributes of the bread, while it transforms in essence into "none other than the flesh born of Mary and suffered on the cross and rose from the tomb."[27] There is a one-to-one identification of the Host with the historical body. Paschasius explains, "We receive in the bread that which hung on the cross."[28] Despite counter arguments against this realist view, Paschasius's theories appear to have been widely held by the tenth and eleventh centuries and were cited by many Ottonian authors, including Gezo of Tortona, Odo of Cluny, Heriger of Lobbes, and Rather of Verona.[29] The increasing dominance of the realist perspective around the millennium arguably led to the denouncement of Berengar of Tours as a heretic in 1059 and Paschasius's canonization in 1073.[30]

Together Amalarius's allegorical view of the liturgy and Paschasius's theory of the Real Presence create the ideological and devotional lens through which the Ottonian cross altar was viewed in Cologne. Accordingly, each third of this central site in the church – the crucifix, the altar itself, and the ritual performed there – expresses one of the three primary days of the Passion. Amalarius's metaphors create the narrative setting for this interpretation while Paschasius's conviction that the Eucharist is the Real Presence of Christ allows the Host to function like a dramatic character, performing each of these essential scenes in a Passion play.

First, the crucifix with the Eucharist imbedded within its head literally represents Christ's death on the cross on Good Friday. By depicting a life-sized body raised above the congregation, the crucifix dramatically re-presents the historical moment of the Crucifixion in medieval Cologne – affirming Amalarius's view that the liturgy recreates Biblical events to be experienced again by believers in the present, as well as Paschasius's view that the bread "hung on the cross." The additional presence of the cross relic within the *corpus* further underscored this association, since it provided a tangible link to the very cross that bore Christ's real body.

Second, the presence of the Eucharist within the altar evokes the Saturday following the Crucifixion when Christ lay buried in his tomb. The association between altar and tomb stretches back to the altars placed over the graves of the early martyrs and the practice of enclosing relics during the altars' consecrations.[31] Altars are often referred to as tombs of Christ since the Eucharist is prepared upon their surface, an identification that Amalarius himself employs when he designates the altar, in one of its various symbolic associations, as the *sepulchrum Domini* following the Elevation of the elements.[32] This symbolism is greatly enhanced by the "burial" of the Host as Christ's true body and blood inside the altar.[33]

And finally, the Resurrection on Easter Sunday is portrayed by the ceremony of the Mass when Communion was distributed to the laity. According to Amalarius, the Resurrection is represented when the priest completes the *Pater noster*, elevates the Host in the *minor elevatio*, speaks the *Pax Domini*, and places the bread on the paten. The spirit of Resurrection culminates when the believers consume the bread, as voiced by Jesus in John 6:54: "…He who eats my flesh and drinks my blood has eternal life, and I will raise him up at the last day."

Thus, through the presence of the Host in the crucifix, altar, and ritual, Christ's death, burial, and Resurrection are enacted at the center of the cathedral of Cologne. The Eucharist becomes like a character, performing each of these crucial scenes in the Passion play. In fact, the configuration at Cologne echoes the *depositio* and *elevatio* rituals that began in the tenth century.[34] In these ceremonies, the Host (or a small cross) represents Christ's body. It is ritually removed from sight on Good Friday, remains "buried" throughout Saturday (often at an altar), and is triumphantly raised on Easter Sunday. In Germany, the cross altar was often a processional stop or even the site of the 'tomb' in these ceremonies.[35] Although not known if this was the case in Cologne, the triple presence of the Host at the cross altar similarly evokes the three key salvational moments of the Crucifixion, Entombment, and Resurrection.[36] The crucifix, by involving the Host just as the ritual and the altar do, is thus fully integrated within the liturgical efficacy of the cross altar, allowing for a conflated rendition of the salvation narrative and creating a powerful, sacramental core *in medio ecclesia*.

The sacramental nature of the cross

Just as the Host could affect the carved body of the crucifix, however, the sculptural body could also affect the Host. Viewed through the perspective of Paschasius Radbertus's theory of the Real Presence, the carved wood of the sculpture could share in and influence the sacramental nature of the bread it enclosed.

The split between the visible and the invisible is essential to Paschasius's idea that the consecrated bread actually becomes the incarnate body of Christ. After the consecration, the bread is entirely changed into Christ's true body, but this fundamental change remains invisible to the senses. The sacrosanct bread continues to look, smell, and feel like bread. According to Paschasius's semiotics, the external signs of the bread and the wine, the *figura*, envelop and cloak the actual presence of the true body and blood, the *veritas*.[37] The exterior of the Eucharist is a false image, while its interior is the truth.[38]

In this way, Paschasius identifies the Eucharist as a sacrament. Following Isidore of Seville, he defines a sacrament as having two elements: a visible sign and an invisible reality.[39] Through faith, the exterior appearance of a sacrament

may be penetrated in order to perceive its sacred invisible *veritas*. This inner truth may on occasion be miraculously revealed to the eyes, as in a vision in which a piece of bleeding flesh appears in place of the bread.[40] Paschasius asserts, however, that such visions are for the spiritually weak, those who need their faith buttressed through sensual perception. As a true sacrament, the Host cloaks the real corporeal presence of Christ, and the devout believer must trust in the profound change caused by the consecration despite the enduring and deceiving appearance of the bread.[41]

The crucifix in Cologne, as a sculpture that according to Thietmar merged with the Host and the True Cross, reflects and also manipulates Paschasius's idea of the Eucharistic sacrament. The crucifix fully asserts the True Presence in that it literalizes Paschasius's claim that the bread hung on the cross. The historical cross itself miraculously merged with the oak of the carved *corpus*, blurring the distinction between the holy wood of the past and the artistic medium of the sculpture in the present. Imbedded and fused with this hallowed wood, the Host can literally no longer *be seen* as bread. A viewer who believes Thietmar's story knows that the Host is there, but can only see the body around it since the external *figura* of the bread is removed. The particular iconography of the surviving Gero Cross – if it is indeed the cross about which Thietmar writes – further underscores the message by depicting the crucified Christ as a slain man rather than a triumphant God. The monumentality of the crucifix emphasizes this Real Presence of the Eucharist with its life-sized proportions and nearly in the round carving. The weightiness of the body, hanging heavily on the stretched tendons and muscles of the arms, projects an undeniable and startling presence (Figs. 1 and 2). Due to the Host's physical disappearance within this somatic envelope, its true "invisible" essence as the crucified body is now visually displayed.

This change in the exterior aspects of the Eucharist seems, in one sense, to alter its status as a sacrament since its external appearance is no longer different from its internal truth. Looking at the cross, the spectator no longer perceives the false exterior *figura* of the bread, but instead gazes upon that which the Host truly is: the incarnate, historical body of Christ, hanging painfully on the cross. The gap between the visible *figura* and the invisible *veritas* seems to have disappeared, since now the Host's identity as the incarnate body of Christ is revealed.

But does this mean that when viewers look up at the crucifix, they look at the real body of God, as if they were standing before Calvary in 33 AD? I believe the answer is no, and that the carved *corpus* functions more like a reliquary statue that provides a different kind of artistic *figura*, or cloak, around a core of sacred reality. Reliquary sculptures, as mentioned above, allow the saint's body

to be reconstructed around their holy bones, so that the saint is once again perceptible to the senses and not just to the intellect.

For the crucifix in Cologne, the inserted Eucharist functions as a relic. Just as the bones of the saints' continue to assert their actual physical presence on earth, the consecrated Host (according to Paschasius) makes Christ physically present in our midst. The carved wood of a reliquary sculpture is essentially a didactic shell that provides the truth about the relics it encloses. The choice of gold and gems as the materials for these reliquaries accentuates the message that these crumbling bits of decay possess a marvelous future in heaven. Similarly, the miraculous crucifix in Cologne encloses a hidden truth within an explanatory cover. The wood is an additional *figura* that removes some of the difficulty of seeing the Host for what it really is – and it is wood that echoes the holy wood Gero inserted together with the Host. But the sculpted wood still constitutes just another kind of cloak that shrouds the true inner essence. Unlike the practices of the later Middle Ages that encouraged a true visual piety, such as displaying the Host during the *elevatio major* or in a monstrance, the crucifix explains the Host more than it reveals it.

This role of the carved wood as a corporeal envelope around the Eucharist is parallel to the role that Jesus' own human body played during his thirty-three years on earth. Christ's flesh was similarly a cover that hid his divinity and allowed God to walk among men and attain their salvation. As Paul writes in his letter to the Hebrews 10:19: "...we have confidence to enter the sanctuary by the blood of Jesus, by the new and living way which he opened for us through the curtain, that is, through his flesh..."[42] This curtain of flesh hid Christ's true divinity from sight, just like the *figura* shrouding an invisible truth. Due to this same dichotomy between visible exterior and hidden interior, Paschasius also considers the Passion of Christ to be a sacrament.[43] Rather of Verona, writing at the same time as Gero's tenure as archbishop, verbalizes this relationship between the Incarnation and the Eucharistic Real Presence:

> Let us therefore not be deceived or deceive ourselves: God it is who is received ...but just as then He was hidden in the flesh, so now in very reality He is hidden in the bread turned into flesh.[44]

The carved wood of the crucifix adds a further level to this relationship of hidden truth: just as the bread hides the flesh, the carved wooden flesh of the image hides the bread. And thus, just as the devout beholder of the Eucharist knows there is more to the bread than what is visible, so too does the Christian viewer of the Gero Cross know that the sculpture depicts not just a dead man, but the sacrificed son of God.

The sculpture thereby creates a further sacramental context for the holy bread. In one sense, the crucifix clarifies and visualizes the sacrament of the Eucharist, helping the spectator overcome the deceptive *figura* of the bread. But in another sense, the carved body is itself a *figura*, just as Christ's human flesh was a cloak over his divine nature. The sculpture assumes the role as negotiator between the visible and the invisible, by both hiding the sacred *veritas* of the Host within its wood and explaining its True Presence by the form of the *corpus* on the cross. It is thus the perfect complement to the ritual of the cross altar, echoing the sacramental nature of the present ritual and anchoring it to its source of origin in the Biblical past.

The cross altar and its early medieval viewers

In the early medieval period, the cross altar and its crucifix, positioned *in medio ecclesia*, divided the clergy and the laity.[45] The gulf between these groups was already quite prominent in the Ottonian era for a variety of reasons: the prayers at the altar were spoken in Latin, the canon was recited quietly, and the celebrant stood in front of the altar with his back to the congregation.[46] To most, the high mystery was incomprehensible, inaudible, and invisible. In addition, it was nearly inaccessible, since the laity only shared in the taking of Communion on several major holy days in the year.[47] The cross altar underscored this division through its physical placement.[48] The high altar, choir, and apse – the domain of the clergy – were all located behind it to the east. The nave and aisles, where the congregation stood, were in front of it to the west. Except for the few high feast days when the bishop would come to the front of the cross altar and perform Communion for the people, this site was a barrier.

The placement of the crucifix at this juncture revealed a different side of the cross to each portion of the community. The *corpus* faced the congregation. All throughout the Mass, the people could look at the cross's intimate and life-sized portrayal of Christ's sacrifice. In contrast, the back of the cross faced the clergy. They could primarily see only the crossed planks, the simple symbol of the cross. Thus, the clergy, which actually prepared, consecrated, and partook of the Eucharist, saw only a sign, while the congregation, which rarely contacted the Host, could gaze at the revealed and vulnerable body of God on the cross from the moment they entered the sanctuary in the west. In this way, I suggest the cross altar mediated the gulf between congregation and clergy. By displaying the body of Christ (with the hidden Eucharist) to the people, the Host could at least be visually consumable during every Mass.

One particular early medieval viewer of the Gero Cross who himself became a further element of the central site of the cross altar was Archbishop Gero. The

miracle story about Gero's crucifix in Thietmar's *Chronicon* may also be read as a glorification of Gero himself and particularly of his role as bishop – a rank that Thietmar himself held as bishop of Merseburg.

Gero's restoration of the crucifix functioned as a promise to his flock. Just as he administered the Eucharist to the *corpus*, making it whole and perfect again, he could also administer the Host to his congregation. The healed body on the cross acted as a model, demonstrating to its spectators the power of this special, healing bread that the bishop had prepared for them on the altar below. This parallel was underscored by the terms Thietmar employs to describe the insertions. He uses the word *salubriori* (meaning "the healthy remedy") to describe the Host, as God's supreme creation.[49] The adjective "salutifere" describes the relic of the True Cross. Both these terms are based on *salus*, the root of both health and salvation.[50] The healing Gero gave to the crucifix via the inserted bread and wood can be paralleled to the future salvation he could offer his congregation. And this salvation was greatly aided by the sight of the crucifix (hewn of wood that had merged with the wood of Christ's historical cross), as well as by the administration of the Host consecrated by the bishop himself.

The miraculous cross thus functions as a tangible metaphor for the bishop's ability to care for his flock, demonstrating the power of the remedial bread that the high priest had prepared. As such, the crucifix seems to embody the verses in Ephesians I: 22-23: "…and [God] put all things under [Christ's] feet, and gave him to be the head over all things to the church, which is his body." The literal body of Christ in the form of the monumental sculpture and the figurative body of Christ represented by the community of Christians are both healed by the same sacrament. Furthermore, the miracle was centered around the head of the body of Christ – again, literally in the head of the sculpture which was sealed with the healing Eucharist, and figuratively in the form of Archbishop Gero, who was the head of the church of Cologne and who inspired the miracle's occurrence. Implicit in such a reading of Thietmar's passage is the message that neither the crucifix nor the congregation could be healed/saved without the bishop and his mediation.

Gero's own insertion within this dynamic of salvation is further made manifest by his own burial beneath the crucifix. Due to the importance of the altar, its central location, and its use for the celebration of the Mass of the Dead, as well as in possible Paschal rites, burial near the cross altar was a highly coveted position.[51] Gero intended his own body to rest near the representation of his slain lord from the Biblical past and the repeated re-creation of that same body in the present during the Eucharistic feast held at the cross altar.

The cross altar in Cologne thus makes explicit some of the connotations that may have been inherent to many early medieval cross altars. Through the miracle

tale preserved in Thietmar's *Chronicon* that asserts the union of the *corpus* with the Eucharist and the True Cross, the ability of the crucifix to share in the efficacy of the altar, and to both echo and influence the Real Presence that was distributed on the *mensa* below it, is made overt. Together, altar, image, and ritual formed a powerful core to the cathedral, where the Biblical past became a part of the present via the liturgical ceremony and inspired the hopes of the crucifix's maker and its many other subsequent viewers to attain future salvation.

Frequently cited sources

Bandmann, Günter. "Früh- und Hochmittelalterliche Altaranordnung als Darstellung." In *Das Erste Jahrtausend. Kultur und Kunst in werdenden Abendland an Rhein und Ruhr*, 1: 377-378. Düsseldorf, 1962.

Braun, Joseph. *Der christliche Altar in seiner geschichtlichen Entwicklung.* 2 vols. Munich, 1924.

Doppelfeld, Otto. "Die Dombegrabung XV." *Kölner Domblatt* 21/22 (1963): 110ff.

Kessler, Herbert L. "Real Absence: Early Medieval Art and the Metamorphosis of Vision." In *Morfologie Sociali e Culturali in Europa Fra Tarda Antichità e Alto Medioevo*, 2: 1157-1211. Spoleto, 1998.

Kier, Hiltrud. "Der Fussboden des Alten Doms in Köln." *Kölner Domblatt* 33/34 (1971):109-124.

Macy, Gary. *The Theologies of the Eucharist in the Early Scholastic Period.* Oxford, 1984.

Mitchell, Nathan. *Cult and Controversy: The Worship of the Eucharist Outside Mass.* Collegeville, 1974.

Nußbaum, Otto. *Die Aufbewahrung der Eucharistie.* Bonn, 1965.

Snoek, Godefridus J. *Medieval Piety from Relics to the Eucharist. A Process of Mutual Interaction.* Leiden, 1995.

Parker, Elizabeth Crawford. "The Descent from the Cross: Its Relation to the Extra-Liturgical Depositio Drama." (Ph. D. Diss., New York University, 1975).

Weyres, Willi. "Der karolingische Dom von Köln." In *Karolingische Kunst*, ed. W. Braunfels and H. Schnitzler (Düsseldorf, 1965), vol. 3 of *Karl der Grosse. Lebenswerk und Nachleben*, ed. W. Braunfels, 384-423. Düsseldorf, 1965-1968.

Notes

1 This study is part of a larger investigation into issues of absence and presence in regard to Ottonian means of representing the Crucifixion and Resurrection. I would like to thank Dr. Linda Seidel for her insight throughout the development of this paper, as well as Dr. Søren Kaspersen and Dr. Erik Thunø for their advice and initiative both in organizing the Kalamazoo conference during which this paper was presented and in arranging for this publication.

2 Günter Bandmann, "Früh- und Hochmittelalterliche Altaranordnung als Darstellung," in *Das Erste Jahrtausend. Kultur und Kunst im werdenden Abendland an Rhein und Ruhr* (Düsseldorf, 1962), 1: 377-378.

3 Cross altars remained widespread throughout the Middle Ages until the 16th century; see Joseph Braun, *Der christliche Altar in seiner geschichtlichen Entwicklung* (Munich, 1924), 1: 401. According to the *Liber pontificalis*, Pope Hilarus and Pope Symmachus both erected versions for Old St. Peter's in Rome, each adorned with a cross and the relic of the True Cross; LP 1: 242 and 261. William Tronzo argues that the central altar of Simon and Jude in Old St. Peter's, located under a large painting of the Crucifixion, was where the cult of the cross was celebrated, and was therefore the prototype for the medieval cross altar in western Europe; "The Prestige of St. Peter's: Observations on the Function of Monumental Narrative Cycles in Italy," *Studies in the History of Art* 16 (1985): 104-105.

4 For a survey of documents mentioning the cross altar, see Braun, *Der christliche Altar*, 401-406. On its importance, secondary only to the high altar, see Günter Bandmann, "Zur Bedeutung der Romanischen Apsis," *Wallraf-Richartz-Jahrbuch* 15 (1953): 39.

5 Elizabeth Crawford Parker believes this nearly invariable placement *in medio ecclesia* references the Early Christian tenet expressed by Cyril of Jerusalem (*Catechesis*, XIII, 28 [PG 33: 805]) that the cross on Golgotha stood in the center of the cosmos, its arms stretching to the cardinal directions of its realm; in "The Descent from the Cross: Its Relation to the Extra-Liturgical Depositio Drama" (Ph. D. Diss., New York University, 1975), 113.

6 Braun, *Der christliche Altar*, 403; F. Oswald discusses the range of physical locations that this phrase could imply in "In medio Ecclesiae," *Frühmittelalterliche Studien* 3 (1969): 313-326.

7 For example, the *Consuetudines Farfenses* from the late 10th century (Br. Albers, ed., [Stuttgart, 1900], 57) specifies that the laity received their Easter communion at the cross altar and a 1099 text from Angers (L. De Farcy, *Monographie de la Cathedral d'Angers* [Angers, 1905], 3: 21) designates the cross altar as Pfarraltar. See also Braun, *Der christliche Altar*, 405-406; and Christian Beutler, *Der älteste Kruzifixus. Der entschlafene Christus* (Frankfurt am Main, 1992), 64.

8 For example, Franz Arens, *Liber Ordinarius der Essener Stiftskirche und seine Bedeutung für die Liturgie. Geschichte, und Topographie des ehmaligen Stiftes Essen* (Essen, 1901); on the copy of the Holy Grave near the cross altar in the Ratgar basilica in Fulda, see Helmut Beumann, "Die Lage des Bonifatiusgrabes und seine Bedeutung für die Entwicklung der Fuldaer Klosterkirchen," *Marburger Jahrbuch* 14 (1949): 27ff. See also Günter Bandmann, "Zur Deutung des Mainzer Kopfes mit der Binde," *Zeitschrift für Kunstwissenschaft* 10 (1956): 159.

9 Parker, "The Descent," 143-144.

10 For a variety of sources see Braun, *Der christliche Altar*, 404-405; Christian Beutler, *Bildwerke zwischen Antike und Mittelalter, Unbekannte Skulpturen aus der Zeit Karls des Grossen* (Düsseldorf, 1964), 28; and George Henderson, *Early Medieval* (Toronto, 1993), 236.

11 For Essen see Arens, *Liber Ordinarius der Essener Stiftskirche*, 135; for Hildesheim see Francis Tschan, *St. Bernward of Hildesheim* (South Bend, 1951), 2: 271-273. The imposing size of these arrangements is suggested by the cross in St. Denis that stood on a column and would have originally reached over six meters into the air; Abbot Suger, *De Administratione*, XXXII (Erwin Panofsky, ed., *Abbot Suger on the Abbey Church of St.-Denis and its Art Treasures* [Princeton, 1946], 56-61, and nt. 58). On methods of erecting large crucifixes, see Christa Schulze-Senger et al.,"Das Gero-Kreuz im Kölner Dom, Ergebnisse der Restauratorischen und Dendrochronologischen Untersuchungen im Jahre 1976," *Kölner Domblatt* 41 (1976): 34-36.

12 "Interim Gero, Agripinae sedis egreius provisor, obiit; de quo quia pauca prelibavi, quae tunc reservavi, paucis edicam. Hic crucifixum, quod nunc stat in media ecclesia, ubi ipse pausat, ex ligno fabricari studiose praecepit. Huius caput dum fissum videret, hoc summi artificis et ideo salubriori remedio nil de se presumens sic curavit. Dominici corporis porcionem, unicum in cunctis necessitatibus solacium, et partem unam salutifere crucis coniugens pasuit in rimam et prostratus numen Domini flebiliter invocavit et surgens humilibenedictione integritatem promeruit." My translation varies slightly from David Warner's in *Ottonian Germany: The Chronicon of Thietmar of Merseburg* (Manchester and New York, 2001), 128. For an exhaustive study, see Helmut Lippelt, *Thietmar von Merseburg. Reichsbischof und Chronist* (Cologne, 1973).

13 Whether the crucifix is or is not the miraculous cross of Archbishop Gero that Thietmar describes has received a great amount of scholarly attention and is not the primary issue that concerns me here. Richard Hamann first claimed that the surviving cross was Gero's in "Grundlage zu einer Geschichte der mittelalterlichen Plastik Deutschlands," *Marburger Jahrbuch für Kunstwissenschaft* 1 (1924): 17ff. This identification has been repeated in many studies, including Reiner Haussherr, "Der Tote Christus am Kreuz, Zur Ikonographie des Gerokreuzes," (Ph.D. diss., Rheinische Friedrich-Wilhelms-Universität zu Bonn, 1952). The major studies contesting this identification include Günter Binding, "Die Datierung des sogenannten Gero-Kruzifixus im Kölner Dom," *Archiv für Kulturgeschichte* 64 (1982): 63-77; Renate Kroos, "Liturgische Quellen zum Kölner Domchor," *Kölner Domblatt* 44/45 (1979-1980): 46-47 and 92-114; and Heribert Müller, "Studien zu Erzbischof Everger von Köln (985-999)," *Jahrbuch des Kölner Geschichten Vereins* 49 (1978): 16. These scholars' arguments center largely around the dendrochronological dating of the wooden *corpus* and the cross beams: the tree from which the *corpus* was carved was felled in 965, and the tree for the cross beams was felled between 971 and 1020; Schulze-Senger et al., "Das Gero-Kreuz," 9-56. While the oak for the body thus corresponds in date to Gero's time in episcopal office, the wood for the cross may have been felled after his death, and thus the surviving cross may instead date to around the turn of the millennium. However, archeological investigations have revealed that after the Ottonian era, a Staufer choir screen was added to the cathedral with a gap in the center for an altar. The only suitable one would have been the cross altar, and thus Willy Weyres suggests that the altar, together with the Gero Cross, was moved here in the Staufer period; in "Zur Baugeschichte der Vorgotischen Kölner Kathedralen," *Kölner Domblatt* 26/27 (1964): 20-21. This change in site may have caused the *corpus* to be placed upon a new cross and so account for the difference in the dendrochronological dating of the corpus and the cross. In any case, my argument concerns the cross described by Thietmar and remains valid whether or not the surviving cross is indeed identical with the miraculous one described in the *Chronicon*.

14 Willi Weyres, "Der karolingische Dom von Köln," in *Karolingische Kunst*, ed. W. Braunfels and H. Schnitzler (Düsseldorf, 1965), vol. 3 of *Karl der Grosse. Lebenswerk und Nachleben*, ed. W. Braunfels (Düsseldorf, 1965-1968), 384-423; Arnold Wolff, "Der Alte Dom," in *Köln: Die Romanische Kirche. Von den Anfängen bis zum Zweiten Weltkrieg*, ed. H. Kier and U. Krings (Cologne, 1984), 1: 145. On the similarity of St. Gall with the Carolingian cathedral of Cologne, see Carol Heitz, "Reflexions sur le Plan de Saint-Gall et son Eglise-Abbatiale: "Versus ad Orientem?" in *Orbis Romanus Christianusque Travaux sur l'Antiquité Tardive*, ed. N. Duval (Paris, 1995): 297-310.

15 Otto Doppelfeld, "Die Dombegrabung XV," *Kölner Domblatt* 21/22 (1963): 110ff.; Hiltrud Kier, "Der Fussboden des Alten Doms in Köln," *Kölner Domblatt* 33/34 (1971): 109-124.

16 Doppelfeld, "Die Dombegrabung," 111; Weyres, "Der karolingische Dom," 402, 409ff. Kier instead suggests that this may have been the place where the relics of the Three Kings were kept after they were transferred to Cologne from Milan in 1164, "Der Fussboden," 117-118.

17 Kier proposes that the cross stood on a column, like the ones remaining at Essen and Hildesheim; "Der Fussboden," 118. It is also likely, however, that the monumental crucifix stood upon its own vertical cross arm.

18 Thietmar's phrase had long been interpreted as implying that the crucifix was a reliquary cross with a receptacle for the True Cross and the Host in the back of its head, much like the Gerresheim Cross near Düsseldorf, the Ringelheim Cross now in Hildesheim, or the Georg Cross in the Schnütgen-Museum in Cologne (Fig. 4), which all have such cephalic openings. Despite older sources even citing the exact dimensions of such a reliquary opening in the Cologne sculpture, the restoration of the Gero Cross in 1976 revealed that no receptacle exists in the *corpus*'s head; Schulze-Senger et al., "Das Gero-kreuz," 20-21, 25. I, however, wish to resist Günter Binding's and Renate Kroos's conclusion that the lack of reliquary in the so-called Gero Cross proves that it is not the one described in Thietmar's *Chronicon*; see note 13. After all, the *Chronicon* does not specify that the cross has a reliquary opening, but rather that the inserted Host and True Cross miraculously fused the cracked wood of the sculpture. Therefore, from the perspective of a devout medieval reader, it is inversely the presence of a reliquary that would disprove the identification of the Gero Cross with the miraculous one in the account.

19 Ellert Dahl, "Heavenly Images: The Statue of St. Foy of Conques and the Signification of the Medieval 'Cult-Image' in the West," in *Acta ad Archaeologiam et Artium Historiam Pertinentia* 7 (1978): 175-191; Hans Belting, *Likeness and Presence. A History of the Image before the Era of Art* (Chicago, 1994), 297.

20 With this claim I do not mean to comply with Hagen Keller's theory that medieval sculpture absolutely necessitated relics in order to come into being; "Zur Entstehung der sakralen Vollskulptur in der ottonischen Zeit," in *Festschrift für Hans Jantzen* (Berlin, 1951), 71-91. For a concise refutation of Keller, see Helen Forsyth, *The Throne of Wisdom, Wood Sculptures of the Madonna in Romanesque France* (Princeton, 1972), 76-80.

21 For example, the Ringelheim Cross had a small bag with stones from the Holy Sepulchre in its head while the Anno Cross in the Grafschaft Monastery had a receptacle holding a piece from the column to which Christ was bound during the Flagellation; Georg Wagner, *Volksfromme Kreuzverehrung in Westfalen, Von den Anfängen bis zum Bruch der mittelalterlichen Glaubenseinheit* (Münster, 1960), 35; and Rudolf Wesenberg, "Das Ringelheimer Bernwardkreuz," *Zeitschrift für Kunstwissenschaft* 7 (1935): 6.

22 Anatole Frolow, *La Relique de la Vraie Croix* (Paris, 1961).

23 Haussherr, "Der Tote Christus," 39; Keller, "Zur Entstehung," 71 and 85; Hans Haedeke, "Das Gerokreuz im Dom zu Köln und seine Nachfolge im 11. Jahrhundert," *Kölner Domblatt* 14/15 (1958): 44. While it has been suggested that these crucifixes had liturgical uses and functioned like elaborate tabernacles that stored the Host before Communion, it is far more probable that, following in the tradition of altar consecrations and reliquary sculptures, the Eucharist was considered akin to a relic and inserted within crosses like other *brandea* of Christ were; Haedeke, ibid.

24 "Deinde ponit tres portiones corporis domini intus in confessione et tres de incenso et recluduntur reliquiae intus in confessione," rubric 11 of the Roman *Ordo* XLII on the consecration of the altar, widespread in western Europe from the 8th century until the 15th (M. Andrieu, *Les Ordines Romani du Haut Moyen Age* [Louvain, 1931-1961], 4: 400). For a survey of such

practices in the *Ordo* and in many other pontificals from the ninth to thirteenth centuries
see Otto Nußbaum, *Die Aufbewahrung der Eucharistie* (Bonn, 1965), 187-188; Anton von
Euw, "Liturgische Handschriften, Gewänder und Geräte," in *Ornamenta Ecclesia, Kunst und
Künstler der Romanik*, ed. A. Legner (Cologne, 1985), 1: 385-414; Arnold Angenendt, *Heilige
und Reliquien. Die Geschichte ihres Kultes vom frühen Christentum bis zur Gegenwart* (Munich,
1994), 217; Braun, *Der christliche Altar*, 694; and, particularly on the Sacramentary of the
Bishop Drogo of Metz and related citations in 10th and 11th century documents, see Godefri-
dus J. Snoek, *Medieval Piety from Relics to the Eucharist. A Process of Mutual Interaction* (Leiden,
1995), 186-188. The Synod of Chelsea (Celchyte) of 816 overtly states that if no relics happen
to be available in order to consecrate an altar, the Eucharist alone may be used "quia corpus et
sanguis est domini nostri Iesu Christi," (Mansi 14: 356); see Snoek, *Medieval Piety*, 187; and
Nußbaum, *Die Aufbewahrung*, 187-188. Among the numerous 10th and 11th century texts
that make the same stipulation as the Chelsea Synod is, for example, the Romano-German
pontifical (Cyrille Vogel, *Le Pontificale romano-germanique du dixième siècle* [Vatican, 1963],
1: 88), the pontifical of the Archbishop Egbert of York (E. Martène, ed., *De antiques ecclesiae
ritibus* [Venice, 1788], 2: 249, lib. II, c. 13. ordo 2), and that of Narbonne (ibid., 268, lib.
II, c. 13. ordo 7); see also Snoek, *Medieval Piety*, 187-188. While the English sources may
suggest that the Eucharist was placed inside altars only due to the relative scarcity of relics on
the British Isles, the widespread practices of altar consecration on the continent show that the
Eucharist was used even where there was no shortage; ibid., 188.

25 Rather of Verona, *Synodica,* 10 (Fritz Weigle, *Die Briefe des Bischofs Rather von Verona* [Weimar,
1949], 124-137); trans. Peter L. D. Reid in *The Complete Works of Rather of Verona* (Bring-
hamton, 1991), 449.

26 Amalarius, *Liber Officialis* 3 (Ioannes M. Hanssens, ed., *Amalarii Episcopi Opera Liturgica
Omnia* [Vatican, 1948], 2: 340-343). See also Christine C. Schnusenberg, *The Relationship
between the Church and the Theatre, Exemplified by Selected Writings of the Church Fathers
and by Liturgical Texts until Amalarius of Metz 775-852 A.D.* (New York, 1988), especially
316-321.

27 Paschasius Radbertus, *De corpore et sanguine Domini*, I (*CCCM* 16, 27); translated in Snoek,
Medieval Piety, 201-202.

28 Paschasius Radbertus, *Epistle to Fredugard* (*CCCM* 16,151,190-95); translated in Edward J.
Kilmartin, *The Eucharist in the West, History and Theology*, ed. R. J. Daly (Collegeville, 1998),
84.

29 Paschasius's principle opponent in the Carolingian period was Ratramnus (J. N. Bakhuizen
van den Brink, ed., Ratramnus, *De corpore et sanguine Domini* [Amsterdam, 1954]). The Ot-
tonian writers who rearticulated and reinterpreted Paschasius include Gezo of Tortona, *Liber
de corpore et sanguine Christi*, pr. (PL 137: 371-406); Odo of Cluny, *Collatiunum Libri Tres*,
II, cxxxii (PL 133: 577); Heriger of Lobbes, *Libellus de corpore et sanguine Domini* (PL 139:
179-188); and Rather of Verona, *Dialogus confessionum*, 14-15 and 42, after which Rather
includes excerpts from Paschasius's *De corpore et sanguine Domini* (Reid, ed., *The Complete
Works*, 277-279 and 314), and *Epistle ad Patricus* (Weigle, ed., *Die Briefe*, 66-69). See Gary
Macy, *The Theologies of the Eucharist in the Early Scholastic Period* (Oxford, 1984), 31-35;
Charles R. Schrader, "The False Attribution of an Eucharistic tract to Gerbert of Aurillac," in
Mediaeval Studies 35 (1973): 178-204; and Jaroslav Pelikan, *The Growth of Medieval Theology
(600-1300)* (Chicago, 1978), especially 185-192.

30 For a brief survey of the Berengarian controversy, see Macy, *The Theologies*, 35-43. On the
late 11th century nuances to Paschasius's views, see Alger of Liège, *De sacramentis corporis et*

sanguinis dominici (PL 180: 739-854) and Rupert of Deutz, *De divines officiis* 2,2 (PL 170: 35A-B); also Miri Rubin, *Corpus Christi. The Eucharist in Late Medieval Culture* (Cambridge, 1991), 20-22.

31 Jerome, for example, defends the relic cult by declaring the graves of Peter and Paul to be altars of Christ upon which sacrifices are offered in *Contra Vigilantium* 8 (PL 23: 346); Augustine makes reference to altar graves in *Contra Faustum*, lib. XX, c. 21 (PL 42: 384). Gregory of Tours in the 6th century placed bodily relics in altars (*Vitae Patrum.* c. XV.1, MGH *Scriptores rerum Merovingicarum* I, 2, 271), a practice that is mandated by numerous Carolingian and later texts, see Angenendt, *Heiligen und Reliquien*, 168-172.

32 During the Elevation, the altar symbolized the cross, but immediately following the *Per omnia saecula saeculorum*, the altar's identity shifts to the tomb in the garden of Joseph of Arimathea; Amalarius, *Liber Officialis* 3 (Hanssens, *Opera Liturgica*, 2, 347). Amalarius also refers to the altar as Christ's tomb in *Eclogae de Officio Missae* (PL 105: 1326).

33 Even the presence of the elements upon the altar's *mensa* caused writers to claim an identification with Christ's tomb; for example, Hrabanus Maurus, *de Institutione clericorum*, lib. I, c. 33 (PL 107: 324); Honorius Augustodunensis, *Gemma Animae*, lib. I, c. 47 (PL 172: 555). See also Nußbaum, *Die Aufbewahrung*, 196; and Yrjö Hirn, *The Sacred Shrine* (Boston, 1957), 69-70.

34 Among the earliest sources for these ceremonies are Gerhard von Augsburg, *Vita Sancti Uodalrici: die älteste Lebensbeschreibung des heiligen Ulrich*, ed. and trans. W. Berschin and A. Häse (Heidelberg, 1993); Arens, *Liber Ordinarius der Essener Stiftskirche*; Aethelwold, Bishop of Winchester, *Regularis Concordia, The Monastic Agreement of the Monks and Nuns of the English Nation*, trans. Thomas Symons (New York, 1953). See also Pamela Sheingorn, *The Easter Sepulchre in England* (Kalamazoo, 1987), 6-25; and Parker, "The Descent," especially 65-96 on the relationship between Amalarius's new interpretations of the liturgy and these early theatrical performances.

35 See note 8.

36 On the evidence for such rites in later sources for Cologne, see Franz Niehoff, "Das Kölner Ostergrab, Studien zum Heiligen Grab im Hohen Mittelalter," *Wallraf-Richartz-Jahrbuch* 51 (1990): 7-68.

37 "He [Christ] left us this sacrament—a visible figure and image (*figura*) of his flesh and blood— so that our mind and our flesh could be more richly nourished through them, and so that we could grasp things invisible and spiritual through faith. What is externally perceived in this sacrament is an image or sign; but what is received internally is truth (*veritas*), and no mere shadow…;" Paschasius, *De Corpore*, IV (*CCCM*, 28-30); translated in Nathan Mitchell, *Cult and Controversy: The Worship of the Eucharist Outside Mass* (Collegeville, 1974), 77.

38 For discussions of the theology of the Real Presence, see ibid., 73-80; Pelikan, *The Growth*, especially 186-200; Josef Geiselmann, *Die Eucharistielehre der Vorscholastik* (Paderborn, 1926), 146-147; and Kilmartin, *The Eucharist in the West*, 80-85.

39 In particular, Isidore of Seville, *De ecclesiasticis officiis* 2, 15-18 (PL 83: 753ff) and *De fide catholica contra Iudaeos* 2, 27 (PL 83: 535-536); Geiselmann, *Die Eucharistielehre*, 146-147.

40 Paschasius cites the example of a devout yet simple-minded man who could not accept the True Presence until he had a vision of a baby sliced open upon the altar during Communion. The officiant offered the man a hunk of the baby's flesh on the paten. Only in the last moment before his consumption of the bloody offering did this grizzly vision cease and the flesh turn back into bread; Paschasius, *De Corpore*, 14 (*CCCM* 16, 88-89).

41 "God knows that human nature cannot bear to eat raw flesh; therefore he transformed his body into bread and his blood into wine for those who receive it in faith;" ibid.; translated in Mitchell, *Cult and Controversy*, 79.

42 Herbert Kessler discusses this verse at length in "Real Absence: Early Medieval Art and the Metamorphosis of Vision," in *Morfologie Sociali e Culturali in Europa Fra Tarda Antichità e Alto Medioevo* (Spoleto, 1998), 2: 1157-1211.

43 Geiselmann, *Die Eucharistielehre*, 146; Michael Kobialka, *This is My Body, Representational Practices in the Early Middle Ages* (Ann Arbor, 1999), 70. Various parts of the salvation story were specifically associated with the mystery of the sacrament, such as the creation of Jesus' flesh from the Virgin paralleled to the transubstantiation of the bread and wine into Christ's body; see Rubin, *Corpus Christi*, 15.

44 Rather of Verona, *Dialogus confessionum* (PL 136: 403); translated in Reid, ed., *The Complete Works*, 222-265.

45 von Euw, "Liturgische Handschriften," 404.

46 The inability of the people to understand the Latin services had already become a problem by the early 9th century, which caused the Council of Tours to decree that at least the sermons should be preached in the vernacular in order to effectively spread God's word; Snoek, *Medieval Piety*, 38. See James J. Megivern, "Concomitance and Communion. A Study in Eucharistic Doctrine and Practice," *Studia Friburgensia*, n.s. 33 (1963): 32; and Joseph M. Powers, *Eucharistic Theology* (New York, 1967), 25; Otto Nußbaum, "Kirchenbau im Dienst der Liturgie," *Liturgisches Jahrbuch* XIX (1969): 1-26 and 10-11.

47 This is explicitly stated by Rather of Verona (see note 25 above) and discussed by Megivern, "Concomitance," 34; and Snoek, *Medieval Piety*, 40.

48 This nature of the cross altar as a barrier would have become only more overt when the cross and altar moved to the center of the choir screen in the following Staufer period.

49 Indeed, the Eucharist was considered nearly medicinal in its power, dubbed by Ambrose as the "tutamen et salus animae et corporis;" such designations appear in funeral orations (Leo P. McCauley, ed., *Funeral Orations by Saint Gregory Nazianzen and Saint Ambrose* [New York, 1953], 161-259) and in *de Sacramentis* (Edward Yarnold, ed. and trans., *The Awe-Inspiring Rites of Initiation* [Slough, 1971], 99-153). On "salus" see Piero Camporesi, "The Consecrated Host: A Wondrous Excess," in *Fragments for a History of the Human Body*, ed. M. Feher (New York, 1989), pt. 1: 221.

50 This same linguistic association is retained in modern German with the root "heil-" found in both "Heiland," which means "Savior," and "zu heilen," which means "to heal, to make whole."

51 Haedeke, "Das Gerokreuz," 44. Bandmann suggests that the cross altar references the Mount of Calvary in the Holy Sepulchre complex in Jerusalem, which was believed to have been the grave of Adam, the first man who was redeemed by Christ's dripping blood from the cross, and was thus a highly desired burial site for Christians; in "Früh- und Hochmittelalterliche Altaranordnung," 399; Parker links this association between the cross altar and Calvary specifically with the Mass of the Dead that was performed at some cross altars and the idea of resurrection that it implied; in "The Descent," 134.

The Golden Altar of Sant'Ambrogio in Milan

Image and Materiality

Erik Thunø

Between 824 and 859, Angilbertus bishop of Milan commissioned a new and magnificent golden high altar for the church of Sant'Ambrogio in Milan. The altar, still *in situ* in the church, presents a frontal with images worked in gold repoussé framed by gems, pearls and multi-colored enamel set within subtle patterns of filigree. Two sections with New Testament episodes flank the central compartment with the enthroned Christ surrounded by symbols of the Evangelists and the twelve Apostles (Figs. 1+1a). The back of the altar is sheathed in silver and displays twelve scenes from the life of St. Ambrose († 397), former bishop of Milan, Church Father and the basilica's titular saint. The narrative is worked in gilded repoussé and surrounds a rectangular opening with hinged panels to the tombs of St. Ambrose and two early Christian Milanese martyrs, Gervase and Protase (Fig. 2).[1]

The golden frontal represents a significant, and in fact the oldest, surviving example of a large and geographically widespread group of altar frontals produced in costly metals and decorated with gems and historiated narratives. Chronologically speaking, the early medieval golden altar of Sant'Ambrogio is followed by an Ottonian frontal from the Palatine Chapel in Aachen and by several later examples on the Italian peninsula such as the silver frontals in the cathedrals of Città di Castello and Pistoia that date between the twelfth and fourteenth centuries (Figs. 5-7). A larger and more homogeneous group of medieval altar frontals was produced in Scandinavia between the second quarter of the twelfth and the middle of the thirteenth centuries (Figs. 8-9). Like the Ottonian and Italian examples, several of the Scandinavian frontals show iconographic features that are already present in the golden altar of Sant'Ambrogio, that is, the iconic image of the enthroned Christ at the center of the composition in combination with symbols of the Evangelists and scenes from the New Testament. A particularly illustrative example of this affinity is the frontal in Sahl (Denmark),

produced around 1200, which even includes the twelve Apostles as well as two compartments with six scenes each in gilded repoussé flanking an enthroned, gem-enframed Christ (Fig. 8).[2]

Despite the obvious chronological and geographical gaps, the features shared by the ninth-century golden altar in Milan and the later examples suggest the existence of a shared conceptual mode that shaped both the materiality and iconography of the medieval altar frontal. By focusing on the golden altar from Milan, I shall attempt to unveil some of the ideas and intentions which configured the medieval altar frontal.

The material preciousness, with its powerful visual effect and infinite luminous reflections is one of the altar's most distinctive features. Paradoxically, however,

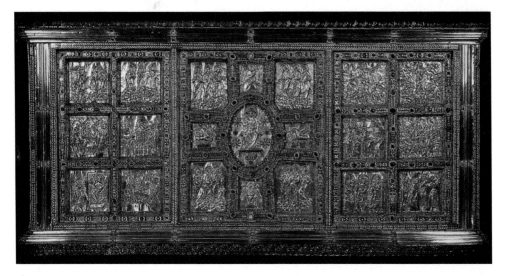

Fig. 1. Golden altar in Milan, Sant'Ambrogio, front. Photo: author's archive.

Fig. 1a. Golden altar in Milan, Sant'Ambrogio, outline of front: 1) Annunciation; 2) Nativity; 3) Presentation in the Temple; 4) Wedding in Cana; 5) Christ raises Jairus' daughter?; 6) Transfiguration; 7) Cleansing of the Temple; 8) Christ heals a blind; 9) Crucifixion; the three last reliefs were lost and replaced with new plates.

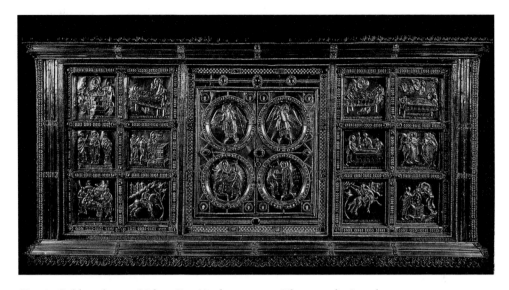

Fig. 2. Golden altar in Milan, Sant'Ambrogio, rear. Photo: author's archive.

Fig. 3. Golden altar in Milan, Sant'Ambrogio, detail.. Photo: author's archive.

Fig. 4. Golden altar in Milan, Sant'Ambrogio, detail. Photo: author's archive.

rather than reinforcing its presence, this visual quality tends by its very nature to dissolve or dematerialize the altar's physicality. Only from a close distance does the Christological narrative become discernable in its entirety. The same paradox applies to the minute geometric and flower-like patterns of the altar's ornament that are only apparent when one is standing quite close (Figs. 3-4). Thus, depending on the standpoint of the viewer, the visual experience can either be powerfully sensual because of the shimmering materiality of the altar, or be that of witnessing the sacred story depicted in the gold panels.

With this blurring power of the materials in mind, it seems that the New Testament images on the golden altar of Sant'Ambrogio were not exclusively made to instruct the unlettered, as Pope Gregory (590-604) would have preferred, at least according to his famous and authoritative *dictum* defined in his two letters addressed to Bishop Serenus of Marseille in the late sixth century.[3] Instead, the foregoing observations raise questions about the ways in which the precious materials were intended to provide a bridge between the viewer and the depicted images.

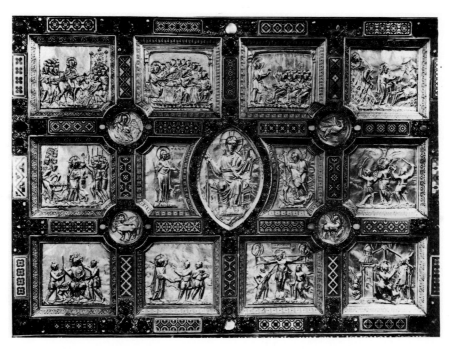

Fig. 5. Golden frontal in Aachen, Palatine Chapel. Photo: Foto Marburg.

"But more potent than all its gold is the treasure…."

On the rear of the Milanese golden altar runs an inscription in capital letters that reads:

> The beneficent shrine shines forth, lovely with its glittering panoply of metal and dressed with gems. But more potent than all its gold is the treasure with which it is endowed by virtue of the holy bones within it. This work the noble bishop, famed Angilbert, offered with joy in honor of the blessed Ambrose who lies in this temple, and dedicated to the Lord in the time when he held the chief place of this brilliant see. Father on high, look upon and pity thy loving servant, and by thy intercession, may God bestow his divine blessing.[4]

In praising the altar's costly embellishment at the same time as subordinating it to the sacred relics conserved within the altar that are deemed more powerful than any gold, the inscription on the altar expresses an interesting assessment requiring further analysis. Also notable is the fact that the inscription avoids any mention of the pictorial decoration covering the altar's four sides. This leads naturally to the question of the status of the images in a hierarchy where sacred bones rank higher than precious gold. Were the New Testament depictions automatically subsumed within the reference to the materials of which they were made, and thus subjected to the same judgment as the materials themselves, or were they assigned a function that is wholly independent of the established hierarchy?

One way of approaching these questions is to examine the theories of images

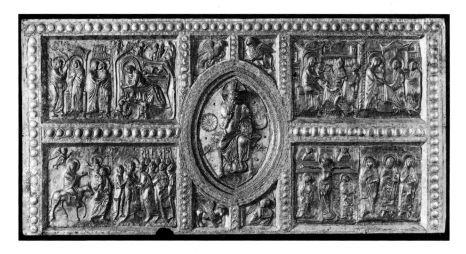

Fig. 6. Silver frontal in the Cathedral of Città di Castello. Photo: Alinari.

developed during the period when the golden altar of S. Ambrogio was manu-
factured. In fact, the subordination of man-made images to relics was an issue
treated in the *Opus Caroli regis contra synodum*, often called the *Libri Carolini*.
The latter is a treatise on images written between 791 and 793 by Theodulf,
the bishop of Orléans, in Charlemagne's name, on the occasion of the Second
Council of Nicaea in 787, which reinstated the use of images after decades of
Byzantine Iconoclasm.[5] Since Milan was under Carolingian rulership, it is rea-
sonable to suppose that if the altar decoration was influenced by contemporary
image theories, the most likely candidate was that formulated by the Carolin-
gians. According to the *Opus Caroli*, images were unconsecrated pieces of matter,
separated from the realm of the spirit and only useful for decoration or to recall
past events, with no legitimate place within religious devotion. Relics, on the
other hand, were consecrated because deriving from saints and martyrs. Relics
possessed a sacred aura that pictures could never claim and, like the vases and
utensils of the altar, were essential to the divine service.[6]

Seen through the eyes of the *Opus Caroli* the inscription on the golden altar

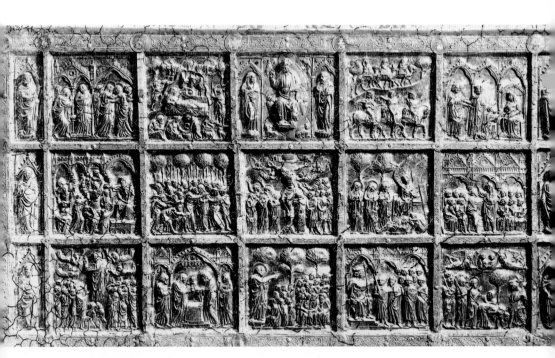

Fig. 7. Silver frontal in the Cathedral of Pistoia. Photo: Alinari.

could be seen as a comment on the limited role assigned not only to the altar's manufactured materials in general, but to its figural depictions in particular. Still, it remains an open question whether the image theoretical issues presented in the *Opus Caroli* are sufficient to explain the priorities set forth in the inscription on the golden altar. That is, in whatever way the *Opus Caroli* expressed itself with regard to the function of religious images, its subordination of manufactured images to relics or Scripture only becomes meaningful to the present analysis if we suppose that the inscription on the golden altar actually included the images in its praise of the materiality of its object. But what if it did not, and instead meant exactly what it says, as a comment on its materiality *per se*?

Another instance in which the spiritual capacity of material splendor is minimized, this time with respect to the written Word of God, is found in an unillustrated Bible from Le Puy in France, commissioned in ca. 800 by none other than Theodulf, author of the *Opus Caroli*.[7] The Le Puy Bible cover is worked in gold and embellished with precious stones and pearls. On the penultimate page (fol. 348v) of the codex, we find the following dedicatory inscription:

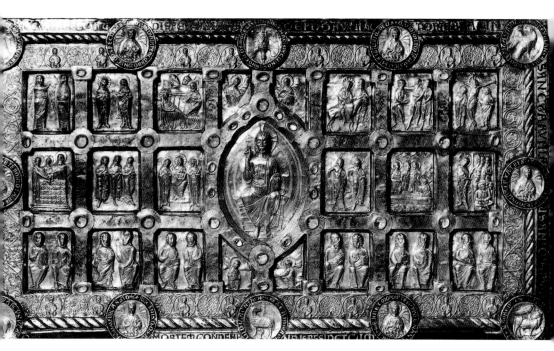

Fig. 8. Golden altar in Sahl Church, Denmark. Photo: Sophus Bengtsson, National Museum, Copenhagen.

The work of this codex was commissioned by Theodulf, out of love for the one whose sacred law reverberates here. From the outside this shines through precious stones, gold and purpure. Its radiance within is even stronger, though, on account of its great glory.[8]

In contrast to the golden altar of Sant'Ambrogio, the Bible cover is aniconic. Had it not been so, there would have appeared another interesting parallel to Theodulf's *Opus Caroli* that placed both the Word and relics in a position superior to that of manufactured images which, we recall, were considered to have no spiritual value. In Scripture, Theodulf writes, one could penetrate spiritual thought and be touched directly by the Word of God.[9] Since the inscription on the aniconic Bible cannot however imply figural depictions it does not have, it makes no sense to connect it to the period's image theory. Thus we are unable to ascertain whether the inscription on the golden altar – making a similar judgment on precious materials – implicitly intended a discourse on the role of the images it fails to mention.

Material splendor – immaterial beauty

Other epigraphic evidence also confirms that the assessment set forth by the inscription on the golden altar should not be considered merely as a product of the image controversy of the eighth and ninth centuries. In fact, an inscription in the apse of S. Martin of Tours written during the sixth century compared S. Martin's with the Temple of Solomon, that is, shining with gems and gold and silver, and stated that the faith practiced in the church was more valuable than any precious metal.[10] Another example, also distant in time and place from Milan but typologically much closer than any of the above-mentioned examples, is an altar frontal from Stadil in Denmark from the first quarter of the thirteenth century (Fig. 9). Here, an inscription along the border of the elaborately ornamented and gilded frontal reads:

More than with the golden radiance by which you see it shine, this work shines by virtue of the knowledge it conveys about sacred history. Indeed, it unveils the marvelous story of Christ, whose glory surpasses gold, for those of pure heart. Therefore all you who read this, if you desire the joy of beholding the heavenly light, cleanse your soul with faith.[11]

As in the inscriptions on the golden altar and the Bible from Le Puy, the examples from Tours and Stadil reiterate the relative inferiority of manufactured exterior splendor with respect both to relics, which represent the saints in Heaven, and

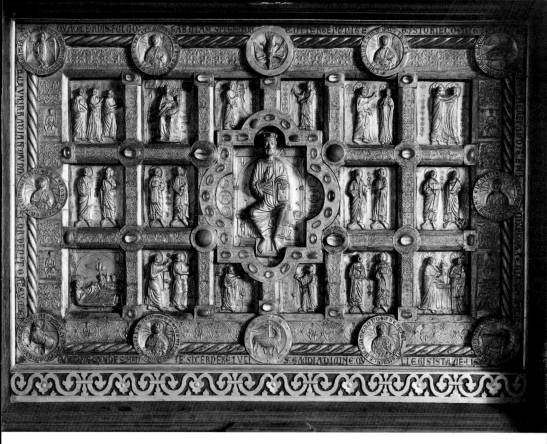

Fig. 9. Golden frontal in Stadil Church, Denmark. Photo: Sophus Bengtsson, National Museum, Copenhagen.

to immaterial and spiritual contents such as the Word of God, faith in God or Christ's own glory. Rather than merely a product of the Iconoclastic controversy, the common idea expressed in these medieval inscriptions from various places and periods leads us to look beyond specific chronological frameworks for a persistent and unchanging aspect of medieval thought and aesthetics.

The present issues in fact evidently reflect a notion of the beautiful that originated in Antiquity with Plato and Plotinus, and which became fundamental to medieval aesthetics through its adaptations of such key figures as S. Augustine and Pseudo-Dionysius.[12] According to the latter, the quality of beauty was applicable both to the body and the soul – it was both sensible and intelligible. Supreme beauty, which transcended the beauty of the world, was God. His beauty was entirely beyond the senses and could only be contemplated by the spirit. Sensuous beauty, on the other hand, should be appreciated as a symbol rather than for its own sake. Not without value, since it too was the work of God, it was however only a reflection of the highest beauty; it was transitory and relative, whereas the highest beauty was eternal and absolute. In this way,

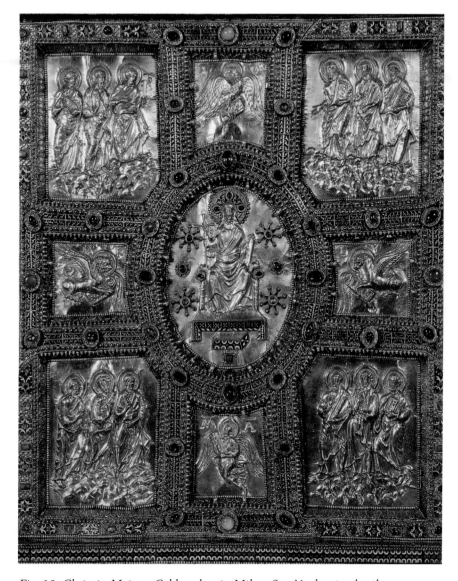

Fig. 10. Christ in Majesty. Golden altar in Milan, Sant'Ambrogio, detail.
Photo: author's archive.

the inscription on the golden altar of Sant'Ambrogio reminds us that its material splendor, though shining and glittering, remains merely sensuous and is but a mirror of the divine beauty possessed by the saints in Heaven who are repre-

sented in the material world by the bodies inside the altar. Additionally, both Augustine and Pseudo-Dionysius emphasized that terrestrial beauty consisted in the qualities of light and color, which are the most distinctive characteristics of the early medieval golden altar.[13]

Between earth and Heaven

That the explicit materiality of the altar could serve as a symbol of the immaterial beauty that characterizes the heavenly saints is also suggested by the various ways that it mirrors the altar's iconography in recalling the Book of Revelation (Fig. 10). The representations of the Four Living Creatures surrounding the enthroned Christ (Rev. 4) are flanked by twelve gems, and twelve pearls are inserted into Christ's mandorla; here the reference is probably to the twelve jewels adorning the foundations of the heavenly city and to the twelve gates of the city described in Revelation (21: 19-21). Medieval exegesis also repeatedly emphasized gold as a symbol of the splendor of the heavenly city based on the description in Revelation of its streets paved with pure gold. In fact, as Søren Kaspersen observed, these Apocalyptic references invite us to go a step further and see the golden altar as the earthly counterpart of the heavenly golden altar spoken of in the Book of Revelation (8; 3). We shall return to this comparison later.[14]

In addition to the notion of the altar as a representation of both material and ideal beauty, and with the manifold references in the altar to the Heavenly Jerusalem, was a growing concern during the early Middle Ages that the terrestrial Church should act as an image or mirror of the heavenly Church. The most powerful union of these counterparts took place in the celebration of the Eucharist. Gregory the Great, a theologian who was frequently cited during this period, expressed this bridging of the two worlds in the following way:

> Who of the faithful can doubt that Heaven opens itself at the very moment of the offering by the voice of the priest…that the highest unites with the lowest, that the terrestial joins the heavenly and that the visible becomes one with the invisible.[15]

Against this background, the priest and the congregation participating in the liturgy become a mirror of the heavenly celebrants: that is, Christ the high priest, the elders and the angels. As the liturgical table upon which this sacramental union was celebrated, the altar assumed a central role in the mediation between the terrestrial and heavenly Church.

Fundamental to the mediating significance of the Eucharist was the fact of

the Incarnation, that Christ himself as both divine and human served as a mediator, as Paul's Letter to Timothy (1; 5) makes explicitly clear. To place emphasis on this Christological point, the New Testament narrative on the golden altar departs from the lower left corner with an image of the Annunciation, and passes from bottom to top through images such as the Nativity, Presentation in the Temple, Transfiguration, Crucifixion and Ascension, all of which provide historical proof of how God linked humanity with the divine through his becoming flesh. Several of these images also facilitate a sacramental reading, as for instance the new-born Child who lies on a structure that seems more an altar than a crib, or the explicit inclusion of a Christian altar in the Presentation scene. The adjacent Wedding at Cana is also a case in point, since Christ's transformation of water into wine had been interpreted since the early Christian period both liturgically and as a metaphor for the transition from the Old to the New Testament through Christ's blood.[16] Accordingly, the New Testament cycle culminates in a depiction of Pentecost, the most powerful statement on the establishment of the Church.[17] The pictorial program of the golden altar thus may be seen as a clear reflection of the early medieval emphasis on the Eucharist as a bridge between Heaven and earth, ultimately authorizing the celebrating bishop as the new mediator between his congregation and God in Heaven.

Finally, the sacramental reading of the pictorial program also extends to the central portion of the ninth-century golden altar (Fig. 9). The predeliction for depicting Christ in majesty on altar frontals was probably influenced by the Carolingian theologian Paschasius Radbertus, author of *De corpore et sanguine Domini*, an influential treatise on the Eucharist written in the 830's. Here Radbertus identifies the consecrated bread and wine of the Eucharist with Christ's historic and elevated body in Heaven. The latter was identified with the above-mentioned heavenly golden altar, as described in Revelation (8; 3), and could be shared by the believers through the liturgical transformation of the bread and the wine into Christ's true body and blood. In this way, the terrestrial altar would be joined with its heavenly counterpart, as expressed through the image of Christ seated in Heaven. The fact that this image is also inscribed within a cross seems to confirm the influence of Paschasius Radbertus, who saw the saving power of the Eucharist in direct relation to Christ's sacrifice on the cross.[18]

Anagogical effects

The foregoing observations on the pictorial program of the golden altar of Sant'Ambrogio can be carried even further in terms of the medieval notion of sensuous and spiritual beauty. Pseudo-Dionysius was particularly explicit in launching physical beauty as a bridge to the invisible, without claiming, however,

that the physical possessed any inherent sacredness. For Pseudo-Dionysius light and color in particular were efficient means of raising the attention of the faithful towards the immaterial realm. The fact that Pseudo-Dionysius's writings were translated into Latin precisely at the time the golden altar of Sant'Ambrogio was made could help to explain the precedence given to the power of the materials in evoking the immaterial through the effects of light and color.[19] In this case, the visual experience of the medieval viewer standing before the altar would have been similar to that of Abbot Suger of S. Denis when he gazed at his twelfth-century golden altar richly decorated with gems:

> Thus, when – out of my delight in the beauty of the house of God – the loveliness of the many-colored gems has called me away from external cares, and worthy meditation has induced me to reflect, transferring that which is material to that which is immaterial, on the diversity of the sacred virtues: then it seems to me … that by the grace of God, I can be transported from this inferior to that higher world in an anagogical manner.[20]

Against this background, the union with God through the reception of the Eucharist was reinforced by the special materiality of the precious altar.

The foregoing discussion leads us to conclude that on one level, the images and their materials conjoined to evoke the invisible realities of Heaven. In relation to the viewer, however, these aspects took different paths: whereas the materials elicited an anagogical experience, the imagery served to authorize the power of the Eucharist by offering the historical evidence of Christ's dual nature. Thus, while still at a distance the viewer would be inspired with a sense of awe at the sight of glimmering gold and sparkling colors, upon approaching he would gain insight and be stimulated by the memory of the events of sacred history that had made it possible to be united with God in the present.[21] This tension between proximity and distance was further strengthened by the altar's jeweled ornament, which not only added to the strong visual impact at a distance, but also ensured the attention of the viewer and encouraged him to approach for a clearer and more intelligible view.[22] In this way, by appealing directly to both the senses and the intellect, the interaction of materiality and image brought the altar to the center of the beholder's attention in accordance with its special status within the church as the point of encounter between earth and Heaven.

In the final analysis the visual experience of the pictured altar frontal may be characterized as being both anagogical and pedagogical, a double role which corresponded neither with the prescriptions established by the *Opus Caroli* nor with the statements on images formulated by Gregory the Great. The example of the golden altar of Sant'Ambrogio thus demonstrates that contemporary

opinions on images were sometimes overshadowed by a long and authoritative tradition within medieval aesthetics. We are thus induced to reflect on the effective influence of the *Opus Caroli* on medieval culture, as well as on the theoretical positions regarding images in general and the degree of their impact on contemporary imagery.[23]

Frequently cited sources

Bertelli, Carlo. "Sant'Ambrogio da Angilberto II a Gotofredo." In *La città del vescovo dai Carolingi al Barbarossa*, ed. C. Bertelli, 16-81. Milan, 1988.

Braun, Joseph. *Der christliche Altar*, 2 vols. Munich, 1924.

Elbern, Victor. *Der karolingische Goldaltar von Mailand*. Bonn, 1952.

Ferrari, Mirella. "Le iscrizioni." In *L'Altare d'Oro di Sant'Ambrogio*, ed. C. Capponi, 145-155. Milan, 1996.

Kaspersen, Søren. "Gyldne altre og nadverliturgi." In *Ting och tanke. Ikonografi på liturgiska föremål*, ed. I. Pegelow, 150-166. Stockholm, 1998.

Nørlund, Poul. *Gyldne altre. Jysk metalkunst fra Valdemarstiden*. Copenhagen 1926; 2nd ed., Århus 1968.

Opus Caroli regis contra synodum, ed. A. Freeman. MGH, *Concilia*. Hannover, 1998.

Tatarkiewicz, Wladyslaw. *History of Aesthetics*, vol. 2: *Medieval Aesthetics*. The Hague/Paris, 1970.

Notes

1 Important contributions to the golden altar of Sant'Ambrogio include: Victor Elbern, *Der karolingische Goldaltar von Mailand* (Bonn, 1952); Carlo Bertelli, "Sant'Ambrogio da Angilberto II a Gotofredo," in *La città del vescovo dai Carolingi al Barbarossa*, ed. C. Bertelli (Milan, 1988), 16-81; *L'Altare d'Oro di Sant'Ambrogio*, ed. C. Capponi (Milan, 1996); Cynthia Hahn, "Narrative on the Golden Altar of Sant'Ambrogio in Milan: Presentation and Reception," *Dumbarton Oaks Papers* 53 (1999): 167-187; Valerie Figge, *Das Bild des Bischofs. Bischofsviten in Bilderzählungen des 9. bis 13. Jahrhunderts* (Weimar, 2000), 50-73.

2 Joseph Braun, *Der christliche Altar* (Munich, 1924), 2: 90-108; Poul Nørlund, *Gyldne altre. Jysk metalkunst fra Valdemarstiden* (Copenhagen, 1926; 2nd ed., Århus, 1968 with English summary); idem, "Les plus anciens retables danois," *Acta archaeologica* 1 (1930): 147-164; *Nordens gyldne billeder fra ældre middelalder* (text: Paul Grinder Hansen; Copenhagen, 1999), and Otto Norn and Søren Skovgaard Jensen, *The House of Wisdom* (Copenhagen, 1990) – the Sahl altar.

3 Gregory the Great, *Epistola*, IX, 209, and XI, 10 (CCSL 140A, ed. D. Norberg, p. 768 and pp. 873-876); Lawrence G. Duggan, "Was Art Really the 'Book of the Illiterate'?," *Word and Image* 5 (1989): 227-252; Celia M. Chazelle, "Pictures, Books, and the Illiterate: Pope Gregory I's Letters to Serenus of Marseille," *Word and Image* 6 (1990): 138-153.

4 AEMICAT ALMA FORIS RUTILOQUE DECORE VENUST(A)
 ARCA METALLORUM GEMMIS QUAE COMPTA CORUSCA(T)
 THESAURO TAMEN HAEC CUNCTO POTIORE METALL(O)
 OSSIBUS INTERIUS POLLET DONATA SACRATI(S)
 (AE)GREGIUS QUOD PRAESUL OPUS SUB HONORE BEAT(I)
 INCLITUS *AMBROSII TEMPLO RECUBANTIS IN ISTO*
 *OPTULIT ANGILBERTUS OVANS DOMI*NOQUE DICAVI(T)
 TEMPORE QUO NITIDAE SERVABAT CULMINA SEDIS
 (A)SPICE SUMME PATER FAMULO MISERERE BENIGN(O)
 (T)E MISERANTE DEUS DONUM SUBLIME REPORTE(T); Angelo Silvagni, *Monu-
 menta epigraphica christiana*, vol. 2. *Mediolanum* (Vatican, 1943), tab. V, 6; translation from
 George Bishop Tatum, "The Paliotto of Sant'Ambrogio at Milan," *Art Bulletin* 26 (1944):
 25-45, p. 26. Letters in parentheses occur at the corners and are used in two words, one writ-
 ten horizontally and the other vertically, see also Mirella Ferrari, "Le iscrizioni," in *L'Altare
 d'Oro*, fig. 3.

5 For this treatise, see *Opus Caroli regis contra synodum*, ed. A. Freeman, MGH, *Concilia* (Han-
 nover, 1998), 2, 1: 36-50; on Byzantine Iconoclasm and the theories on images, see Leslie
 Barnard, "The Theology of Images," in *Iconoclasm*, ed. A. Bryer and J. Herrin (Birmingham,
 1977), 7-15; Belting, *Bild und Kult. Eine Geschichte des Bildes vor der Zeitalter der Kunst* (Mu-
 nich, 1990), 170-175; Daniel J. Sahas, *Icon and Logos: Sources in eighth-century iconoclasm*,
 Toronto Medieval Texts and Translations 4 (Toronto, 1986), 3-44; Hans Georg Thümmel,
 *Bilderlehre und Bilderstreit. Arbeiten zur Auseinandersetzung über die Ikone und ihre Begründung
 vornehmlich im 8. und 9. Jahrhundert* (Würzburg, 1991), esp. 40-63, 105-114.

6 *Opus Caroli regis contra synodum*, ed. A. Freeman, 2. 29; 3. 24; David F. Appleby, "Holy relic
 and holy image: saints' relics in the western controversy over images in the eighth and ninth
 centuries," *Word and Image* 8, 4 (1992): 333-343, p. 335.

7 Elbern, *Karolingische Goldaltar*, 58; Bertelli, "Sant'Ambrogio," 42-43, who links the altar to
 the Iconoclast controversy.

8 CODICIS HUJUS OPUS STRUXIT THEODULFUS AMORE
 ILLIUS HIC CUJUS LEX BENEDICTA TONAT
 NAM FORIS HOC GEMMIS, AURO SPLENDESCIT ET OSTRO
 SPLENDIDIORE TAMEN INTUS HONORE MICAT; Léopold Delisle, *Les bibles de
 Théodulfe* (Paris, 1879), 7-8. The manuscript is dated to between 788-821.

9 *Opus caroli regis contra synodum*, ed. A. Freeman, 2.30; 3.30. See also Celia Chazelle, "Mat-
 ter, Spirit, and Image in the Libri Carolini," *Recherches Augustiniennes* 21 (1986): 163-184, p.
 169.

10 Luce Pietri, *La Ville de Tours du IVe au Vie siècle: Naissance d'une cité chrétienne* (Rome,
 1983), 810, no. 16: QUAE SALOMONIACO POTIS EST CONFLIGERE TEMPLO, SEP-
 TIMA QUAE MUNDO FABRICA MIRA FUIT. NAM GEMMIS, AURO, ARGENTO SI
 SPLENDUIT ILLUD, ISTUD TRANSGREDITUR CUNCTA METALLA FIDE.

11 QUAM CERNIS FULVO TABULAM SPLENDORE NITENTEM PLUS NITET ISTORIE
 COGNITIONE SACRE PANDIT ENIM CHRISTI MYSTERIA QUE SUPER – AURUM
 IRRADIANT MUNDIS CORDE NITORE SUO ERGO FIDE MUNDES MENTEM SI
 CERNERE LUCIS GAUDIA DIVINE QUI LEGIS ISTA VELIS; Nørlund, *Gyldne altre*,
 186-187.

12 On the history and theory of medieval aesthetics, see the fundamental works of Edgar de
 Bruyne, *Études d'esthétique* médiévale, 3 vols. (Bruges, 1946); Wladyslaw Tatarkiewicz, *History*

of Aesthetics, vol. 2: *Medieval Aesthetics* (The Hague/Paris, 1970), 27ff (Pseudo- Dionysios), 47ff (Augustine); Rosario Assunto, *La critica d'arte nel pensiero medioevale* (Milan, 1961); Monroe C. Beardsley, *Aesthetics from Classical Greece to the Present* (New York/London, 1966), 89-98; and Umberto Eco, *Art and Beauty in the Middle Ages* (New Haven, 1986 with detailed bibliography).

13 Augustine, *De Musica*, IV, 12, 38; idem, *Confessionum*, X, 34 (CCSL 28, I, 1, ed. L. Verheijen, 182); Pseudo-Dionysios, *De coelesti hierarchia*, ed. K. Aland and E. Mühlenberg, *Corpus Dionysiacum* (Berlin/New York, 1991), 2: 7-9; see also Tatarkiewicz, *History of Aesthetics*, 30, 50-51 and Norn/Skovgaard Jensen, *House of Wisdom*, 59-69.

14 Søren Kaspersen, "Gyldne altre og nadverliturgi," in *Ting och tanke. Ikonografi på liturgiska föremål*, ed. I. Pegelow (Stockholm, 1998), 150-166.

15 "Quis enim fidelium habere dubium possit in ipsa immolationis hora ad sacerdotis vocem coelos aperiri, in illo Jesu Christi mysterio angelorum choros adesse, summis ima sociari, terrena coelestibus jungi unumque ex visibilibus atque invisibilibus fieri"; Gregory the Great, *Dialoges* IV, 58 (PL 77: 428A). See also Yves Congar, *L'Ecclesiologie du haut moyen âge* (Paris, 1968), 104ff.

16 On the significance of these scenes and their details with regard to the Patristic literature, see Robert Deshman, *The Benedictional of Æthelwold* (Princeton, 1995), 19-21, 39-43; Erik Thunø, *Image and Relic. Mediating the Sacred in Early Medieval Rome* (Rome, 2002), 38f, 43ff, 92ff.

17 Peter Low, "The City Refigured: A Pentecostal Jerusalem in the San Paolo Bible," *The Real and the Ideal Jerusalem in Jewish, Christian and Islamic Art*, ed. B. Kühnel (Jerusalem, 1998), 265-275.

18 Paschasius Radbertus, *De corpore et sanguine Domini*, 8 (PL 120: 286CDB); Kaspersen, "Gyldne altre," 152ff. See also Godefridus Snoek, *Medieval Piety From Relics to the Eucharist. A Process of Mutual Interaction* (Leiden, 1995), 183.

19 Pseudo-Dionysios, ed. K. Aland and E. Mühlenberg, 2: 7-9. The complete Dionysian corpus did not arrive in the West before 827 and was first translated ca. 838 by Hilduin, abbot of St. Denis. Some decades later John Scotus, also called Eriugena, finished a fresh translation in 862 on commission by Charles the Bald. For the diffusion of Pseudo-Dionysius' thought in the West, see introduction by Jean Leclercq in *Pseudo-Dionysius. The Complete Works* (New York, 1987), 25-32.

20 Suger, *De rebus in administratione sua gestis* (ch. 23); trans. E. Panofsky, *Abbot Suger. On the Abbey Church of St.-Denis and its Art Treasures*, ed. E. Panofsky (Princeton, 1946, 2. ed. 1979), 65.

21 Mary Carruthers, *The Book of Memory. A Study of Memory in Medieval Culture* (Cambridge, 1990), 16-45.

22 For the role of ornament in the perception and appreciation of the visual arts, see Oleg Grabar, *The Mediation of Ornament* (Princeton, 1992), esp. 42ff, 135f; 151, 226-237; see also Ernst H. Gombrich, *The Sense of Order. A study in the psychology of decorative art* (Oxford, 1979), 95ff. On the question of materiality in medieval art, see Dominic Janes, *God and Gold in Late Antiquity* (Cambridge, 1998); Jean Claude Bonne, "Entre l'image et la matière: la chóséité du sacré en Occident, in *Les images dans les sociétés médiévales: Pour une histoire comparée*, ed. J.-M. Sansterre and J.-C. Schmitt (Brussels/Rome, 1999), 77-108.

23 For a (unique) example of how Carolingian theory, as exemplified by the *Opus Caroli*, directly influenced the configuration of a contemporary pictorial decoration, see Ann Freeman and Paul Mayvaert, "The Meaning of Theodulf's Apse Mosaic at Germigny-des-Prés, *Gesta* 40/2 (2001): 125-141.

Narrative 'Modes' in the Danish Golden Frontals

Søren Kaspersen

Introduction

So-called 'golden altars' from the 12th and 13th centuries still exist from a number of churches (nine or ten) in the Scandinavian region. They were most likely made in the western part of medieval Denmark – more specifically, in various workshops in Jutland.[1] Each 'golden altar' may have consisted not only of a frontal (antependium/antemensale) for the *mensa* but also a low mounting at the back of the table, a retable (reredos) – most often, crowned by a large 'arch of heaven'. Both frontals and retables are made of copperplates attached to a skeleton or frame of oak and, as a rule, the panels are carved from the oak planks. The thin copper sheets are embossed, engraved, stamped or nearly plain and covered by fire gilding. Especially on narrow, plain parts but also on embossed areas, there may be a decorative combination of fire gilding and brown varnish ('vernis brun'). The use of this combination is most common in the oldest altarpieces, while total fire gilding was preferred on the more recent altars. All the frontals (and, at least, one reredos) were also decorated with large rock crystals mounted in settings on the intersections of the framework – often, in close proximity to the main motif at the center of the composition. The intention was to make the altars glitter in the dim light of church interiors of that day.

Most of the golden altars are now in the medieval collection of the National Museum in Copenhagen: a frontal and retable made around 1135 from Lisbjerg Church,[2] another early retable from Odder or, perhaps, Saksild Church,[3] a number of detached and cutted sheets from Tamdrup Church, stemming from a frontal and, perhaps, a retable or a reliquary as well,[4] and three later frontals from Sindbjerg Church,[5] Ølst Church,[6] and Odder Church.[7] All these churches are located in Jutland, where two additional golden altars are preserved in Sahl Church (frontal and reredos)[8] and Stadil Church (frontal). Another Jutland frontal from Kværn (Quern) Church in Schleswig is now in the National Mu-

seum in Nuremberg,[9] while a frontal and reredos from Broddetorp Church in
Västergötland, Sweden, related to the Lisbjerg altar, are now in the Historical
Museum of Antiquities in Stockholm.[10]

Two larger, metal-plated and gilded crucifixes with a separate wooden-core
figure of Christ, are secondarily connected with the arched retables of the altars
from Lisbjerg and Odder (or Saksild) Churches. A third crucifix of the same
type is mounted above the low reredos of the Broddetorp altar – perhaps, the
original setting. Finally, a much smaller gilded crucifix with an embossed figure
of Christ is mounted on the reredos in Sahl Church. It is flanked by the figures
of Mary and St. John, all harmoniously framed by the crowning arch.

Preserved cast figures, gilded sheets of copper and smaller remnants of such
sheets, together with written sources, demonstrate that many other churches in
Scandinavia were adorned with golden altars during the High Medieval period.[11]
Altogether, we know of 41 examples – 32 of which, no less, are from medieval
Denmark.[12] Even the preserved Danish material represents an abundance, com-
pared to other countries – particularly when its small geographical area is taken
into consideration.

The norm for the Jutland golden altars is for the frontals to be structured
in three sections. The middle section includes a large panel portraying Christ
enthroned in a mandorla or aureole as the primary motif, while the flanking
sections have panels in three zones – though the Broddetorp frontal has four
– depicting scenes from the life of Christ. Sometimes a row of apostles may be
added. The whole is surrounded by a tripartite frame, to which there are at-
tached four or more medallions adorned with symbols of the four evangelists,
busts of prophets or angels, together with other motifs such as the dove of the
Holy Spirit and the Lamb of God.[13]

The structural relationship between the representational scene, *imago*, and
the narrative scenes, *historiae*, alternates: the central motif, which most often
takes up two or almost two ordinary fields in breadth,[14] may be limited in height
to a part of the central section, so that the narrative scenes run over and under
the aureole, as may be seen on the frontals from Sindbjerg and Ølst Churches
(Figs. 1 & 2). The representation may also fill the entire middle section – and
be limited to that, as on the Odder frontal (Fig. 3) and as was probably the case
with the Tamdrup frontal (Fig. 4). The narrative series – at any rate, on the
first altar mentioned – still run along three horizontal zones across the frontal.
Finally, the central motif may not only fill the middle section, but also reach
out into the narrative sections via an accompanying group of apostles, as in the
frontal from Broddetorp Church (Fig. 7) and the frontals at the Sahl and Stadil
Churches (Fig. 5 & 6). Here, the narratives are arranged from top to bottom in
each section separately.[15]

Fig. 1. Sindbjerg frontal with original programme indicated by the author. Outline (1:15) after Tage E. Christiansen, 1968.

Fig. 2. Ølst frontal with reconstructed programme suggested by the author. Outline (1:15) after Tage E. Christiansen, 1968.

Fig. 3. Odder frontal with reconstructed programme indicated by the author. Outline (1:15) after Tage E. Christiansen, 1968.

Fig. 4. Tamdrup frontal, reconstruction with programme indicated by Tage E. Christiansen/the author. Outline (1:15) after Tage E. Christiansen, 1968.

Fig. 5. Sahl frontal with programme indicated by the author. Outline (1:15) after Tage E. Christiansen, 1968.

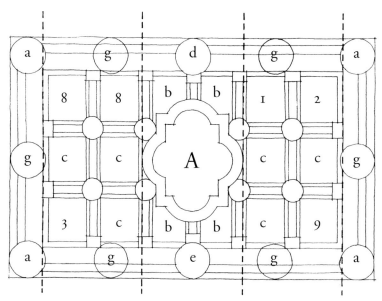

Fig. 6. Stadil frontal with present programme indicated by the author (theme 1 & 2 and theme 8 have most likely been shifted around). Outline (1:15) after Tage E. Christiansen, 1968.

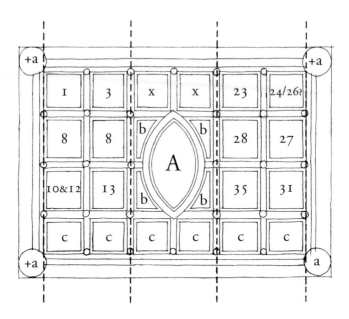

*Fig. 7. Broddetorp frontal with programme indicated by the author. Outline (1:15)
after Tage E. Christiansen, 1968.*

The front of the altar table sets rather narrow limits for the scope of the narrative
series, if the work is to be done on a scale that is legible from a distance. The
longest Danish series is in the Tamdrup frontal, which includes at least eighteen
panels. On the Sindbjerg and Ølst frontals, sixteen panels are available for the
Christological series; whereas, there are only twelve panels on the Broddetorp,
Sahl and Odder frontals and, on the Stadil frontal, no more than six. This means
that the organizer of the program in each case was forced to make a number of
decisions that, on the narrative plane, operated between a continuous sequence
and focused abridgement. The rhythm in the sequence may well be rather smooth
within separate periods of Christ's life, but it is characterized by condensations
or clear emphases as well as some breaches in chronology.

At the same time, the narrative aspect is distinguished by important differ-
ences in the basic stories of Christ's life – the Gospels' accounts of his child-
hood, passion and resurrection/glorification and, particularly, the traditions
that had accrued for the depiction thereof. The absolute condensation point in
the sacred story was the *triduum sacrum*, i.e. the period from the Last Supper
to Easter morning in which the protagonist appears in a long series of episodes
in a temporally tight sequence. The rhythm in the other part of the story is de-

termined more by the central events, each described in a single scene, following one upon the other – for example, the 'Annunciation' and the 'Visitation' at the beginning of the sequence and the 'Ascension of Christ' and the 'Descent of the Holy Ghost' at the end.[16] Yet, a certain condensation has arisen around Christmas, which includes the special cycle of the Three Magi.

An overview of the scenes that appear on the frontals – and their frequency – may cast light on these relationships (+ = plate lost; [] = reconstructed motif):

Imagines

A Christ in Majesty/*Majestas Domini*
a Emblem of an evangelist
b Angel attending Christ in Majesty
c Apostle attending Christ in Majesty

d Dove of the Holy Ghost
e Lamb of God/*Agnus Dei*
f Ornament
g Bust of angel
h Half-figure/prophet?

x Sun and moon
y The Church/*Ecclesia*
z The Synagogue/*Synagoga* (led away by Moses)

The Childhood and Public Life of Christ (1 ff.)

1 The Annunciation – *7 examples*
 (Broddertorp, Tamdrup, +Sindbjerg, Ølst, Sahl, Stadil, Odder)
2 The Visitation – *6 examples*
 (Tamdrup, +Sindbjerg, Ølst, Sahl, Stadil, Odder)
3 The Nativity – *7 examples*
 (Broddertorp, [Tamdrup], Sindbjerg, Ølst, Sahl, Stadil, Odder)
4 Joseph's First Dream – *1 example*
 (Ølst – combined with the Nativity)
5 The Annunciation to the Shepherds – *3 examples*
 (Tamdrup, + Sindbjerg, Ølst – only shepherds on the field)
6 The Journey of the Magi – *1 example*
 (Odder)

7 The Magi Questioning Herod – *2/3 examples*
 (Tamdrup, +Sindbjerg, [Odder])
8 The Adoration of the Magi – *6/7 examples*
 (Broddetorp, Tamdrup, [Sindbjerg?], Ølst, Sahl, Stadil, Odder)
9 The Presentation in the Temple – *5 examples*
 (Tamdrup, +Sindbjerg, Sahl, Stadil, Odder)
10 Herod's Feast/The Legend of Stephen the Stable Boy – *1 example*
 (Broddetorp – combined with the Massacre)
11 Herod Orders the Massacre – *2 examples*
 (Ølst, Odder)
12 The Massacre of the Innocents – *3 examples*
 (Broddetorp – combined with Herod's feast, Ølst, Odder)
13 The Flight into Egypt – *4 examples*
 (Broddetorp, Tamdrup, +Sindbjerg, Sahl)
14 The Baptism of Christ – *3 examples*
 (Tamdrup, +Sindbjerg, Odder)
15 The Temptation(s) of Christ – *2 examples*
 (Tamdrup – 2 plates: in the wilderness and on the Temple, +Sindbjerg – epi-
 sode unknown)
16 The Marriage at Cana – *1 example*
 (+Sindbjerg)
17 The Transfiguration – *2 examples*
 (Tamdrup, +Sindbjerg)

The Passion and Resurrection/Glorification of Christ (20 ff.)

20 The Entry into Jerusalem – *2 examples*
 (Tamdrup, Ølst)
21 Christ Washing the Feet of the Disciples – *1 example*
 (Tamdrup)
22 The Last Supper – *1 example?*
 (Ølst?)
23 The Kiss of Judas – *2 examples*
 (Broddetorp, Tamdrup)
24 The Arrest of Christ/Christ Led to Judgement – *1 example?*
 (Broddetorp? – Christ Led Away by Two Tormentors)
25 The Flagellation – *1 example*
 (Tamdrup)
26 The Road to Calvary – *1/2 examples*
 (Broddetorp?, Sahl – both examples without the bearing of the Cross)

27 The Crucifixion – *4 examples*
 (Broddetorp, Tamdrup, Ølst, Sahl)
28 The Deposition – *2 examples*
 (Broddetorp, Sindbjerg)
29 The Harrowing of Hell /Christ's Descent – *3 examples*
 (Tamdrup, Ølst, Sahl)
30 The Harrowing of Hell/Redemption of the Righteous – *2 examples*
 (Ølst, Sahl)
31 The Resurrection – *2 examples*
 (+Sindbjerg, Ølst – only the Sepulcher with an angel is shown)
32 The Holy Women at the Sepulcher – *2 example*
 (Broddetorp, Sahl)
33 Christ in Emmaus – *1 example?*
 (Ølst?)
34 The Incredulity of Thomas – *1 example*
 (Ølst)
35 The Ascension – *2 examples*
 (Broddetorp, Sindbjerg)
36 The Descent of the Holy Ghost – *1 example*
 (+Sindbjerg)

This overview of the subject matter in the frontals and the frequency with which the individual episodes appear clearly show that the period in Christ's life most closely described is his childhood. On the Stadil frontal and the frontal from Odder there are only scenes from the story of Christ's childhood – on the latter frontal, concluding with his entrance into public life, the 'Baptism'. The 'Annunciation' and the 'Nativity' must be considered obligatory scenes, but, beyond that, we see that the 'Visitation' also plays a large role. Otherwise, there is the story of the Three Wise Men to which much space is devoted – in that the 'Adoration' most often takes up two fields, while an episode such as the 'Circumcision' does not figure in at all.

As regards the rest of Jesus' life, only the frontals from Sindbjerg and Tamdrup (cf. Figs. 1 & 4) contain episodes from Jesus' public life between the beginning and end of his historical mission of salvation – and, even then, not scenes of his teachings but scenes that, in an extension of the 'Baptism', reveal his divinity. There is no attempt at a cyclical narrative to bridge the two basic stories – rather, a sort of epilogue to the story of his childhood, since both the 'Temptations of Christ' and the 'Wedding of Cana' are closely connected chronologically to the 'Baptism'. Remaining is the 'Transfiguration', with which the Tamdrup frontal seems to have concluded the middle zone, before the

story of the Passion began with the 'Entry into Jerusalem' in the lower series
of panels.

Even though the story of Christ's suffering and resurrection/glorification in-
cludes many more episodes than the story of his childhood, it is never attributed
more room on the frontals than this – and often less, which is why the account
becomes more disconnected. The longest, most condensed sequence is found in
the Tamdrup plates (Fig. 3), which takes up only the last third of the eighteen
plates. Here may be seen today the 'Entry into Jerusalem', the 'Washing of the
Feet', the 'Kiss of Judas', the 'Flagellation', the 'Crucifixion' and the 'Descent
into Hell'. The leaps are evident and one may wonder about the emphasis: why
the 'Washing of the Feet' and not – or not, as well – the 'Last Supper'? And the
relief with the 'Descent into Hell' shows only half the episode – namely, Christ
crushing the Devil's power.[17]

All in all, the 'Prayer at Gethsemane', the interrogation scenes, the 'Crown of
Thorns' and the 'Mocking' are unknown in the Passion reliefs of the frontals. It
is intriguing that the 'Last Supper' is only depicted in one and, even then, un-
certain example in the Ølst frontal. Was the motif considered redundant? The
sacrificial death on Golgotha was, understandably, an obligatory episode; but,
on the Sindbjerg frontal (Fig. 1), it is only represented by the 'Descent from the
Cross'. Correspondingly, the resurrection of Christ is always described: through
the 'Descent into Hell' and/or the empty grave/the 'Women at the Sepulcher'.

It may be said that the focus on the stories of Jesus' childhood and his suffer-
ing and glorification is quite understandable in relation to the function of the
altar table as the place for the celebration of the Mass: in the sacrament of Holy
Communion, Christ is incarnate once more and it is his sacrifice on Golgotha
that is offered up to the elevated Majesty and received as the food of salvation
for resurrection and eternal life. Corresponding Christological series are famil-
iar enough from decorations around high altars – for example, wall paintings
in the chancel.[18] And these subjects are the most widespread in all of Christian
art – particularly, in the Romanesque, Gothic and Late Gothic periods during
which Jesus' public life and deeds are barely represented in relation to the cycles
connected to the major church festivals of the year. What may lend the frontals
a certain distinctive character is the condensed and isolated occurrence of the
cycles.[19] At the same time, it may be worth stressing that an attempt was made
at a sequential representation of the Christological story, regardless of how few
scenes were available, where the alternative might have been a more monoscenic
structure, familiar from, for example, the so-called Byzantine festal cycle of the
iconostas.

Concepts of narrativity

If one goes beyond these general considerations and characteristics and inquires into the nature and distinctive traits of the narrativity of the golden altars, one must first acknowledge that there are great differences in the way individual frontals depict these stories. In addition, a number of difficult questions are raised – with respect to defining narrativity as a phenomenon and understanding it more broadly in relation to the subject matter and the function it has in the specific culture, including the viewer context and the equally intricate question of how and on what premises the viewer can read the stories. In an interesting and penetrating study of three phases of Greek art, Mark D. Stansbury-O'Donnell has dealt with and accentuated these diverse problems through both an Aristotelian and a structuralist-semiotic lens.[20] This study does not permit a separate discussion of all these specific matters. Instead, an attempt will be made to introduce to the subject through various points of impact in which both individual motifs and phenomena in the larger structures are dealt with.

We presume at the outset that visual art, like literature, is able to narrate and that narrativity can be defined in relation to any visual representation of an event – mythic, historical or fictive, regardless of how little narrative staging a modern viewer can immediately grasp.[21] Ernst Gombrich has argued for the Greeks' epoch-making achievement in the history of narrativity through the introduction of fiction into literature – especially, Homeric poetry. For art, this meant that the picture acquired a completely new function: it was not only to describe *what* happened, as before, but *how* it happened.[22] A completely new form of narrative representation developed from archaic to Hellenistic times, based on an increasing naturalism or illusionism.

For Kurt Weitzmann, this form of narrativity found its full potential developed in illuminated papyri, which in late Antiquity were replaced by more spacious and durable codices.[23] With these media, a heretofore unseen compactness arose in narrative sequence, and this tradition formed the crucial foundation for Christian narrative art – and, perhaps, even for Jewish art in the Diaspora.[24] At any rate, extensive stories from the Gospels and the books of the Old Testament arose early in Christian art. Visual traditions were created on which organizers and artists could build and in relation to which they were often forced to make condensations or fusions of several sequential episodes in one and the same scene. Important for the narrative character of Christian art is also the fact that *historia* replaces *fabula*, that the idea of fiction is formally suspended,[25] that the emphasis is moved from literal narration to its multiple spiritual meanings and that illusionistic representations of reality yield to other strategies. In this sense, it is a good idea to keep Max Dvorak's classic study of idealism and naturalism in Gothic art in mind.[26]

In the development of pictorial narrative thus outlined, there are different methods of telling a story. In a classic study of Greek art from 1881, Carl Robert enumerated three successive stages in the history of narration: 'kompletive Verfahren', 'Situationsbilder' and 'Bilderzyklen'/'Chroniken-Stil'.[27] Later research has to a large extent based its analysis on this tripartite division. Thus, Kurt Weitzmann, in a manner similar to Carl Robert, speaks of 'simultaneous', 'monoscenic' and 'cyclic' narrative. Other terms, such as 'panoramic', 'unified', 'serial' and 'progressive' narrative, are also brought to bear. However, the evolutionary understanding of the development has become increasingly problematic.[28]

The narrative series in the golden altars clearly belong to the cyclical method, as it is defined, for example, by Weitzmann: "By conceiving each changing situation of the text as a picture in itself, the artist creates now a series of consecutive compositions with separate and centered actions, repeating the actors in each and so observing at the same time the rules of the unity of time and place.... As the eye in reading a text moves from one writing column to another, so it moves now from one picture to the next, reading them, so to speak, and the beholder visualizes in his mind the changes which took place between the consecutive scenes."[29]

In this method, the simplest and most frequently utilized system is to place the scenes in one or more friezes with a common base. Thus, the scenes follow each other in a continuous space with or without inserted partitions in the form of trees, architecture, etc., or each scene may have its own framework, as is the case in our frontals.[30] At the same time, however, the framework is to be looked upon as a structure working at a different level, a specific form, within which the sacred story appears, since the 'Adoration of the Magi' is most often divided into two panels.[31] The same holds true in a couple of instances – the Ølst and Odder frontals – for the depiction of the 'Massacre of the Innocents'; but here the episode may be read in two phases: Herod orders the massacre and the slaughter takes place.

The question of narrativity concerns both the individual scene on each frontal and their relationships within the general structures. In his study, Stansbury-O'Donnell adopts a conceptual apparatus developed by Roland Barthes in a structural analysis of narrative. Barthes distinguishes among three planes in every narrative presentation: "a level of 'functions', a level of 'actions', and a level of 'narration' (discourse)," planes connected together "according to a mode of progressive integration." In addition, narrative's functional level is made up of four elements or units – 'nuclei', 'catalyses', 'indices' and 'informants'.[32] This conceptual apparatus can clearly lend itself to the analysis of pictorial narrative and may have a number of clarifying effects. In the first instance, I have decided to limit myself to a simpler structuring taken from rhetoric, which has had de-

cisive significance for art theory since late Antiquity.[33] Therefore, a fundamental distinction is made between two levels, *dispositio* and *elocutio*, understood respectively as the ordering and ornamentation of the material or the narrative that the artist through *inventio* has selected and placed his focus, according to the effect and meaning he is striving to communicate to his audience.[34]

'Modes' of narration: the 'Visitation'

One can get an impression of how an individual episode may be reproduced in different ways and with varying emphasis on the frontals by looking at the four reliefs of the 'Visitation', which belong to the 'embrace type' – namely one of the Tamdrup plates and panels in the Ølst, Stadil, and Odder frontals. The last preserved depiction, on the Sahl frontal, shows the other primary type in which the women stand separately at their encounter. Of the deed itself, the Vulgate says: "Exurgens autem Maria in diebus illis abiit in montana cum festinatione [hurry/haste], in civitatem Iuda. Et intravit in domum Zachariae et salutavit Elisabeth. Et factum est, ut audivit salutationem Mariae Elisabeth, exsultavit infans in utero eius et repleta est Spiritu sancto Elisabeth, et exclamavit voce magna et dixit: Benedicta tu inter mulieres, et benedictus fructus ventris tui. Et unde hoc mihi, ut veniat mater Domini mei ad me? Ecce enim, ut facta est vox salutationis tuae in auribus meis, exsultavit in gaudio infans in utero meo. Et beata quae credidisti, quoniam perficientur ea, quae dicta sunt tibi a Domino" (Lk. 1, 39-45).[35] Then, Mary breaks out into a lengthy paean (v. 46-55), that begins: "Magnificat anima mea Dominum, et exultavit spiritus meus in Deo salutari meo; quia respexit humilitatem ancillae suae" (v. 46-47) – a paean that appears in the liturgy as early as the sixth century.

This is a relatively simple story with an implied dialogue and concluding hymn, but it challenged the artist with a number of demands and significant barriers. Of the scene's setting in time and space, it is only said that the encounter took place at Zachariah's home in a mountain village in Judea – shortly after the angel's visit to Mary. Hence, all other details of the persons and the environment were open.[36] The wording of Mary's greeting is not known from the dialogue, only Elisabeth's subsequent praise, which again arose from a phenomenon difficult to reproduce: namely, the embryo that leapt into Elisabeth's womb, of which attempts were made only later – for a brief period – to visualize concretely. Likewise, there was not – nor, for understandable reasons, did there arise – any tradition for placing a dove above Elisabeth in order to show that, through Mary's greeting, she is filled with the Holy Spirit.[37] Finally, the great weight on verbal expression in the story accentuated the artist's general problem: he cannot imitate sound; it was not even appropriate to represent an

open mouth, much less one shouting in a loud voice. In all four reliefs, the use of written captions to clarify the nature of events is avoided.

Thus, the ordering, *dispositio*, and ornamentation, *elocutio*, of the plain pattern of action were to communicate the historic event and its spiritual meanings. The movements and the whole body language of the characters were central here. By presenting Mary's greeting and the encounter as an embrace, the episode is put paradigmatically in relation to a set of motifs in Christian art that speak of union and harmony – of virtues, contradictions, etc. Furthermore, during this period, 'Anna and Joachim at the Golden Gate' appeared in Western art, a motif in which an aging Anna is united with her husband Joachim in an embrace and becomes pregnant with Mary. Bonaventura's introduction and merging of the feast of the 'Visitation' with the feast for Anna and the conception of Mary in the Franciscan order in 1263 shows that the Middle Ages clearly saw a parallel between the events.

The description of the embrace seems most realistic in the early and the late examples – i.e., in the Tamdrup and Odder reliefs. In the Tamdrup plate (Fig. 8), one would immediately understand the woman, who is on the left embracing the other woman and placing her cheek against her head, as Mary, just arrived from Nazareth. At the same time, however, the other woman with her frontal position and deacon-like tunic with richly embellished band seems to have a higher status, which creates some doubt. Yet, the more rounded head of the figure in profile in a comparison with the Annunciation scene speaks for the fact that she is Mary and, compared to her, the other woman seems older, more matronly. The emphasis in the story apparently shows how Elisabeth upon Mary's greeting feels the embryo in her womb, is filled with the Holy Spirit and breaks out into praise – hence, her frontal position and status.

At the same time, the priest Zachariah, who observes the event attentively, broadens the story in time and space. For the knowing observer, he refers back to his own 'annunciation' in the temple, where Gabriel proclaimed to him that his aging wife would become fertile and bear a child, whereupon he is struck dumb, because he cannot immediately believe the archangel's statement. When he leaves the shrine, the people understood that he had a vision in the temple ("et cognoverunt quod visionem vidisset in templo" – Lk. 1: 22). Of the conception itself, we only hear about in the Gospel: "And it came to pass, that, as soon as the days of his [Zechariah's] ministration [in the sanctuary] were accomplished, he departed to his own house. And after those days his wife Elisabeth conceived,..." (Lk., 1: 23-24).

Thus, Zachariah forms a bridge between the 'Annunciation' and the wondrous meeting between the two women by recalling his own encounter with the archangel and his wife's miraculous fertility. At the same time, with his visionary

*Fig. 8. The 'Visitation'.
Golden relief from
Tamdrup Church.
Copenhagen, National
Museum. Photo:
Jesper Weng, National
Museum, Copenhagen.*

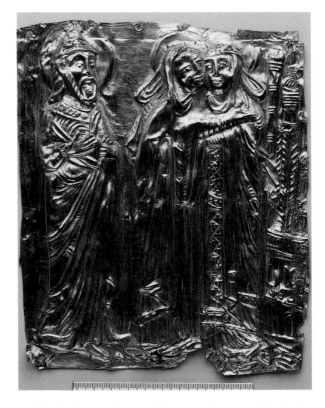

expression, he may very well lead the mind toward his own praise of God after Elisabeth's confinement, when his voice returns and he is filled with the Holy Spirit (cf. Lk. 1:57 ff.). The artist or planner thus tried to expand the moment, which after all governs the representation in the relief, to make visible several phases of the story around the culmination – aided by the fact that there are three tales of miraculous conception that make great use of common elements.

Behind Elisabeth, squeezed up against the panel's right edge, is an architectonic structure – a peculiar 'building' in two storeys, crowned by a series of slender, round towers, taller than the 'building' itself. The structure may depict the mountain village in Judea to which Mary comes, if not Zachariah's house. However, because of its peculiar characteristics, one may also ask whether it might be the temple Zachariah served,[38] or perhaps an elegant seat from which Elisabeth has just risen. In the latter case, her condition at the meeting is being characterized: she has, since her conception, lived secluded from the world, i.e. she has kept indoors ("and hid herself five months, saying, Thus hath the Lord dealt with me in the days wherein he looked on *me,* to take away my reproach among men"(Lk. 1: 24-25)).

The relief sets the stage so that if one has basic knowledge of the story, one can understand and memorize its pattern and the causally-related connections between the three persons. If one inquires further into its form of expression, its *elocutio*, one may begin by noting that the relationship between narrativity and the illusionist description of reality with which Gombrich operates in Greek art is a complicated question. It is undoubtedly related to the fact that *mimesis* – also in the visual arts – was a far more differentiated concept than simply a question of imitating sensible reality. It was a concept that was linked just as much to the effect of the work on the observer. And whether a visual narrative seems convincing and lifelike, for example, depends to a large degree on the eyes of the beholder, including the alteration and stylization of the forms of perception they expect or view as expressive. In the visual arts, there is a wealth of gradation from forms that represent through immediate recognizability to forms that can only poorly or not at all be determined to be meaning-bearing units – and it is all a part of the idiom of the individual representation. The layers of meaning and power of expression arise through the mutual connection among the elements and are also determined by a number of paradigmatic relationships and overlapping styles or, if you will, 'linguistic systems'.

For us – and undoubtedly for the contemporary observer as well, the most moving feature of the Tamdrup plate's description of the event is the proximity of the heads at the embrace and, more than anything, the way in which Mary places her cheek against Elisabeth: a greeting that seems to carry her whole nature with it. Even in its partially abstract form, the embrace may very well have seemed a convincing, vivid reproduction of the character and feelings of Mary and Elisabeth upon their meeting. Nor is there any problem in understanding the narrative on several levels – that is, to read two phases into the depiction: Mary expresses the delight at the meeting upon her arrival and the more frontally-directed Elisabeth the effect of the arrival of the blessed Virgin.

Mimesis as an effect-filled imitation develops in the description of the character and mental state of the persons, focuses on the expression of the characters and their relationship at the meeting, and can, as in Greek tragedy, be said to be concerned with expressing the direct action gathered into a moment; while the narrative in its broader context emerges more indirectly, which could be called the *diegesis* of the image. The faces possess the highest degree of reality. And even though the three physiognomies may be designated as typified and standardized, they may also have seemed especially vivid to the contemporary observer – i.e., they lived up to the experience and conception of specific blessed states, of euphoria, anticipation and delight, of stages on the way to a total identification with the inner image of God, i.e., toward the non-individual and universal, toward undifferentiated being.

The effect of the idiom also arises from its rhetorical character, from its adorned expression. In the Tamdrup relief, for example, it is striking that both women in their union bear head coverings, hanging down in a large, heavy fold. It signifies an abundance of cloth, which in its rounded downward-streaming form may be meant as a metaphor for the outpouring of the Holy Spirit, for conception and pregnancy. It is through the ear that the words of blessing penetrate. Via the head, mercy streams into the body and is deposited as a special fullness, as a salvation-bringing fruit. This happened to Mary at the 'Annunciation', both physically and spiritually and, with Mary's embrace and greeting, the miracle of her fertility is now brought about for Elisabeth.

Whereas symmetry arises from the proximity of their heads, the difference in their costumes may emphasize the transformation, the transmission of the blessing from one woman to the other. A tight hatching advances toward Mary's long, drooping wristband, whose form and pattern in larger format and increased beauty adorn the costume of her relative – like a magnificent staff, girded with a band studded with precious stones in front of her lap. The simple indications of folds in Mary's costume contrast with a living, moving flow in Elisabeth's cloak. And what begins as a thin dry form on one side of the relief through the accentuation of Zachariah's right leg ends on the other side of the composition as 'fireworks' in the form of slender, round 'towers'. Zachariah contains a transformation in himself. The 'dry staff' becomes green and flowers, his upper body and head open up into vivid and ornate forms.

What is just as interesting about the whole of this 'staging' is that the narrative across the relief is carried by many different kinds of signs – from mimetic to stylized to abstract-metaphorical. And these signs are part of a richly varied and moving modelling of the surface, where the forms unceasingly seem to breathe life into meaning. But what is to be understood as meaning-bearing components and what they narrate clearly becomes a question of interpretation.

On the Ølst frontal (Fig. 9), we find a completely different idiom and iconography, i.e., a completely different way of telling the story. Here, Mary and Elisabeth stand side by side, frontally-oriented, with an arm around each other's shoulder, united in embrace; but the attention of both is directed outward, apparently toward the space of the observer. Even though the woman to the right has the greater weight and is equipped with a facetted halo of the same type as in Mary's 'Annunciation' scene,[39] her dress clearly shows that it is Elisabeth. The woman to the left is depicted as having just arrived in that her left foot is placed above Elisabeth's right foot. Mary lifts her right hand in a gesture of speech, while Elisabeth holds her left hand in front of her breast with the palm outward, a gesture that indicates that something wonderful is happening, that

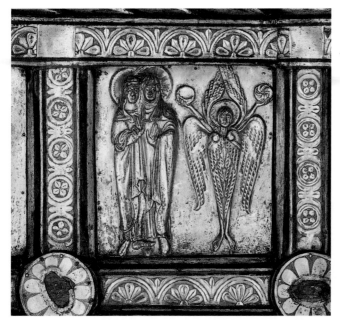

Fig. 9. The 'Visitation'. Golden frontal from Ølst Church, detail. Copenhagen, National Museum. Photo: John Lee, National Museum, Copenhagen.

something divine is being revealed. In this dual gesticulation, we see an expression of Mary's greeting and the Holy Spirit that has filled Elisabeth.

Beyond this, the scene contains no narrative traits. On the other hand, beside the two women is a six-winged seraph, displaying with upraised arms a moon and a sun. This must be considered as a unique feature of the 'Visitation' and probably finds its explanation on a metaphorical plane. In Isaiah's vision at his calling, the seraphim surround the throne of the Lord, praising Him in his magnificence (cf. Is. 6:1-3).[40] Since the sun and the moon are generally signs of the Lord's omnipotence, it is obviously possible to understand the representation as a depiction of the *Magnificat* of the Almighty Lord that Mary utters in conclusion. More specifically, Mary speaks of her own blessed condition and that "he that is mighty hath done to me great things" (Lk. 1: 49). The exaltation of the Lord hearkens back to Hannah's exaltation during the old covenant ("And Hannah prayed, and said, My heart rejoiceth in the Lord, mine horn is exalted in the Lord: my mouth is enlarged over mine enemies; because I rejoice in thy salvation. Etc." (1 Sam. 2: 1ff.)) and to one of Isaiah's hymns, in which it is said: "I will greatly rejoice in the Lord, my soul shall be joyful in my God; for he hath clothed me with the garments of salvation, he has covered me with the robe of righteousness, as a bridegroom decketh *himself* with ornaments (Quasi sponsum decoratum corona), and as a bride adorneth *herself* with her jewels" (61: 10).

Fig. 10. The 'Visitation'. Golden frontal at Stadil Church, detail. Photo: author.

In relation to the 'Visitation', the justice that sprouts is John the Baptist and Christ. If we understand the moon and sun as signs of the Precursor and the true Savior, the exultant seraph with his uplifted heavenly bodies exposes to the eyes of all how justice and praise spring up from the meeting of Mary and Elisabeth. While, with respect to the rhetorical embellishment in the Tamdrup relief, one can speak of an *ornatus facilis*, of a special rhetorical 'coloring', then one can speak in the Ølst relief of an adornment that is more difficult to read, of a complex metaphor or an allegory, of an *ornatus difficilis*.[41]

In the Stadil as well as the Odder frontal, the encounter between Mary and Elisabeth seems to express a sympathy between the two women, but it is depicted in very different ways. In both, the episode is purged of any other narrative feature except the two actors and, in both, the women embrace each other with outstretched arms. In one, however, the scene is entirely oriented toward the observer or, rather, toward something outside the two women; while, in the other, the scene is self-enclosed. In the Stadil relief (Fig. 10), Elisabeth and Mary stand beside each other, both almost *en face* with toes pointing forward, while their partially turned bodies merge into one large body through the way their cloaks fuse together in the wave-like motion of the folds. Whereas their dress communicates submission at the meeting, the dual frontality most likely expresses the two hymns, Elisabeth's praise of the mother of God and Mary's *Magnificat*.

Fig. 11. The 'Visitation'. Golden frontal from Odder Church, detail. Copenhagen, National Museum. Photo: John Lee, National Museum, Copenhagen.

The symmetry in the representation has suspended the meaning of the narrative direction, for Mary does not come from the 'Annunciation' relief but stands to the right with her flowing, wavy hair partially visible beneath her head-dress, while the headgear of the woman on the left indicates that she is the ma-tron Elisabeth. Upon closer inspection, one also sees that Mary is allotted the greatest frontal breadth and that the downward folds of her cloak spread like rings in the water toward her relative, whom she is visiting. The granulated lin-ing in her cloak appears at the bottom in a triangular section. Behind Elisabeth and Mary, small ornamental plaques are to be seen as a decoration against the empty golden background.

There is also a high degree of symmetry in the Odder relief (Fig. 11) but no frontality. The two women's leaning posture upon their meeting probably indicates a hasty movement that has now achieved its goal – in Luke, it is men-tioned that she went to Elisabeth's town "cum festinatione". Elisabeth comes to meet her by rising onto her toes – perhaps, she has just stood up. The two women look intensely at one other, as they hasten toward each other with outstretched arms. Mary stands to the left and, with her uncovered hair, seems almost like a repetition of Gabriel in the 'Annunciation', while Elisabeth on the right wears a head covering – like Mary in this episode.

The drapery is no longer typified by the Italo-Byzantine idioms of the Romanesque period but now stresses the movement of the bodies through the streaming rhythm of the folds. A new naturalism that accompanies the coming of the Gothic style is apparent. It may be said that the idiom to a higher degree derives from a 'first mode of seeing', but this is far from saying that it is bound by this mode.[42] It seems evident that the whole pattern of expressive movement is highly staged. In this context, it may be remarked that Elisabeth's cloak opens in a large rounded form toward Mary through a draped fold over her arm. Naturalism or a metaphorical expression?

It may be further asked whether the fixed gaze is only the expression of a new interest in psychological description. The phenomenon is part of the new naturalism and, at the time, could be seen in a 'Visitation' group in Chartres Cathedral, for example.[43] But how was this new conscious look understood? What knowledge did it contain? And what role might it play in relation to the narrative? In the Odder frontal, it communicates the immediate intensity of the meeting, but expresses for us neither Elisabeth's praise of God nor Mary's subsequent *Magnificat* with any certainty. Only if one sees in this "facie ad faciem" view a *visio facialis*,[44] a parallel with the final view of the truth in the meeting of the bride and bridegroom (cf. 1 Cor. 13:12), does the event enter into a sphere in which praise of God may arise. In *De visione Dei* at the end of the Middle Ages, Nicholas Cusanus formulates the idea in this way: "In allen Gesichtern erscheint das Gesicht aller Gesichte verschleiert und wie im Rätsel – enthüllt aber kann es nicht gesehen werden, solange nicht, über alle Gesichter hinaus, eingegangen wird in jenes geheime und dunkle Schweigen, in dem nichts mehr übrigbleibt von dem Wissen und dem Begriff des Gesichts."[45] It is peculiar to Mary and Elisabeth that they both are made fertile in a wondrous way and both bear a blessed fruit from their wombs. In this light, one understands that the mirror of the soul into which they peer can put them into a form of rapture. From such a perspective, the conscious look and its view of the state of the soul take on an active role in the story.

Narration and main structures

Every representation sets up its own problems and offers a number of different choices. If the staging of the same episode turns out so differently, it depends to a high degree on a number of external relationships with different general frameworks – for example, the sequence of scenes in which the motif takes a part or even the program for the whole frontal of which it is to act as a part. Some features about the rhythm, emphases and connections in the individual frontals may illuminate this.

Fig. 12. Golden altar from Broddetorp Church. Stockholm, Museum of National Antiquities. Photo: Gérard Franceschi, Silkeborg Museum of Art.

As previously mentioned, the story of the Magi and, particularly, the presentation of their gifts takes a prominent place in the frontals. The story is certainly important because of its position in the liturgical drama and because of its parallel to the adoration and exchange of gifts in the Eucharist. In the Broddetorp frontal (Fig. 12), on the vertical frame behind the 'Adoration of the Magi', can be read: "The Caldeans present mystic gifts to the highest king."[46] This episode alone takes up two panels in the story of the Childhood and matches a corresponding focus in the Passion in which the 'Crucifixion' is followed closely by the 'Descent from the Cross'.

Fig. 13. The 'Arrest of Christ'/'Christ Led to Judgement'. Golden frontal from Broddetorp Church, detail. Stockholm, Museum of National Antiquities. Photo: Gérard Franceschi, Silkeborg Museum of Art.

The six reliefs containing Jesus' childhood on the left of the frontal concludes with the 'Flight into Egypt'; while the Passion on the right of the frontal is introduced by the 'Kiss of Judas'. One of the more unusual features of the story is that Judas' embrace of Christ takes place in or in front of a large city gate. This can be seen as an attempt to link the two series together – in an extension of the Holy Family in flight – by a reference to the 'Entry into Jerusalem'. In this way, the reversal, *peripeteia*, in the narrative is adopted in both transitional episodes from Childhood to Passion: the flight, which was caused by the martyrdom of the innocent children, ended in the triumphant arrival at Sotinen; while Christ's

triumphal entrance into Jerusalem also became an ingress to treason and mar-
tyrdom.

It may be asked whether the purpose of this hinging and correspondence
hearkens back to the unusual coupling of the 'Massacre of the Innocents' with
Herod's banquet in the legend of Stephen the stable boy. The mealtime scene
with the roasted cock that miraculously rises up and crows that Christ is born
then becomes a figure to recall or replace the missing 'Last Supper' scene.

Just after the 'Kiss of Judas', Christ is seen surrounded by two executioners,
the foremost of whom pulls him by the hair and holds one wrist, while the one
in back pushes him forward (Fig. 13). This probably depicts the captured Christ
on his way to his first interrogation.[47] However, even though Christ is not led
away, bound, as in the Sahl frontal, the scene may also illustrate the road to Gol-
gotha.[48] More broadly, the representation may be said to encompass the entire
movement from betrayal to sacrificial death, to show the pilgrimage from one
station to another in the martyrdom. A miniature with twelve smaller scenes
in the Gospel Book of St. Augustine from around 600 illustrates this very well:
after Judas' betrayal, Christ is depicted being seized by two executioners, who
lead him away. In the next scene, he is about to leave the interrogation of Caia-
phas and, in the 'Mocking' Christ once again stands between two executioners.
Then he is led away from the judgment by Pilate, and the two final episodes
show Jesus on the way toward his place of execution – in the last scene, together
with Simon of Cyrene, who helps to bear the Cross.[49] The indeterminate ico-
nography of the Broddetorp frontal may thus be understood as a contraction
of a long sequence by focusing on a repetitive element – and thereby as richly
charged with narrative meaning.

On the Odder frontal (Fig. 3), where two of the plates are missing today,
a study of the nail holes has shown that two reliefs with the 'Adoration of the
Magi' in the middle zone were originally coupled together on the left of the
Majestas Domini. At the same time, the episode with the 'Journey of the Magi'
has apparently always been placed where it is today – at the end of the upper-
most series of scenes (Fig. 14). This means that the first two panels in the second
zone could probably only have shown the 'Magi Before Herod'. In that case, the
entire frieze around the original crowned king of Heaven was dedicated to the
story of the Three Wise Men.

Since, in all probability, the relief with Herod, who ordered the Massacre of
the Innocents in the bottom frieze, was originally placed together with the de-
scription of the massacre, this means that, on the left of the frontal, there were
two representations of Herod enthroned, one on top of the other; while, on the
right of the frontal, there was a dual description of the Epiphany with the faith-
ful Virgin with Child right above Jesus in the Jordan River. As we have already

Fig. 14. Golden frontal from Odder Church, reconstructed condition. Copenhagen, National Museum. Photo: John Lee. National Museum, & photomontage © Svend Erik Andersen.

seen in the 'Visitation', the Odder frontal makes use of a simple idiom to communicate deeper connections and meanings.

In the Sindbjerg frontal (Fig. 1), the story in the uppermost series is concluded, according to the inscriptions in the individual panels, with a leap from the 'Magi Before Herod' to the 'Flight into Egypt'. The 'Adoration of the Magi' is sorely missed – to which there is also a reference by inscription in the main framework.[50] The episode may, in fact, have been described in the first undetermined field in the next zone.[51] Such a sequence could be based on the liturgy, as the story of the 'Flight' was a part of the readings on the feast day for the death of the innocents on January 1, while the feast day for the Adoration of the Magi followed on January 6.[52]

In this case, the four large panels around the *Majestas Domini* depicted the 'Adoration of the Magi' and the 'Presentation in the Temple' on one side and the 'Wedding at Cana' and the 'Baptism of Jesus' on the other. By placing the

wedding scene before the 'Baptism' and – as assumed here – the adoration scene after the 'Flight', the programmer moves from a syntagmatic- to a more paradigmatic-oriented narrativity, where the four panels deal with bringing gifts and offerings, with water and wine, with transformation and epiphany – i.e., we have a middle zone, where the sacramental mysteries come to the fore on either side of the vision of the Lord in his magnificence.

In the Sahl altar, the six panels with the story of the Childhood on the right of the frontal conclude with the 'Adoration of the Magi' depicted in two panels, here situated after the 'Presentation in the Temple' (Fig. 15). In one of these panels, just to the left of the Lord in His Majesty, Mary is enthroned with the child Jesus, flanked by two haloed women. It is uncertain who these women are, since they are without attributes – one simply expressing piety and admiration, the other merely divine revelation.[53] They endow the representation of Mary, who is holding a piece of round fruit(?) lifted in her right hand, with a statuary quality, giving her through their framing autonomy in relation to the narrative.

As a counterpart to the panel, just to the right of the Christ in Majesty, is an allegorical scene – Moses leading away the Synagogue (Fig. 16). With Christ's incarnation, the old law is set aside and Mary comes forward as contrast to Eve. As opposed to the Synagogue, she personifies the Church. At the same time, the scene with the Synagogue is a part of the Passion/Resurrection cycle in the uppermost six panels to the left of the frontal. It follows, logically enough, the Crucifixion, which depicts the ultimate redemption of mankind.

The Passion is introduced compositionally with the 'Flight into Egypt', an 'out of place' conclusion to the story of the Childhood, which is used as a kind of hinge between the frontal's two main narratives. By its placement, Mary riding with the Child recalls the 'Entry into Jerusalem' – and it may be noticed that the Jesus child lifts his right hand in blessing, as Christ often does on his triumphal entrance. At the same time, the subsequent scene with Christ being led to Golgotha (Fig. 16) seems to underscore the child Jesus in flight from the evil Herod as a tale of his future, unjust persecution, since Christ does not walk in the same direction as the two executioners but steps back toward the holy family in flight.[54]

Some formal parallels bind the above-mentioned group of scenes together in a meaningful structure: the gesture of the captured Christ is repeated with variations in the Synagogue and in Christ at the Gates of Hell. Moses, who is leading the Synagogue away, is brought not only into an interplay with Joseph above, who leads Mary and Child towards Egypt,[55] but also with Christ, who is led to the place of execution and, perhaps especially, with Christ, who leads the righteous out of the Kingdom of Death up to Paradise. Just as the Synagogue has lost its crown and tramples its own banner under foot, Christ conquers and

chains the Prince of the World upon his descent to the Kingdom of Death.[56] Between these two panels, a panel depicting the three women who are informed at the Sepulcher of the final institution of the new law forms a sort of middle axis. And at the same time, the women point toward their counterparts on the left part of the frontal – the panel with the three Magi who behold and worship the new law that has now appeared. Yet another hinge is established between these two series.

The present sequence of the reliefs in the Ølst frontal (Fig. 17) is due to an attempt to bring order to a long disturbed composition during a restoration in the latter half of the 1930s by metalworker and sculptor William Larsen.[57] The reconstruction, naturally enough, has the narrative proceed chronologically from left to right in all three zones. This means that, today, we see the introduction to the Passion – i.e., the 'Entry into Jerusalem' – concluding the two uppermost rows with reliefs of the story of the Childhood. The scene immediately follows the 'Massacre of the Innocents' and may also stand for the 'Flight into Egypt', which is missing – that is, a 'reverse' coupling of the Christological series in relation to the Sahl frontal.

It might have been to serve as a sort of substitute for the flight scene that the 'Entry' only depicts Christ riding a donkey. However this 'abridged' iconography may also be a reference to the liturgical drama – i.e., the "Palm Sunday Donkey" used in the Palm Sunday processions.[58] Finally, the scene with Christ, who seems to ride out into empty space, may also serve as a commemoration of the transition in the mass from the preface to the canon, since the second and last part of the "Sanctus" – concluding the preface – is taken from the praise of Christ on Palm Sunday: "Blessed is he who is coming in the name of the Lord. Hosanna in the highest heavens" (Matt. 21: 9, et al.).

Narratively, at any rate, it is a striking placement, a sort of breach with continuity. But the only possibility for placing the relief in the lower zone is, for example, to read the meal scene, where Christ is flanked by two haloed persons, not as the Last Supper but as an earlier event – for example, the 'Wedding at Cana'. However, this seems to be precluded; on the other hand, it could be the 'Supper at Emmaus' and should, thus, be placed in the penultimate field of the bottom row. Nevertheless, an alternative model for the placement of the mounted Christ can be imagined. It may be noted that in both the top and bottom rows, the direction of movement in the final episode – the 'Adoration of the Magi' and 'Doubting Thomas' – is from right to left. The direction of the gaze in the uppermost row might indicate that, in the next zone, one is to read the story from right to left – a principle that has been recognized in other narrative series in Christian art.[59] This means that, at the very least, one must switch the reliefs the 'Shepherds in the Field' and the 'Entry'. In that case, the mounted Christ

Fig. 15 Golden frontal at Sahl Church, left side. Photo: Gérard Franceschi, Silkeborg Museum of Art.

Fig. 16 Golden frontal at Sahl Church, right side. Photo: Gérard Franceschi, Silkeborg Museum of Art.

Fig. 17. Golden frontal from Ølst Church. Copenhagen, National Museum. Photo: Gérard Franceschi, Silkeborg Museum of Art.

will once again turn the direction of movement at the end of the middle zone and, in this way, call for a left-to-right reading of the lowest zone.

It might also be asked whether the two plates with the 'Massacre of the Innocents' originally flanked the frontal's central image, the Majestas Domini, or whether the episode should be placed together on one side of the frontal – which is to say, on the right – beneath the two reliefs with the 'Adoration of the Magi' (cf. Fig. 2). Of course, this means that the 'Shepherds in the Field' must really be taken out of chronological sequence. Instead of following the 'Adoration of the Magi'[60] as it does now, the scene would come after the 'Massacre of the Innocents', and the justification of its placement must then be sought in a paradigmatic relationship – and this seems possible, as well.

The narrative in the pastoral scene (Fig. 18) is 'abridged' in that there is no announcing angel to be seen and has a mystical-allegorical dimension added in that the two shepherds stand around a symmetrically-formed tree with a crown of seven heart-shaped leaves. Two goats have climbed into this tree and

Fig. 18. The 'Annunciation to the Shepherds'. Golden frontal from Ølst Church, detail. Copenhagen, National Museum. Photo: John Lee, National Museum, Copenhagen.

are dancing on their hind legs around the trunk. "Ascendam in palmam" as it is put metaphorically in Song of Solomon (7: 8) about Christ, who voluntarily climbs the cross and everything about the tree between the shepherds seems to be fashioned to point toward the cross as the 'tree of life', a reference that would stand out even more clearly, if the scene were placed above the 'Crucifixion' – the possibility discussed here.

One shepherd points upward, toward the star of Bethlehem one might think, but there are three equally large stars in the sky, and this gesture may instead be directed toward the 'Annunciation' and the 'Visitation'. In the *Magnificat*, the soul of Mary praises the Almighty Lord and, as previously mentioned, this praise refers to Isaiah 61: 10-11, where it says: "I will greatly rejoice in the Lord …For as the earth bringeth forth her bud, and as the garden causeth the things that are sown in it to spring forth; so the Lord God will cause righteousness and praise to spring forth before all the nations." Do these metaphors garb the pastoral scene in the Ølst frontal in its particular grandiloquent form? If so, this also speaks for the episode having originally formed a 'bridge' between the 'Visitation' and the 'Crucifixion'.[61]

Image and *historia* – Eternity, time and narration

These various examinations in the overall structures of the frontals have indicated different things concerning the structure of the narratives in time and space. A syntagmatic or chronological linking of the episodes sometimes yields to other considerations; paradigmatic relationships emerge and determine the choice and placement of the motif. In relation to a literary epic, the pictorial narrative gains its uniqueness, for instance, in its use of spatial relationships, both with respect to the *dispositio* in various episodes and the relationships underscored between them, based upon analogous elements and placements.

In general, it may be said that Christian narrative in the Middle Ages developed in relation to three different views of time. Behind all Christian narrativity is the fundamental story of Salvation, which stretches from the Creation to Judgment Day. In ecclesiastical-religious art, it constituted the total set of objects and actions in the world that could be imitated in a narrative medium.[62] Every part of this story contained, in principle, the entire sequence from beginning to end in that it acquired its real meaning from the totality. In contrast to this total continuum was the momentary annulment of time and space by the intervention of eternity into the created world, an annulment that continually took place during the Mass, when Christ was incarnated in the bread and wine, when the deity once again became present in flesh and blood, when the chancel opened up to heaven and heaven opened up to the chancel – as Pope Gregor writes,[63] and the Church triumphant united with the Church militant. It can be called a point without extension as opposed to a linear, irreversible sequence.[64] Between the line and the point was the cyclical dimension in the form of the liturgy's annually recurring remembrance of Christ's work of redemption. However, it is important to stress that the Christian understanding of history is clearly separate from the cyclical theories of antiquity in that the cyclical sequence 'rolled' along the time line from a beginning to an end. The work of redemption was a decisive turning point in history, invoked again and again in the pilgrimage of God's people on their way to the promised land, toward eternal salvation.[65]

The groups of subjects in the golden frontals and their function as altar decorations makes it immediately relevant to see their narrativity as being determined by the point as well as the cyclical dimension. The former appears with great force in the central motif, *Majestas Domini*. As a visionary motif, it illustrates the appearance and intervention of the divine into the world. With the transformation of the bread and the wine, this appearance in the interior of the church becomes quite concrete, and there arises a meaningful interplay between the Majestas figure and the sacrament. The figure of Christ enthroned in heaven and the medallions with the dove of the Holy Spirit and the *Agnus Dei*, which on most frontals are placed in an axis above and below

that figure, may be linked to prayers in the canon of the Mass[66] (cf. Figs. 14 & 21).

On the frontals in the Sahl and Stadil Churches, a row of angel medallions, wreathed by inscriptions, emphasize the exchange between heaven and earth during the mass (Figs. 15 & 16).[67] The angels in the medallions on the upper, horizontal frame speak of how they accompany the divine in its manifestations and, like it, are present everywhere;[68] while, in the two medallions in the center on the vertical frame, the stress is on the angels' function as messengers between the two spheres in the Eucharist.[69] Finally, the angels in the two medallions on the lower, horizontal frame announce that they support those who are struggling and crown the victorious.[70] The intervention of eternity into time through the mystery of the sacrament, then, is connected to the hardships of those struggling in a world of sin and, correspondingly it is through the communion that the faithful continue to partake of Christ's body and become a part of the Church militant.

In the Ølst frontal (Fig. 17), the purifying effect of the sacrament of the Last Supper is connected with Christ's conquest of death and subsequent elevation: "Forcing His way through the gates of Hell, He travels to the stars …/ From sin and burdens the people are sheltered by the sacrificial bowl, when they offer tears and prayers with a pure heart. By prayers, the bands are loosed and guilt dies away. Always carry with you a prayer to the Holy Apostles."[71] There is no row of apostles on the frontal, but there may have been an accompanying retable, in which such an assembly flanked, for example, a Christ as Judge. What is important is that the Apostles are most likely to be understood as representatives for "the earth-born brothers."[72]

Just below the Christ in Majesty, the background for the redeeming effect of the sacrament is recalled through two reliefs with the 'Descent into Hell'. A descending movement into Hell is followed by a rising movement towards blessedness. The movement is continued in the panel to the right above the four-lobed aureole with the angel soothing Joseph's doubt about Mary's pregnancy by pointing toward the Nativity scene, of which Joseph is also a part. With his palm extended outward, Joseph indicates that something wonderful has taken place, that the divine is manifest. The bed-ridden Mary's left hand is directed in a gesture of speech and blessing toward the swaddled Child in a noble, altar table-like crib (Fig. 19). However, just as interesting is how she stresses her ear with her right hand, probably to emphasize her conception through the annunciation of the angel, through the Word. With a few well-chosen gestures, the narrative of Joseph's doubt is communicated and the reality of the virgin birth and the divinity of Jesus are accentuated.

Read thus, the circle around the Majestas figure concludes in the Incarnation relief,[73] which breaks the pattern of movement already mentioned and, on

*Fig. 19. The 'Nativity'.
Golden frontal from
Ølst Church, detail.
Copenhagen, National
Museum. Photo: Gérard
Franceschi, Silkeborg
Museum of Art.*

the whole, distinguishes itself from all the other reliefs by its lack of movement
and monumentality, its tight structure of simple geometrical forms (cf. Fig. 17).
The relationship between figure and background is completely different from
the other scenes: through the density and ornamental uniqueness of the scene,
the actual presence of the sacramental body and its glorious and curative full-
ness seem to be expressed. The birth was the event *par excellence* in Christ's life,
which visualized the high point in the Eucharist – namely, the transubstantia-
tion, the miraculous transformation of the bread and the wine, the "repeated"
incarnation, the appearance and presence of the divine majesty on the altar.

The Christ enthroned in heaven itself forms the ending point in his eternally
celebrated redemption. He is himself evidence of the victory over death and the
glorification that is made possible through his incarnation and sacrificial death.
In the frontal from Broddetorp, the narrative direction in the last four episodes
of Christ's life are oriented toward the elevated Majesty, i.e., running from right
to left (Figs. 7 & 12). And the last panel with the 'Ascent into Heaven' hearkens
back to an earlier Christian iconography, where Christ walks out and is drawn

*Fig. 20. The 'Ascension'.
Golden frontal from
Broddetorp Church,
detail. Stockholm,
Museum of National
Antiquities. Photo:
Gérard Franceschi,
Silkeborg Museum of
Art.*

up by God's hand to heaven (Fig. 20).[74] He himself takes up the entire field – gone are the disciples and the two men in white gowns (cf. Acts 1: 9-11). There is hardly any movement upward, but a strong movement forward toward the mandorla, a heaven that is descending and a ground that is rising. A powerful and moving use of the visual surface expresses the fulfillment of redemption – heaven and earth are bound together.

In this sequence, Christ is coming directly from the grave, where an angel tells the women that the Savior has risen. An inscription on the vertical frame relates that the women's "hearts enlightened by God foretell that a king, born of a virgin, will shatter the law of death."[75] The conception of the virgin introduces the story of redemption in the frontal – on the main frame around the 'Annunciation' uppermost to the left may be read: +ANGELVS DOMINI NUNCIA-VIT MARIE.[76] With God's only begotten Son on the way to heaven, the circle is closed and the relief, as the frontal's most eye-catching, seems inspired by the promising message.

On the remaining part of the upper frame, it is proclaimed that the "holy

order of apostolic elders is present."[77] On the frontal's lowest zone, a sitting group of apostles forms a sort of fundament for the narrative.[78] The time-bound account of Christ's work of redemption ends in eternal glory. However, just as the historically-anchored sequence is memorialized year after year in the liturgy, the heavenly court appears incessantly in the ecclesiastical space, the Church triumphant is connected with the Church militant in time, particularly through the mystery of the sacrament.[79]

The inscription on the Sahl altar's framework proclaims that the apostolic assembly, which is redeemed from death through death, rules along with the monarch of Heaven, who administers justice by desert.[80] And, as on the Broddetorp frontal, a sitting group of Apostles is seen below the Christological series that ends with the Savior, who has conquered the Devil and broken down the gates of Hell – a redemption predicted through sacrificial death on the cross in the relief above (cf. Figs. 15 & 16). In a further extension of the iconographic and compositional features discussed above, it is possible to consider the whole Christological series in this frontal as a narrative of the two cities, i.e., of those who, like the three Magi, seek and worship the divine and those who, like the Synagogue, turn away from the Lord and are damned and lost. To the left on the frontal, the Church and its redeeming sacraments are established and accentuated – the Word is incarnated just above the monumentally enthroned Mary-*Ecclesia* figure. On the right, the earthly pilgrimage toward salvation is depicted as a *via dolorosa* with persecution and martyrdom, as it was for the Apostles. Elevated in heaven and beyond time, the glorified Christ represents the truth, which distinguishes between right and wrong and grants eternal life. He is the true royal road to eternity.

On the Sahl frontal, the Majestas figure forms the center of a sort of cross: with adoring angels above and below and an "allegorical" panel on each side, re-ferring to *Ecclesia* and *Synagoga*, the elevated Christ reaches out in the narrative of historic salvation, distinguishing between the god-fearing and the godless. (Fig. 21). The large *alpha* and *omega* around him indicate that his hegemony stretches from beginning to end. He is the center of the narrative of universal history and permeates everything in it. As the inscription on the mandorla states, he is "the triune God who discerns every single part and governs everything, who vivifies, sustains and nourishes everyone who is alive. Encompassing the remot-est things and penetrating the inmost things, being beneath everything, above everything and the motive force of everything He is unshakable Himself."[81]

The *Majestas Domini* motif can be said to gather all three views of the course of time and space together. The Christ enthroned is the eternal center of the cyc-lic narrative of the liturgical year, which as the basic story and core of worship surrounds the people of God on their pilgrimage through the world of sin. He

Fig. 21. Golden frontal at Sahl Church, central part. Photo: Gérard Franceschi, Silkeborg Museum of Art.

is the eternally-present judge, "the way, the truth and the life" (cf. John 14: 6) in the universal history of salvation. The whole character or mode of the narrative is determined here, as elsewhere in Christian art, by the central motif. The King of Kings clearly plays the dominant role in the entire composition and may be said to envelope it in that the figures in the medallions on the main frame of the frontal relate to him.

Conclusion

Finally, the character of the narrativity must be seen in the entirety of its context, particularly in the general development of style that influences the idiom used on the individual frontal. In time, the golden altars span approximately a century – from the second quarter of the 1100s to approximately 1225. That is, they span the high to late Romanesque periods in Scandinavia, which is also the period for the first reflections of or parallels to early Gothic or proto-Gothic, which is developing along similar lines in France, including the 'style of the year 1200'. Stylistically, it is the question of a very complicated interplay between Romanesque and early Gothic art and, in many ways, an as yet unclarified periodization.[82]

The frontals are far from being pearls on a string. They do not depict any clear line of development but represent different attempts at communicating sacred history within the horizon of possible idioms in a certain period. Basically, we can observe that a more naturalistic manner of representation emerged in the late altars, especially the Stadil and Odder frontals. In an interesting and problematic article on 'the simple perception of matter', Madeline H. Caviness has discussed the relationships between naturalistic styles of narrative and 'the first and lowest corporeal mode of seeing', as defined by Richard of St. Victor.[83] Aristotelian-inspired thinkers, particularly in the 13th century, write about this 'first mode of seeing' in the belief that higher truths may be reached through visual perception. At the same time, however, Caviness concludes with respect to the culmination of this form of depiction in the frescoes of the Arena Chapel: "The more concrete the rendering of human experience, the less evident were the spiritual truths of sacred history. Yet even Giotto balanced the 'simple perception of matter' in these narrative scenes between the allegories of virtues and vices, and the vision of the Last Judgement, which, respectively, constitute the second and the third mode of seeing."[84]

Caviness may be correct that a realistic idiom may, at first blush, be problematic for communicating the Christian message, as we have touched on in connection with the 'Visitation' in the Odder frontal. However, it is a complicated problem that is, to a high degree, connected to contemporary reception, to the horizon

of understanding or mentality of the eyes that see – to the framing, as Caviness indicates. In addition, there are a number of different possibilities – also for a naturalistic idiom – for indicating deeper layers of meaning than the literal, particularly by linking individual episodes into a compositional whole, as we noted in the Odder frontal.

From my point of view, it is important to maintain the perspective of Max Dvorak's classic article on the Gothic[85] – that is, to understand and go deeper into the transformation the idiom went through in the West since late Antiquity to allow for a communication not only of the literal but also the spiritual meanings in Christian stories, on one hand, and, on the other, to understand that Gothic naturalism emerges upon a completely new foundation and combines in many different ways with idealistic features. Therefore, it can also be stated that naturalism based on Antiquity was only an element of shorter duration in the transformation. It ultimately proved to be an insufficient means of expression for a new orientation toward reality. A completely new idiom or, rather, a wide new range of expressive means that were no longer based – in one way or the other – on the art of Hellenism or late Antiquity – as transmitted primarily by Byzantium, were created in the visual arts and, in that sense, the use of the concept of the Gothic is appropriate, since the break with tradition is just as fundamental as in the architecture.

In the Danish frontals, we do not find a true appearance of the Gothic, only stages in the transformation, which would prove to result in the new idiom. If, for example, the Tamdrup plates are compared to the reliefs on the Odder frontal, it is clearly a question of separate phases in the transformation from Romanesque to Gothic and, on the basis of the quite variegated physiognomies, it is also evident that the narratives are based on different anthropologies. At the same time, the dramatic nerve that characterizes the *historiae* in the Tamdrup plates could well be imagined as being transplanted to the time of the Odder frontal as another key in which to narrate than on this frontal or the Ølst frontal. Within the various stages of the development of the style, one must operate with different narrative modes or rhetorics – which, as Caviness once again has indicated, may be related to different "modes of seeing."

The scope of the modes or rhetorics depicted on the Danish frontals ranges from the Tamdrup plates at one end to the Ølst frontal on the other. One is full of life and dramatic staging. The other uses a distinct, polished narrative method. The pulse of the narrative is fast in the Tamdrup plates, the account of the individual episode comes alive, seems independent of any overall system or structure based on referential statements between the different scenes.

This differs from the Ølst frontal, where everything is told through a few, clearly distinguished figures and objects, often with an abbreviated iconogra-

phy, which helps direct the focus on individual elements. We have mentioned that there are no announcing angels in the 'Shepherds in the Field' and that the 'Entry into Jerusalem' is reduced to Christ riding on the donkey. In the scene of Christ's sepulcher, we do not see the women with their ointments but only some soldiers and an angel, who is swinging a censer above the grave, labeled with a conspicuous inscription: SEPVLCRVM. Furthermore, the 'Crucifixion' shows only Mary and John around the suffering Christ and he is on a larger scale than they, hanging on a cross with end plates, i.e., an imitation of a processional cross or a crucifix.[86] One may speak of a sort of ritual modus in which a spiritual mode of seeing has pared the narrative down to an accentuation of the meaningful elements, which have undoubtedly been linked together in a number of relationships that can no longer be determined with any certainty.

In conclusion, it may be said that narrativity in our golden altars unfolds with diversity and complexity within a reasonably uniform framework, formed by the overall structure of the frontals, by their common central motif and groups of subjects and altogether by the relationship between *imago* and *historiae*. It is undoubtedly important for the staging of the stories on the altars that the total representation could be read from a single position, that the observer could easily compare the motifs in every direction in his or her perception of the frontal. Thus, artist and programmer had a wealth of opportunity for creating connections and references among the scenes and, in this way, extrapolate layers of meanings. At the same time, the central motif, through its position and proximity to the narrative panels, could very concretely exercise its effect on the whole structure and, thus, make visible the light in which the story should be read.

Just as important for the reception was the gilding on the reliefs. This provided the frontals with a special status, placing them in a group of especially valuable and elaborate objects and lifting their *elocutio* up to a level of high style. Together with rock crystals and an ornamental framework, the gilding endowed the frontal with an elaborateness that was to emphasize the special momentousness of the story.[87] As it appears in the inscription on the Stadil frontal, one should not be dazzled by this special rhetorical shading, by the glitter of gold. It was only an *ornatus* meant to open one's eyes to an even greater radiance, to the spiritual light that radiates from the divine mysteries of which the story speaks: QUAM CERNIS FULUO TABULAM SPLENDORE NITENTE(M) PLUS NITET YSTORIE COGNITIONE SACRE PANDIT ENIM CHR(IST)I MYSTE-RIA QVE SUP(ER) – AURVM IRRADIANT MVNDIS CORDE NITORE SVO ERGO FIDE MVNDES MENTE(M) SI CERNERE LVCIS GAUDIA DIUINE QUI LEGIS ISTA UELIS.[88]

Finally, it must be assumed that the placement of the frontal on the high altar

in the chancel creates an important framework for its reception. The narrative is placed at the heart of the liturgy and made a part of the sacramental act, where the highest is united with the lowest, as Gregor the Great put it, where heaven opens up and a host of angels is present in the chancel, where the visible is made one with the invisible.[89] Time and space are annulled, when the King of Glory steps forth at the altar: as a richly ornamented visionary image on the frontals and corporally and concretely in the Sacrament. Around the Christ in Majesty, his works of salvation may be seen on the frontals, the event that, above all else, constitutes the reversal, *peripeteia*, in the salvation story and which, in this way, links the beginning and the end together in the Majestas figure, enthroned in eternity. These frameworks might be said to provide the visual narratives in the gilded frontals a special modus – a modus that, as a golden luminosity, radiates from every part and, in a certain sense, eradicates all differences, takes history in time and space back to its point of radiance, to the One, to the progenitor of all motion and being.

Selected literature

Alter, Robert, *The Art of Biblical Narrative*. New York, 1981.

Auerbach, Erich, *Mimesis – Dargestellte Wirklichkeit in der abendländischen Literatur*. Bern, 1946.

Barthes, Roland, "Introduction to the Structural Analysis of Narratives," *New Literary History* 6/2 (1975): 237-72.

Bialostocki, Jan, "Ars auro gemmisque prior", *Mélanges de littérature comparée et de philologie offerts à M. Brahmer*, 55ff. Warschau, 1967 (reprint in idem, *The Message of Images*, 9-13 + notes ("Ars Auro Prior"). Wien, 1988.)

Caviness, Madeline H., "'The Simple Perception of Matter' and the Representation of Narrative, ca. 1180-1280," *Gesta* 30 (1991): 48-64.

Chatman, Seymour, "Towards A Theory of Narrative", *New Literary History* 6 (1975): 295-318.

Congar, Yves, *L'Ecclesiologie du haut moyen âge*. Paris, 1968.

Danbolt, Gunnar, "Bilde som tale – St. Olavs-antemensalet i Nidarosdomen," *Kunst og Kultur* 71 (1988): 138-58.

Danmarks Kirker, ed. Nationalmuseet. Copenhagen, 1936ff.

Deuchler, Florens, "Le sens de la lecture – A propos du boustrophedon," *Études d'art medieval offertes à Louis Grodecki*, 251-58. Paris, 1981.

Dvořák, Max, "Idealismus und Naturalismus in der gotischen Skulptur und Malerei," *Historische Zeitschrift* 119 (1918): 1-62 + 185-246 (reprint in idem, *Kunstgeschichte als Geistesgeschichte*. Munich, 1924.)

Gombrich, Ernst, "Reflections on the Greek Revolution," idem, *Art and Illusion – A Study in the Psychology of Pictorial Representation*, 116-45. London & New York, 1960.

Historisches Wörterbuch der Rhetorik, ed. Gert Ueding, Iff. Tübingen, 1992ff.

Jülich, Theo, "Gemmenkreuze – Die Farbigkeit ihres Edelsteinbesatzes bis zum 12. Jahrhundert", *Aachener Kunstblätter* 54/55 (1986/87): 98ff.

Kaspersen, Søren, "Stil som hermeneutisk begreb – Refleksioner over gotikken som stilfænomen," *Tegn, Symbol og Tolkning – Om forståelse og fortolkning af middelalderens bilder,* ed. Gunnar Danbolt et al., 99-134. Copenhagen, 2003.

McKeon, Richard, "Rhetoric in the Middle Ages," *Speculum* 17 (1942): 1-32.

Murphy, James J., *Rhetoric in the Middle Ages: A History of Rhetorical Theory from Saint Augustine to the Renaissance.* Berkeley, 1974.

Nørlund, Poul, *Gyldne Altre – Jysk Metalkunst fra Valdemarstiden.* Copenhagen, 1926 (English summary, 221-46) (reprint with an Appendix by Tage E. Christiansen. Århus, 1968.)

Pictorial Narrative in Antiquity and the Middle Ages, Studies in the History of Art, 16, ed. Herbert L. Kessler & Marianna Shreve Simpson. Washington, 1985.

Robert, Carl, *Bild und Lied – Archaeologische Beiträge zur Geschichte der Griechischen Heldensage,* Philologische Untersuchungen, 5. Berlin, 1881.

Schiller, Gertrud, *Ikongraphie der christlichen Kunst,* I-V, 7 vols. Gütersloh, 1966-91.

Stansbury-O'Donnel, Mark D., *Pictorial Narrative in Ancient Greek Art.* Cambridge, 1999.

Weitzmann, Kurt, *Illustrations in Roll and Codex – A Study of the Origin and Method of Text-Illustration,* Studies in Manuscript Illumination, 2. Princeton, 1947/1970².

Wienberg, Jes, "Gyldne altre, kirker og kritik," *hikuin* 22 (1995): 59-76

Notes

1 The standard work on these altars is Poul Nørlund, *Gyldne Altre – Jysk Metalkunst fra Valdemarstiden* (Copenhagen, 1926) – English summary, p. 221-46. Reprinted with an Appendix by Tage E. Christiansen (Århus, 1968)- English summary pp. 21*-31*. See also idem, "Les plus anciens retables danois," *Acta archaeologica* 1 (1930): 147-164. A short introduction to the material is given by Harald Langberg, *Gyldne billeder fra middelalderen* (Copenhagen, 1979). Poul Grinder-Hansen, *Nordens gyldne billeder fra ældre middelalder* (Copenhagen, 1999) provides another introduction, along with the publication of a marvelous collection of photographs of the Scandinavian material of golden copperplate works by the photographer Gérard Francheschi. Some of the material is treated by Peter Lasko, *Ars sacra 800-1200* (Pelican History of Art; Harmondsworth, 1972), 237-38. This article is part of a project aiming for a new corpus work on the Danish golden altars, a project supported financially by the medical firm Novo Nordic.

2 The altar is dendrochronologically dated. It has been treated most recently in *Danmarks Kirker,* ed. Nationalmuseet, *Århus Amt,* III (Copenhagen, 1976), 1400-12, ill.

3 The retable came in 1821 along with a later frontal from Odder Church to the national col-
lection from Tvenstrup Church, south of Odder. However, the retable may have come to
Svenstrup from Saksild Church. Cf., most recently, *Danmarks Kirker*, ed. Nationalmuseet,
Århus Amt, V (Copenhagen, 1983-87), 2536-51, especially 2538-45 and 2550.

4 The plates came to the museum in 1873, and there are too many to have only been on the front
side of the high altar. For the distribution of the plates on a frontal and a reliquary, cf. Tage E.
Christiansen, "De Gyldne Altre, I: Tamdruppladerne," *Aarbøger for nordisk Oldkyndighed og
Historie* (1968): 153-207. The plates have been treated most recently by Inger-Lise Kolstrup
in *Tamdrup – Kirke og gård*, ed. by Ole Schiørring (Horsens, 1991), especially 71-83, ill.,
and by Ebbe Nyborg in *Danmarks Kirker*, ed. Nationalmuseet, *Århus Amt*, IX, (Copenhagen
2002), 5111-35, ill. The dating of these plates is difficult. Some circumstances may speak for
the golden altar being contemporary with the church – that is, from the end of the 1000s or
beginning of the 1100s. R. Volf has also argued in several articles for a dating as early as around
1050, cf. most recently, "Tamdrup kirke og dens gyldne alter," *Vejle Amts Årbog* (1960): 18-
62 and "Jelling og Tamdrup," *Vejle Amts Årbog* (1970) 119-70. However, stylistically, it is very
difficult to fit the reliefs into these decades. If one dates the Saint-Gilles sculptures at around
1116, as Richard Hamann does, a date early in the 12th century also seems possible for the
Tamdrup plates – cf. R. Hamann, *Die Abteikirche von St. Gilles und ihre künstlerische Nachfolge*,
I-III (Berlin 1955-56) and *idem*, "Die Abteikirche von St. Gilles," *Forschungen und Fortschritte*
34 (1960): 177ff. Poul Nørlund dates the plates as late as the beginning of the 13th century,
even though he indicates that the French parallels are primarily prior to 1150 – cf., *op. cit.*,
155 ff. The later dating is based particularly on an evolutionary linking with the frontal from
Sindbjerg Church (cf. below), which he also dates quite late. Nørlund's dating is largely fol-
lowed by Inger-Lise Kolstrup, *op. cit.*, 72-73 and in *Danmarks Kirker*, *op. cit.*, 5131-32, but
a dating before or around 1150 seems most probable.

5 Probably still from the third quarter of the 1100s, even though Nørlund, *Gyldne Altre*, 155
ff., dates it at the last quarter/end of the 1100s.

6 Nørlund dates it around 1200 – cf., *op. cit.*, 139-40.

7 In 1645, the frontal was sold to a neighboring church in Tvenstrup and then went on to the
National Museum's collection together with the retable mentioned above, when this church
was torn down in 1820 (cf. note 3).

8 Specific themes in the Sahl altar are most recently treated by Otto Norn & Søren Skovgaard
Jensen, *The House of Wisdom – Visdommen i Vestjylland* (Copenhagen, 1990).

9 Cf. Joachim Kruse, "Das kupfervergoldete Antependium aus Gross-Quern in Angeln," *Nordel-
bingen* 30 (1961): 83-99 and *idem*, "Eine Goldschmiedewerkstatt in der Stadt Schleswig um
die Wende vom 12. zum 13. Jahrhundert," *Beiträge zur Schleswiger Stadtgeschichte* 7 (1962):
42-54.

10 Cf. Gunnar Ekholm, "Broddetorpaltaret – Dess kronologiska och konsthistoriska ställning,"
Från stenalder till rokoko – Studier tillägnade Otto Rydbeck den 25 augusti 1937 (Lund, 1937),
247-67 and Rolf Green, "Broddetorpaltaret – en västgötisk(?) illustrerad klassiker från 1100-
talet," *Falbygden – Årsbok* 38 (1984): 6-52.

11 Cf., e.g., Monica Rydbeck, "Antemensalet från Gislöv i Skåne," *Fornvännen* 60 (1965): 158-
62 and Knud J. Krogh, "Gyldent alter, glasmalerier og andre fund fra Malt kirkes kor," *Fra
Ribe Amt – Årbog for Historisk Samfund for Ribe Amt* 17 (1968-71): 513-47.

12 Cf. Jes Wienberg, "Gyldne altre, kirker og kritik," *hikuin* 22 (1995): 59-76.

13 However, we do not know anything about how the main frame of the Tamdrup frontal looked
– and, thus, we do not know whether the framework was tripartite and embellished with

medallions. On the Kværn frontal, the *Majestas Domini* motif is flanked solely by a row of standing apostles in twice three arcades on each side of the mandorla. In addition, the main framework is divided into two parts and has no medallions. The midsection of the Lisbjerg frontal is uniquely formed and has the *Majestas Mariae* as the central motif – cf. Eva de la Fuente Pedersen, "Majestas Mariae, I: Lisbjergalterets ikonografi og motiviske forbilleder," *Ico* (1988/2): 12-30 and Natacha Piano, "La *Maiestas Mariae* – Diffusione e sviluppo di un tema iconografico nell'Occidente medievale (IX-XIII secolo)," *Arte cristiana* 91 (2003): 29-42. The panels in the flanking sections do not contain narrative scenes but only personified virtues and two female saints.

14 In the Sahl frontal, the middle field is a little narrower, so that one can speak of a five-part division of the frontal (cf. Fig. 6). The midsection on the Tamdrup frontal was probably even narrower in relation to the sides (cf. Fig. 4).

15 Similar structures in three sections are well-known, e.g., from the rich number of Norwegian painted frontals. Gunnar Danbolt has made a narrative analysis of one of these: "Bilde som tale – St. Olavs-antemensalet i Nidarosdomen," *Kunst og Kultur* 71 (1988): 138-58.

16 This circumstance – that even a scene like the 'Visitation', which in almost all the frontals makes up a transition between the 'Annunciation' and the 'Nativity', may fall into, for example, four episodes: 'Mary's Departure', 'Mary's Repose During the Journey',the 'Meeting between Mary and Elisabeth' and 'Mary and Elisabeth Say Farewell', as known from a Byzantine manuscript from the 1100s by the monk James of Kokkinobaphos (cf. Gertrud Schiller, *Ikongraphie der christlichen Kunst* (I-V, 7 vols.; Gütersloh, 1966-91), I, 56) – shows that the narrative basically leaps – and must leap – from high point to high point.

17 The release of the righteous from the Kingdom of Death should have been depicted in a subsequent plate, as in the Ølst frontal (Fig. 2). However, more scenes cannot be inserted on the altar without exploding the idea of a frontal and assuming a gild coating on the other sides. Part of this complicated problem with respect to the plates and their original use is, furthermore, that a conception of a gilded ambo-ciborium was present according to one of the reliefs with the legend of St. Poppo – cf. Nørlund, *Gyldne Altre*, 11-12, fig. 11 and *Danmarks Kirker* (as note 4), 5126, fig. 93.

18 Cf., for example, Ann van Dijk's article in this volume.

19 However, 'pure' Christological decorations can, of course, also be found elsewhere. In Denmark, the Romanesque decoration in the chancel in Råsted Church is a striking example – cf. Ulla Haastrup, "Die romanischen Wandmalereien in Råsted – Ikonographie, Bildprogramm und Theater," *Hafnia – Copenhagen Papers in the History of Art* 2 (1972): 69-138 and Lise Gotfredsen, *Råsted Kirke – Spil og Billede* (Copenhagen, 1975)

20 Mark D. Stansbury-O'Donnel, *Pictorial Narrative in Ancient Greek Art* (Cambridge, 1999).

21 Cf. the special number of the *American Journal of Archaeology* 61 (1957): *Narrative and Event in Ancient Art*, ed. Peter J. Holliday (Cambridge, *et al.*, 1993) and *Pictorial Narrative in Antiquity and the Middle Ages*, Studies in the History of Art, 16, ed. Herbert L. Kessler & Marianna Shreve Simpson (Washington, 1985).

22 Cf. Ernst Gombrich, "Reflections on the Greek Revolution," idem, *Art and Illusion – A Study in the Psychology of Pictorial Representation* (London & New York, 1960), 116-45.

23 Cf. Kurt Weitzmann, *Illustrations in Roll and Codex – A Study of the Origin and Method of Text-Illustration,* Studies in Manuscript Illumination, 2 (Princeton, 1947/1970²).

24 The notion of the existence of comprehensive cyclical narratives on rolls of papyrus in Hellenistic culture has, however, become problematic in more recent research – cf. Angelika Geyer,

Die Genese narrative Buchillustration – Der Miniaturenzyklus zur Aeneis im Vergilius Vaticanus (Frankfurt a.M., 1989).

25 For a discussion of these problems, of 'historicized fiction' opposed to myth, cf. Robert Alter, *The Art of Biblical Narrative* (New York 1981), 23-46 ("Sacred History and the Beginnings of Prose Fiction").

26 Max Dvorák, "Idealismus und Naturalismus in der gotischen Skulptur und Malerei," *Historische Zeitschrift* 119 (1918): 1-62 + 185-246 (repr. in *idem, Kunstgeschichte als Geistesgeschichte* (Munich, 1924). Eng. Version: *Idealism and Naturalism in Gothic Art,* trans. Randolph J. Klawiter (Notre Dame, Indiana, 1967).

27 Cf. Carl Robert, *Bild und Lied – Archaeologische Beiträge zur Geschichte der Griechischen Heldensage*, Philologische Untersuchungen, 5 (Berlin, 1881).

28 For an overview of the historical research and terminology, see Stansbury-O'Donnell, *Pictorial Narrative,* 1-8.

29 Weitzmann, *Ills. in Roll and Codex,* 17-18.

30 *Ibid.,* 29. Stansbury-O'Donnell, *Pictorial Narrative,* views 'cyclic' and 'continuous' as two specific methods within syntagmatic narrativity, which also covers 'panoramic', 'unified', 'serial', and 'progressive' narrative – cf. 136-57, especially 145 ff.

31 The Tamdrup plates are an exception as is, possibly, the example in the Sindbjerg frontal.

32 Stansbury-O'Donnell, *op. cit.,* 13-17, *passim,* and Roland Barthes, "Introduction to the Structural Analysis of Narratives," *New Literary History* 6/2 (1975): 237-72 orig. publ. in *Communications* 8 (1966) ("Introduction á l'analyse structurale des récits").

33 Cf. James J. Murphy, *Rhetoric in the Middle Ages: A History of Rhetorical Theory from Saint Augustine to the Renaissance* (Berkeley, 1974) and Thomas M. Conley, *Rhetoric in the European Tradition* (Chicago, 1990/1994²). Cf. also R. McKeon, "Rhetoric in the Middle Ages," *Speculum* 17 (1942): 1-32.

34 Cf. Seymour Chatman's formalist-structuralist distinction between 'story' and 'discourse', which he both relates to and differs from *inventio* and *dispositio* – "Towards a Theory of Narrative", *New Literary History* 6 (1975): 295-318.

35 Cf. King James' Bible: "And Mary arose in those days, and went into the hill country with haste, into a city of Juda; And entered into the house of Zacharias, and saluted Elisabeth. And it came to pass, that, when Elisabeth heard the salutation of Mary, the babe leaped in her womb; and Elisabeth was filled with the Holy Ghost; And she spake out with a loud voice, and said: "Blessed *art* thou among women, and blessed *is* the fruit of thy womb. And whence *is* this to me, that the mother of my Lord should come to me? For, lo, as soon as the voice of thy salutation sounded in mine ears, the babe leaped in my womb for joy." And blessed *is* she that believed: for there shall be a performance of those things which were told her from the Lord."

36 Cf. Erich Auerbach's characterization of the story of Abraham's sacrifice of Isaac in idem, *Mimesis – Dargestellte Wirklichkeit in der abendländischen Literatur* (Bern 1946), 12ff.

37 Theologically, it would have provided an unfortunate comparison with Mary's conception.

38 In the later, Romanesque *officium* for the festival of the "Visitation," Adam Angelicus (+1397) places Elisabeth's home "propinqua templo Domini" – cf. Zsuzsa Urbach, "Die Heimsuchung Mariä, ein Tafelbild des Meisters M S – Beiträge zur mittelalterlichen Entwicklungsgeschichte des Heimsuchungsthemas," *Acta historiae artium* 10 (1964): 78 and 81.

39 Is this to indicate that Elisabeth is experiencing an 'annunciation'?

40 Just as Elisabeth lifts her voice upon meeting Mary, so do the seraphim lift their voices, pro-
claiming "Santus, sanctus, sanctus." But in the relief, the mouths of Elisabeth and the seraph
are closed – compare above in the Tamdrup plate.

41 Cf. Murphy, *Rhetoric*, 172-73 and *Historisches Wörterbuch der Rhetorik*, ed. Gert Ueding (1ff.,
Tübingen, 1992ff.), VI, 432-40, spec. 435 ('ornatus').

42 Cf. Madeline H. Caviness, "'The Simple Perception of Matter' and the Representation of
Narrative, ca. 1180-1280," *Gesta* 30 (1991): 48-64.

43 On the left portal of the northern transept – cf. Willibald Sauerländer, *Gotische Skulptur in
Frankreich 1140-1270* (Munich, 1970), fig. 95. A later very well known example is the ex-
change of looks in Giotto's representation of the meeting of Joachim and Elisabeth at the
Golden Gate in the Arena Chapel in Padua.

44 Cf. Werner Beierwaltes, *Visio Facialis/Sehen ins Angesicht – Zur Coincidenz des endlichen und
unendlichen Blicks bei Cusanus* (Munich, 1988), where the tradition from Plotinus to Augustine
and Pseudo-Dionysius is summarized.

45 Cited by Herbert von Einem, "Das Auge, der edelste Sinn," *Wallraf-Richartz-Jahrbuch* 30
(1968): 281-82.

46 + MISTICA CALDEI DANT SVMO MVNERA REGI – cf. Nørlund, *Gyldne Altre,* 106.

47 Cf., for example, the 'Arrest' in a Theodosian columned sarcophagus from around A.D. 400
and a Carolingian ivory relief from Metz, from around 850 – cf. Schiller, *Ikonographie*, II,
fig. 5 and 165.

48 Interesting is the type in which the 'Bearing of the Cross' depicts Christ being led away from
the final interrogation before Pilate, since there are examples, where the actual bearing of the
Cross is not shown – e.g., left wing of a Carolingian ivory diptych from around 870 and a
miniature in the Gospel Book of Otto III from the end of the 900s – cf. Schiller, *op. cit.*, II,
fig. 276 and 212. See also the scene on the bronze door of the cathedral in Benevento (end of
the twelfth century), which, it is true, includes Simon of Cyrene bearing the Cross, but where
the group with Christ surrounded by two executioners is relatively close to the scene on the
Broddetorp frontal – cf. Schiller, *ibid*, fig. 286.

49 Cf. *ibid.*, II, 24, fig. 11 and Francis Wormald, *The Miniatures in the Gospels of St. Augustine*
– facsimile (Cambridge, 1954).

50 On the uppermost frame may be read: SALVE STELLA MARIS SOLEM VIT[Æ]
[GENE?]RABIS – cf. Nørlund, *Gyldne Altre,* 156 ("Hail to thee, star of the ocean, you shall
bring forth/generate(?) the sun of life") and CELORVM REGI TRIA DANT TRES DONA
SABEI – cf. *ibid.* ("To the king of heaven the three Sabeans give three gifts.")

51 The original frame with an explanatory inscription (*titulus*) has been lost and replaced by a
new one.

52 Cf. Harriet Margrethe Sonne de Torrens, *De fontibus salvatoris: A Liturgical and Ecclesiological
Reading of the Representation of the Childhood of Christ on the Medieval Fonts from Scandinavia*
(Ph.D. diss., University of Copenhagen, 2003). I, 117ff. The programs on the Alskog, Tofta
and Jumkil fonts from Semi-Byzantios' workshop have the same number and sequence of
events: the 'Annunciation', the 'Visitation', the 'Nativity', 'Joseph's Second Dream', the 'Flight
into Egypt', the 'Adoration of the Magi', and lastly the 'Dream of the Magi'.

53 The women may be Mary's mother, Anna, and her relative Elisabeth, but it may also be Anna
or Elisabeth and the prophetess Anna, whom Luke mentions when Jesus is brought to the
temple (Luke 2: 36-38), an episode which is placed achronologically on the frontal before
the 'Adoration of the Magi'. A more in-depth discussion of the problem must also include

the corresponding representation in the mosaics on the east wall of the nave in Santa Maria Maggiore in Rome.

54 A similar 'abridged' representation of Christ being led to Golgotha, in which the man/Simon of Cyrene, who bears the Cross foremost in the procession, is omitted, is already known from Henry II's golden frontal in Aachen (circa 1020) – cf. Schiller, *Ikonographie*, II, figs. 13 and 282.

55 The constellation may well have activated a field of associations: Egypt, where the first heathens, according to the Apocrypha, converted to Christianity upon the Holy Family's arrival at Sotinen, was originally the land Moses led the Israelites out of on their pilgrimage from captivity to the promised land.

56 Moses is "horned" like the Devil but, unlike him, also haloed.

57 When Poul Nørlund published the frontal in 1926, the plates were situated in an arbitrary sequence – cf. Nørlund, *Gyldne Altre*, Pl. IV. Naturally, the present structure shows a story, running in all three zones from left to right, and it may possibly be based on the original nail holes, but nothing is known about this. A study of the nail holes is planned.

58 Cf. E. Wiepen, *Palmsonntagsprozession und Palmesel* (Bonn, 1909).

59 Cf. Florens Deuchler, "Le sens de la lecture – A propos du boustrophedon," *Études d'art medieval offertes à Louis Grodecki* (Paris, 1981), 251-58.

60 Placed outermost to the right in the second zone, the Jesus child on Mary's lap may be understood in the "Adoration" as the target of one shepherd's pointing gesture, tilting upward.

61 It may be noted that, in the three chapters in Isaiah dealing with the future splendor of Jerusalem – chap. 60-62 – it says, among other things: "The sun shall be no more your light by day, nor for brightness shall the moon give light to you by night; but the Lord will be your everlasting light, and your God will be your glory" (60:19-20). A statement that may be part of the reason for the presence of the seraph in the 'Visitation'.

62 Cf. Chatman's 'substance of content' category in "Theory of Narrative," 299-300.

63 *Dialogorum*, Libri IV, 58: "Quis enim fidelium habere dubium posit, in ipso immolationis hora ad sacerdotis vocem coelos aperiri, in illo Jesu Christi mysterio angelorum choros adesse, summis ima sociari, terrene coelestibus iungi unumque ex visibilibus et invisibilibusque fieri?" Cf. *Patrologia Latina*, ed. Migne, 77, 425D & 428A. This view is also expressed in some Danish sources, earliest in a letter of the Abbot Vilhelm of Æbelholt: "In templum siquidem dei, cum divina celebrantur mysteria, cum scilicet verbis dei per sacerdotum ora prolatis corpus Christi conficitur, imis summa iunguntur, chorus assistit angelicus peccantibus ad dominum redeuntibus, venia condonatur." Cf. *Diplomatarium Danicum* (Copenhagen, 1938 ff.), 1. ser., 3, 493: 12-15.

64 Danbolt, "Bilde som tale" in *Kunst og Kultur*, 140 and 153-54, introduces the medieval concept *aevum*, as a category of time between eternity and temporality, as the time dimension of angels and saints.

65 Cf. e.g. Cynthia Hahn, "Picturing the Text: Narrative in the Life of the Saints", *Art History*, 13 (1990): 2-4 and Jochen Schlobach, *Zyklentheorie und Epochenmetaphorik – Studien zur bildlichen Sprache der Geschichtsreflexion in Frankreich von der Renaissance bis zur Frühaufklärung* (Munich, 1980), 28 ff.

66 Cf. Søren Kaspersen, "Gyldne altre og nadverliturgi," *Ting och tanke – Ikonografi på liturgiska föremål*, ed. Ingalill Pegelow (Stockholm, 1998), 150-55. A just as significant interplay developed between the sacrament and the monumental Majestas Domini picture that often embellished the apse vault in the church chancel – cf. Søren Kaspersen, "Majestas Domini – Regnum et Sacerdotium (II): Das Leben des Motivs in Skandinavien während der Kirch-

enkämpfe unter besonderer Berücksichtigung Dänemarks im 12. Jahrhundert (1)," *Hafnia* 10 (1985): 24-72, spec. 26.

67 Cf. Kaspersen in *Ting och tanke*, 155-57.

68 MVNDVM PERCURRO D(OMI)NI CONSPECTIB(VS) ASTO ("I traverse the world, I stand before God's countenance" – cf. Nørlund, *Gyldne Altre*, 178; or perhaps better: "I traverse the world, I stand by at the manifestations of the Lord.") and QVID MIRVM P(RÆ)SENS CUM SIT UBIQ(VE) DEUS ("What wonder, when God is present everywhere" – cf. Nør-lund, *ibid.,* 178-79; or perhaps better: "What wonder (that I am) present, when God may be in all places.")

69 Inscr. on the left: DEFERO UOTA DEO GEMINI CO(M)MERCIA MV(N)DI ("I bring the vows up to God, the intercourse between the two worlds" – cf. Nørlund, *ibid.,* 179; or perhaps better: "I bring the vows, the intercourse between the two worlds, up to God"). Inscr. on the right: THVRA P(RE)CUM CELIS FERO MUN(ER)A CELICA T(ER)RIS (I bring the incense of prayers to the heavens, and the heavenly gifts to the earth" – cf. Nørlund, *ibid.,* 179).

70 TERRIGENIS Q(V)OS PUGNA IUUAT EGO FR(ATR)IB(VS) ASSVM ("I stand by the earth-born brothers about whom the struggle pertains" – cf. Nørlund, *ibid.,* 179); P(RO)TEGO PUGNANTEM UINCENTE(M) IURE CORONO ("I protect the combatant and crown with just cause the victorious" – cf. Nørlund, *ibid.,* 179; or perhaps: "I protect the combatant and crown the by justice triumphant.")

71 Inscr. on the frame – vertical to the left: INFERNI CLAVSTRA P[E]NETRANS CON-CENDIT AD ASTRA... C //- uppermost + vertical on the right: A VICIIS A DELICTI[S] PLEBS LABELA TVATVR: DVM LACRIMAS OFFERT MVNDO CORDE PR(E)CATVR: NEXV[S] SOLV//VNTVR PRECIBVS CVLPE MORIVNTVR: SEMP(ER) HABE TECV(M) S(AN)C(TI)S AP(OSTOL)IS PRECV(M) AP.. – cf. Nørlund, *Gyldne Altre,* 134.

72 Cf. note 70.

73 The placement of the scene corresponds to the place the man of St. Matthew normally assumes as evangelist symbol connected to the *Majestas Domini* – here 'displaced' to the uppermost left corner of the frontal.

74 This iconography still characterized Ottonian art but must be said to have become an unusual phenomenon around 1150 – cf. Schiller, *Ikongraphie,* III, 141-64 + ill.

75 VIRGINEM REGEM MORTIS RE[S]CINDERE LEGEM: PRE[S]CIT (=PRESCISCIT?) COR VATVM (=soothsayers'/prophetesses') DIVINITVS IRRADIATVM – cf. Nørlund, *Gyldne Altre,* 106.

76 Cf. *ibid.*

77 ORDO SENATORVM SACER ADSTAT APOSTOLICORVM – cf. *ibid.*

78 Their names may be read on the frame beneath them.

79 For a discussion of this union, cf. Yves Congar, *L'Ecclesiologie du haut moyen âge* (Paris, 1968), 104-27.

80 Vertical to the left and bottommost: C(O)ETVS APOSTOLJCVS PER MORTE(M) // A MO[RTE REDEMPTVS] MORTEM CONDEMPNANS RESIDET CUM [JUDICE REGNANS] – uppermost and vertical to the right: RECTOR CELORU(M) DISPENSANS IVS MERITORVM FACTOR TERRARUM // SANCTARUM LAUS ANIMARVM – cf. Nørlund, *Gyldne Altre,* 180.

81 Inscr. on the innermost edge of the mandorla: OMNIPOTENS VNVS TRES SVNT NON OMNIPOTENTES + NON DI NON DOMINI DOMIN(VS) TRES ET D(EV)S VN(VS + SINGVLA DISCERNENS D(EV)S IDE(M) CVNCTA GVB(ER)NANS // inscr. on the

external edge of the mandorla: QUE SUNT AVE UIUUNT UITA QUECU(M)A(UE) MOUENTUR + UIUIFICO MOUEO CONTINEO FOVEO + EXTIMA COMPLECTENS PENETRANS SIMVL INTIMA [+] SUBTER CVNCTA SVPER CVNCTA CVNCTA MOVENS STABILIS – cf. Nørlund, *Gyldne Altre,* 179.

82 For an introduction to the problem with additional literature, see, for example, Søren Kaspersen, "Stil som hermeneutisk begreb – Refleksioner over gotikken som stilfænomen," *Tegn, Symbol og Tolkning – Om forståelse og fortolkning af middelalderens bilder,* ed. Gunnar Danbolt *et al.* (Copenhagen, 2003), 99-134 or the following note.

83 Cf. Madeleine H. Caviness, "'The Simple Perception of Matter'", *Gesta* 30 (1991): 48-64, ill. Unfortunately, I have not had access to Madeleine H. Caviness, "Art after 1200: Narrative Mode or Gothic Style," *Event and Image: A Symposium* (1981).

84 Cf. Caviness in *Gesta,* 60.

85 Cf. Dvorak, "Idealismus und Naturalismus", *op. cit.*

86 Above the cross may be seen a sun and moon, which the seraph in the 'Visitation' also holds forth.

87 On the *topos* 'materiam superabat opus', cf. Jan Bialostocki, "Ars auro gemmisque prior", *Mélanges de littérature comparée et de philologie offerts à M. Brahmer* (Warschau, 1967), 55ff. Reprint in idem, *The Message of Images* (Wien, 1988), 9-13 + notes ("Ars Auro Prior"). See also Peter Cornelius Claussen, "*materia* und *opus* – Mittelalterliche Kunst auf der Goldwaage," *Ars naturam adiuvans – Festschrift für Matthias Winner,* ed. V. van Flemming & S. Schütze (Mainz 1996), 40-49. Concerning the role of the materiality of these frontals – ornament, gilding, rock crystals, cf. Marie-Madeleine Gauthier, "L'or et l'église au Moyen Age," *Revue de l'art* 26 (1974): 64-77; Theo Jülich, "Gemmenkreuze – Die Farbigkeit ihres Edelsteinbesatzes bis zum 12. Jahrhundert", *Aachener Kunstblätter* 54/55 (1986/87): 98ff.; Ulrich Henze, "Edelsteinallegorese im Lichte mittelalterlicher Bild – und Reliquienverehrung", *Zeitschrift für Kunstgeschichte,* 54, 1991, 428-51 and the article of Erik Thunø in this volume.

88 "More than by its golden radiance (*plus quam fulvo splendore*) shines the shining tablet (*nitet tabulam nitentem*), you behold by the knowledge (*cognitione*) it spreads about the sacred story (*ystorie sacre*), namely Christ's wondrous deeds (*mysteria*), which by their radiance (*nitore suo*) outshine the gold (*aurum irradiant*) for the pure of heart – Therefore, if you who read this desire to behold the joys of divine light (*lucis gaudia divine*), then purify your mind by faith." This literal translation of mine deviates a bit from Nørlund's, but the two versions are uniform in substance – cf. Nørlund, *Gyldne Altre,* 186-87.

89 Cf. note 63.

Body and Space in the Ølst Frontal

Lena Liepe

Very few medieval images do not contain depictions of the human body.[1] The body is fundamental in Christian thought: the Word that became flesh through Incarnation, *Corpus Christi* as the main focus of devotion in the later Middle Ages, the body of the individual Christian as the Temple of God, the bodies of the dead that will rise again at Judgment Day. For the individual, the body is also the primary category through which the world around her is perceived. The body is a situation, according to phenomenological thought, and this situated bodily condition is the basis for the experience both of the self and of the world.[2] A visual representation of a human body in a medieval context necessarily brings to the fore both dimensions of meaning; the theological, but also the phenomenological, since the latter is part of any perception of a human body. Accordingly, there is ample reason to investigate ways of "reading" the "body language" of medieval images, in an iconographical analysis that searches for meaning in form as well as in motif.

The objective of this paper is to examine to what extent formal properties of an image can be interpreted as meaningful in an iconographic sense: in what way do formal components partake in the construction and communication of meaning? Such an analysis will deal with the composition and the visual space, but above all it will focus upon the human figures, their mutual position and size, the shape and expression of the bodies, including gesticulation and sometimes facial expression. According to Panofsky's classic definition of iconography, features of this kind belong to the "pre-iconographic" level of interpretation.[3] On the other hand, in a study of the illuminations in an early fifteenth-century manuscript, Birgitte Buettner claims that the way an image makes sense cannot be reduced to the production of textual meaning: "images," she says, "create intelligible visibilities that are only partially dependent on words."[4] It is this kind of meaning that I will be looking for here, and the object of study that I have chosen for this purpose is the golden frontal of Ølst.

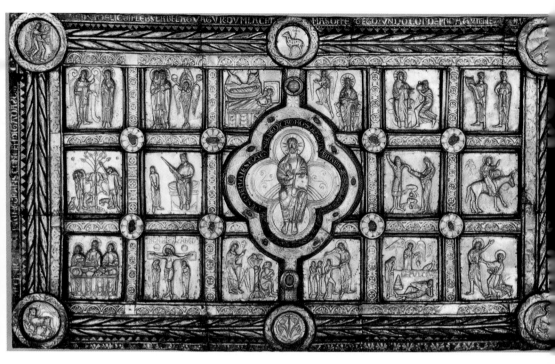

Fig. 1. Golden frontal from Ølst Church, Jutland, Denmark (105 x 182,5 cm.), ca. 1200. Copenhagen, National Museum. Photo: John Lee, National Museum, Copenhagen.

The Ølst frontal

The frontal of the church in Ølst, Jutland, today forms part of the collections of the Museum of National Antiquities in Copenhagen (Fig. 1). It has been dated to ca. 1200, which means that it belongs to the middle category of the preserved Danish metal works of the 12th and 13th centuries.[5]

Like the other Danish frontals, it consists of chasen and gilt copper plates mounted on a wooden framework. It is shaped as a rectangle, about one meter in height, with altogether 23 pictorial fields surrounded by richly ornamented borders. In the centre, Christ sits enthroned in a quatrefoil. In sixteen scenes in three rows on each side, the story of the childhood and passion of Christ is told. In the upper row is seen (from left to right) the Annunciation, the Visitation (Fig. 2), the Nativity (Fig. 3), the Angel Talking to Joseph (Fig. 3), and the Adoration of the Magi (Fig. 4).[6] The middle row shows the Shepherds (Fig. 5), Herod Ordering the Massacre, the Massacre of the Innocents (Fig. 6), and

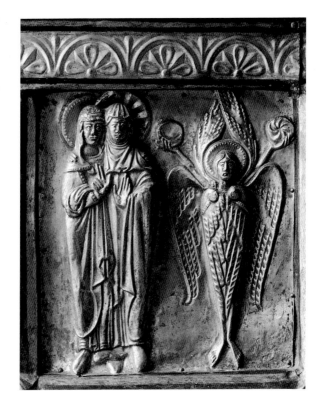

Fig. 2. The Visitation. Golden frontal from Ølst Church, detail. Copenhagen, National Museum. Photo: Photo: Gérard Franceschi, Silkeborg Museum of Art.

Christ's Entry into Jerusalem. The lower row shows a Meal (probably The Meal at Emmaus),[7] the Crucifixion, Christ at the Gates of Hell (Fig. 7), Christ's Descent into Hell Delivering Adam, Eve and John the Baptist (Fig. 8), the Angel by the Empty Grave (Fig. 9), and Christ and Doubting Thomas.

The medallions on the corners contain the symbols of the evangelists, the medallion on the upper border above the enthroned Christ shows Agnus Dei, and the corresponding lower medallion is filled with a vegetative ornament. The Latin inscription on the border speaks of Christ's ascension from Hell to Heaven, and of prayer as the way to salvation from sin and death. The Latin inscription on the inner border of the central quatrefoil asks God to bless mankind from his throne in heaven.

The narrative structure

The sixteen narrative scenes, which will be the main focus of the following analysis, recapitulate a number of incidents from the childhood and passion of Christ. Most of the motifs are also found on one or several of the other Danish

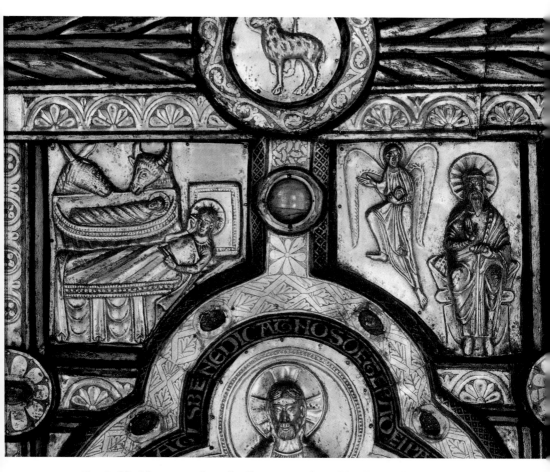

Fig. 3. The Nativity and angel talking to Joseph. Golden frontal from Ølst Church, detail. Copenhagen, National Museum. Photo: John Lee, National Museum, Copenhagen.

frontals; others (the Meal, Christ and Doubting Thomas) are unique to the Ølst frontal. Basically, the scenes are not difficult to identify, other than perhaps the Meal scene; the rest follow a well established iconography that is not particular or unusual in any way. Thus, what is of interest here is not in the first place what is being told, but rather how it is being told, i.e. how the different phases of the story are staged visually.

The composition of the Ølst frontal as a whole is similar to the other Danish frontals, with each scene contained within a framework that in itself plays a rather

conspicuous role in the overall visual impression of the frontal. Each scene cen-
tres on one episode, not once are two episodes fused together in one scene: on
the contrary, the scene showing the Presentation of the Magi is split in two. As
a result, the viewer's impression is one of immediate clarity and readability: the
eye at once registers the crucial elements necessary to identify the scenes.

A further consequence of the design is that the story of Christ's childhood
and passion is presented as a sequence of singular moments, rather than as a
continuous narrative. The framework simultaneously holds the scenes together
and separates them, and the observer is encouraged to proceed step by step and
to focus on one scene at a time, thus having opportunity to contemplate every
episode in a state of concentration that gradually increases as the story unfolds.
Further, the heavy borders emphasize the two-dimensionality of the scenes, lit-
erally tying them to the surface of the frontal and countering the tendencies in
the individual scenes to establish a visual reality of their own.[8] Thus, the frame-
work can be taken to express the concern of the Church to insist on the image
as not real, as nothing more than a fabrication that is of interest only insofar as
it represents something else, a transcendental vehicle that refers to higher truths
beyond itself.

The pictorial space

The main components of the scenes in the Ølst frontal are figures and ground.
More than half of the scenes also contain elements that signify space, but we
are far from seeing an effort to establish something that could be described as a
consistent, three-dimensional spatiality. Where it has been necessary to imply
a location, this is made momentarily, through the use of one or two visual ele-
ments: a piece of furniture, a door opening, a tree, that functions as an indexical
sign of space. The strongest indication of space is found in the scene of Christ's
Descent into Hell (Fig. 8), where Adam, Eve and John the Baptist are enclosed
by the gate of Hell while at the same time the limbs of two of the figures – Eve's
arm, Adam's left leg, and the right foot of both – cut across the frame of the gate
in anticipation of their release.[9]

As a whole, however, the ground is more significant as a visual element. The
ground in the scenes of the Ølst frontal is closed behind the figures, who are all
situated on the same plane: it cannot be penetrated or opened inwards. In an
analysis of the tympanum of Sainte-Foy in Conques, Jean-Claude Bonne has
defined the Romanesque ground in general as qualitative and intensive rather
than quantitative and expansive: it does not primarily establish measurable
spatial relations between visual elements, but functions rather as a medium for
the qualitatively significant connections between the figures in a scene.[10] In the

Ølst frontal, the ground forms this kind of "condensation" that at the same time envelopes the figures and projects them outwards, into the "real" space of the observer.

"Body language"

The content of the scenes on the Ølst frontal is communicated by the figures, through their shape, positioning, gestures and attitudes. The scenes comprise two or three figures, except for the Entry into Jerusalem with Christ alone on the donkey, and Christ's Descent into Hell, where Christ delivers Adam, Eve and John the Baptist (Fig. 8). In some of the scenes, the relative size of the figures carries a specific meaning, most obviously in the scene where Herod orders the Massacre of the Innocent, where the enthroned king towers high in front of the markedly smaller, standing servant. Also, the figure of Christ is larger than the accompanying figures in the scenes of the Crucifixion, the Meal, and Christ's Descent into Hell. However, difference in size as a way of signifying status or importance is not used consistently in the frontal.

One of the most interesting aspects of the figure design is the extent to which bodily expression and attitude are employed in a meaningful way. This kind of "body language" in images can be divided into several aspects: the expression taken as a whole; the position of the body – sitting, standing, etc.; and gesticulation and miming. The typification of the bodily expression in a work of art, or during a specific art historical epoch, is often more or less synonymous with a stylistical characterization: the frontal, hieratic Romanesque attitude vs. the s- or c-curved Gothic attitude. Such generalizations are misleading, since they camouflage the differences that actually exist within the art of a particular period: there are many Romanesque figures that are not frontal or static, and also Gothic figures that are not s-shaped. Furthermore, they are insufficient for an analysis of the specific significance of different attitudes.

The figures of the Ølst frontal are shown in three-quarter-profile or almost *en face*, but with the full frontal view reserved for Christ in the Meal, the seraph in the Visitation (Fig. 2), and the central, enthroned Christ. Several of the other figures are also shown in an approximately frontal position, but with dislocations of hands or heads that, however slight, make a difference. The movement of the body, as shown through dislocation of various body parts, is very limited. The most complicated attitude is seen in the scene of the Descent into Hell (Fig. 8), where Christ is shown with his head and trunk turned left, and the right leg and foot turned right. There is also a marked effort to show whole bodies: overlapping is unusual, only in three scenes (the Nativity Fig. 3, the Meal, and the Angel by the Grave Fig. 9) are some of the figures not visible from top to toe.

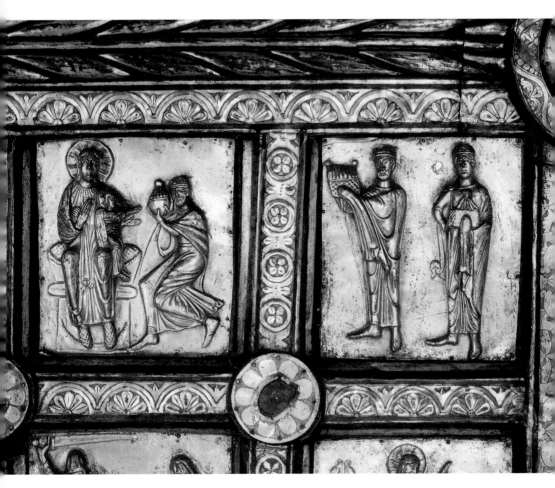

Fig. 4. The Adoration of the Magi. Golden frontal from Ølst Church, detail.
Copenhagen, National Museum. Photo: John Lee, National Museum, Copenhagen.

The thoroughly guarded, well-balanced and measured attitude that characterizes most of the figures on the Ølst frontal carries a pronounced positive signification in medieval art in general, in contrast to uncontrolled or violent motions. Compare for instance the two main figures in the Massacre of the Innocents (Fig. 6): the mother stands collected with her arms held close to her body, while the emotional expression is limited to the inclination of her head and body. The soldier, on the other hand, lifts hands and arms in a gesture both forceful and violent. Not only movements, but all kinds of exaggerated twisting and turning of the body carry negative connotations.[11]

Fig. 5. The Annunciation to the Shepherds. Golden frontal from Ølst Church, detail. Copenhagen, National Museum. Photo: Gérard Franceschi, Silkeborg Museum of Art.

Meyer Schapiro employs the musical term "mode" to describe contrasting effects of this kind: "In medieval art basically different modes of composition coexist within the same personal or collective style, adapted to different types of content, like the modes in music. [...] Elements of two such modes may be used within a single image to convey a duality of meanings or to mark an important distinction."[12] Schapiro takes as an example the contrast between *en face*, profile and three-quarter-profile: the three-quarter-profile represents the "unmarked," standard type of figure representation in medieval imagery, a fact that turns the *en face*-attitude and the profile into "marked" positions with special significance. The frontal position signifies what Schapiro calls a "theme of state," an elevated, de-contexualized immobility.[13] The profile on the other hand is a markedly negative sign. There is no "pure" profile on the Ølst frontal, but the Devil in the scene with Christ in front of the Gates of Hell (Fig. 7) is shown almost in profile, at least to a higher degree than any other figure on the frontal. The whole attitude of the Devil is strikingly different from most of the

other figures: he is shown crouching, with his back towards Christ but with his head turned almost 90 degrees. This distorted and in every respect "low" position clearly signifies evil.[14]

Bodily positions

The Ølst frontal displays a whole set of different bodily positions which carry significance to varying extents. This makes obvious the fact that a bodily attitude has to be interpreted as part of a whole system of signification, and that its meaning is determined according to how it relates to the other elements in the same system. Least marked is the standing position: many figures are shown standing, from the holiest (Christ, the seraphs, Mary) to the basest (the soldier in the Massacre). Two figures are shown lying down: Mary at the Nativity (Fig. 3) and one of the soldiers by the grave (Fig. 9). The position is a general indication of rest and sleep, but does not seem to carry any further connotations, good or bad. More specific is the frontal sitting position that is usually reserved for God, and for important rulers in general, during this period. Apart from the central enthroned Christ (Fig. 1), three figures are shown in this position: Mary with the Christ Child (Fig. 4), King Herod ordering the massacre and Joseph with the angel. This last case might seem somewhat surprising, considering Joseph's relative unimportance during this period. However, there are parallels in contemporary German metal art.[15]

To genuflect is a position with a more or less constant meaning of submission or reverence. One of the kings in the scene of the Adoration of the Magi genuflects in front of Mary and Christ (Fig. 4), and Thomas does the same in front of the risen Christ in the last scene. It is interesting to note how the status of a position can change according to how it is combined with other attitudes. A kneeling figure is always inferior, an enthroned figure is always superior (Mary, Herod), but the status of the standing attitude is relative: the standing Christ is superior to the genuflecting Thomas, but the standing servant is inferior to the enthroned Herod. The rule is broken in one instance, with the Devil sitting with his back towards the standing Christ (Fig. 7). Considering the degrading position of the Devil, however, the hierarchical inversion of the positions serves rather to underline the superiority of Christ in this scene.

Physical contact

The Ølst frontal contains few examples of direct physical contact: the relations between the figures are expressed more through attitude and gesture than through touch. In the five scenes where actual physical contact is displayed, it carries very

different meanings. In the Visitation (Fig. 2), Mary and Elizabeth are standing so close together that they almost merge into one: Mary holds her arm around the shoulder of Elizabeth, while Elizabeth's foot crosses Mary's. A similar intimacy is demonstrated in the scene of the Adoration of the Magi (Fig. 4), where the silhouette of the Christ Child is totally encircled by the body of his mother, apart from his hands.

In the scene showing the Massacre of the Innocent (Fig. 6), the soldier and the mother are standing in front of one another, holding the body of a child between them. The contact between the two large figures is thus mediated through the swaddled child, and the violence of the motif is further expressed through the attitude of each figure: the movement of the mother's whole body towards the border of the pictorial field, and the risen arm of the soldier. A similar chain of indirect contact is established in the scene depicting the Descent into Hell (Fig. 8), but with a very different meaning. Christ is holding Eve's left hand, while John the Baptist seizes her right arm in his right hand. With his left hand,

Fig. 6. The Massacre of the Innocents. Golden frontal from Ølst Church, detail. Copenhagen, National Museum. Photo: Gérard Franceschi, Silkeborg Museum of Art.

Christ clasps Adam's left arm, and in this way the salvaging gesture embraces all three figures in Hell. The lifted, shielding left arm of Christ further underlines the redeeming content of the motif.[16]

In the last scene of the frontal, Thomas touches Christ's side with his hand, pointing at the wound with two fingers. Thomas demanded testimony of Christ's resurrection that he could verify with his senses, through seeing and touching. Here, it is the touch as such that is the carrier of meaning in the motif.

Gestures

The main vehicle of communication in the Ølst frontal are gestures. The positions of the hands and arms are used to make concrete an act, idea or feeling: they signify speech, authority, acceptance, submission, sorrow, obedience, and so on. In medieval imagery, gesture is to a large extent formalized in a fixed repertoire of stock attitudes; but there also exist a number of gestures that have different meanings depending on context. Gestures, as any vehicle of communication, constitute a system of signification that works contextually and relationally, and each gesture has to be interpreted accordingly. Norbert H. Ott has specified three

Fig. 7. Christ at the Gates of Hell. Golden frontal from Ølst Church, detail. Copenhagen, National Museum. Photo: Gérard Franceschi, Silkeborg Museum of Art.

Fig. 8. Christ Delivering Adam, Eve and John the Baptist. Golden frontal from Ølst Church, detail. Copenhagen, National Museum. Photo: Gérard Franceschi, Silkeborg Museum of Art.

functions in a gesture: to characterize the mood or state of mind of a figure; to express communication between figures; and to function as a reference for the viewer.[17] According to Ott, the second function is the most frequent. This goes also for the Ølst frontal, while the last function, to communicate directly with the viewer, is employed only by the central enthroned Christ.

The first function, to signify moods and feelings, is demonstrated among others by Mary and John in the Crucifixion. Both figures hold their hands under their chins in the prevalent gesture of grief and deep sorrow.[18] In the scene show-ing Herod ordering the Massacre of the Innocent, the servant is standing holding one wrist with his other hand, showing his helplessness before the command of the king, and also his distress because of this. The Devil's folded arms at the Gates of Hell (Fig. 7) has a similar meaning, indicating his impotence and powerless-ness.[19] In the Nativity (Fig. 3), Mary is lying down with her head leaning on her right hand, following an iconographical convention for this scene that was established at an early stage.[20] In accordance with Byzantine and early Christian convention, the gesture does not primarily indicate sorrow at the thought of the future destiny of the child. Her lying down means that she is exhausted after the birth, as evidence of her virginity, and the hand under the chin signifies rest and sleep.[21] One of the sleeping soldiers in the scene of the Angel by the Grave (Fig. 9) is lying down in a similar attitude, and even the standing soldier holds his hand under his chin, in a shorthand version of the same motif.

Other gestures of the frontal mainly represent communication between fig-ures. One of the most frequent is the raised hand with three fingers extended. Originally a speech gesture in classical rhetoric, in medieval iconography it is the Latin benediction. On the frontal, Christ makes this gesture over the bread in the scene depicting the Meal, as does the angel by the empty grave, while at the same time holding a censer. This detail might be taken as a reference to how the priest incenses the altar – also a grave – as part of the Mass. At the same time, the raised hand with three fingers extended also retains the origi-nal speech significance, and in several cases the two meanings cannot be clearly separated from each other. This is the case in the Annunciation, where the angel hails Mary, and in the Visitation (Fig. 2), where Elizabeth salutes Mary with the words: "Blessed art thou among women." Here, the gesture can be read si-multaneously as a blessing and a salutation. A third interpretation is indicated by Christ in front of the Devil (Fig. 7): here, the raised hand is held with the back of the hand turned outwards, and is neither a salutation nor a blessing, but rather an attitude of authority.[22] The outstretched hand with extended fingers can also have a more general meaning of pointing or indicating, as when Mary in the Nativity (Fig. 3) gestures toward the Christ Child, or Thomas points at Christ's wound in the last scene.

Fig. 9. The Angel by the Empty Grave. Golden frontal from Ølst Church, detail. Copenhagen, National Museum. Photo: John Lee, National Museum, Copenhagen.

Another common gesture on the frontal is the extended raised hand with straight fingers. In classic rhetorics this is a way to indicate speaking or crying out loud, while the meaning in medieval iconography is broadened to include testimony, acclamation, obedience and agreement: i.e. confirmation and affirmation at the same time.[23] Mary's lifted left hand with the palm turned outwards in the scene of the Annunciation thus indicates her acceptance of the announcement that the angel brings her, and in the Visitation (Fig. 2) she affirms the praise of Elizabeth in a similar way. Joseph lifts his hand in the scene with the angel, thereby obeying the exhortation to take his family and leave for Egypt (if the scene is to be interpreted according to its placing after the Nativity, which has to be original because of the shape of the pictorial field). The angel in its turn demonstrates a variant of the gesture by making an indication in a specific direction, towards Mary and the Christ Child in the previous scene.[24]

Another type of indicating gesture is made by one of the shepherds in the first scene in the middle row (Fig. 5), pointing with his arm and index finger towards the star in the upper left corner. Above, big gestures and agitated body language have been characterized as a breach of the general rule of restraint and moderation that carries positive connotations, according to the general norms

for medieval imagery. Despite this, in this case the intended meaning is hardly to designate the shepherds as bad people; their body language is rather an example of how gesture is used to mark social status, in this case low status.[25] In a study of nativity and adoration motifs in manuscripts from the twelfth century, T. A. Heslop has argued that differences in position, facial features, gesticulation, and sometimes also painterly execution, are employed intentionally to differentiate between the shepherds on the one hand and the magi on the other. The lower status of the shepherds is shown not only through their simple costume, but also through their less disciplined attitudes and coarse appearance, sometimes verging on caricature.[26] The latter cannot be said to be the case on the Ølst frontal, but the gesture of one of the shepherds, holding onto his hood, can be compared with one of the shepherds in the Winchester Psalter (1140-1160), turning his head inside his hood so that his sight is blocked, as an expression of either fright or stupidity.[27]

Conclusion

In conclusion, it is possible to distinguish between "strong" and "weak" variables in the construction of the singular scenes of the Ølst frontal as carriers of meaning in the narration of the totality. The relational variables are strong: the placement of the figures in relation to each other in the pictorial field, their relative size, and mutual attitudes and expressions. Gesticulation can also be counted among the relational variables, at least regarding those gestures that express communication, with a content that is defined according to whom they are directed to. On the other hand, overlapping and physical contact are weak variables, not to mention facial expressions, which are not employed at all. The ground between the figures is an active, visually present element in the pictorial composition, but spatial configuration is not an essential part of the creation of meaning in the scenes.

According to Birgitte Buettner, three factors can be enumerated that, taken together, form a taxonomy for analyzing what she calls the pictorial, self-referential articulation of meaning, that is, how meaning is produced internally through visual means in an image or a series of images. These factors are similarity or repetition, contrast and variation.[28] In the Ølst frontal, as in all pictorial series, a basic *similarity* between the scenes is necessary in composition and design to enable the observer to recognize the figures from scene to scene, and in general to comprehend the single scenes as part of a coherent whole. One instance of the use of likeness in details for this purpose is the design of the halos of Christ (a cross halo) and Mary (with a "folded" pattern) to distinguish them from the other figures. Another example is the parallelism between two different scenes, in

the position of one of the magi (Fig. 4) and of Doubting Thomas, respectively: in both cases, genuflection signifies veneration of the Lord.

In this manner, different kinds of imaginary lines can be drawn back and forth between the scenes of the frontal. Some scenes, however, stand out in isolation since they do not repeat visual elements from other scenes. For instance, the servant who receives the order from the enthroned Herod is not similar to the soldier who performs the massacre (Fig. 6): if this had been the case, the narrative connection between the two scenes would have been emphasized, but obviously this was not deemed necessary.

With the help of bodily positions and gestures, on the other hand, meaning is created using the principles of *variation* and *contrast*. The different combinations of standing, seated and genuflecting positions, for instance, can be described as variations on the mutual theme of superiority and inferiority, where the significance of each position is established through its relation to the other. Also, the general differentiation between "good," guarded and well-balanced attitudes on the one hand and exaggerated, "bad," violent body language on the other demonstrates how meaning is produced through contrasting effects.

<div align="center">*</div>

The analysis that I have presented in this paper might seem banal, and in many ways it is, which is exactly my point. Iconographical interpretations have a tendency to focus more or less exclusively on the lexical meaning of an image, i.e. the kind of meaning that can be read in books. Doing so, they neglect the basic ways in which images make sense visually. The purpose of this exercise has been to indicate some of the possibilities that lie in an interpretation, however elementary, of basic visual elements, such as composition and figure design, as carriers of meaning.

Bibliography

Amira, Karl von. "Die Handgebärden in der Bilderhandschriften des Sachsenspiegels." *Abhandlungen der philosophisch-philologischen Klasse der königlich bayerischen Akademie der Wissenschaften* 23 (1905-1909): 161-263.

Barasch, Moshe. *Gestures of Despair in Medieval and Early Renaissance Art*. New York, 1976.

Bonne, Jean-Claude. *L'art roman de face et de profil: Le tympan de Conques*. Paris, 1984.

Bryson, Norman. *Vision and Painting. The Logic of the Gaze*. Houndmills and London, 1983.

Buettner, Birgitte. *Boccaccio's* Des cleres et nobles femmes. *Systems of Signification in an Illuminated Manuscript.* Seattle and London, 1996.

Camille, Michael. "The King's New Bodies: An Illustrated Mirror for Princes in the Morgan Library." In *Künstlerischer Austausch/Artistic Exchange. Akten des XXVIII. Internationalen Kongresses für Kunstgeschichte*, 2: 393-405. Berlin, 1993.

Davidson, Clifford. "Gestures in Medieval British Drama." In *Gesture in Medieval Drama and Art*, ed. C. Davidson, 66-127. Early Drama, Art, and Music Monograph Series 28. Kalamazoo, 2001.

Freedman, Paul. *Images of the Medieval Peasant.* Stanford, 1999.

Garnier, François. *Le langage de l'image au Moyen Age.* 2 vols. Paris, 1982-1989.

Gotfredsen, Lise and Hans Jørgen Frederiksen. *Troens billeder. Romansk kunst i Danmark.* 2nd ed. Herning, 1988.

Grinder-Hansen, Poul (text) and Gérard Franceschi (photo), *Nordens gyldne billeder fra ældre middelalder.* 10000 års nordisk folkekunst. Copenhagen, 1999.

Haastrup, Ulla. "Kristus en face = Deus Majestatis." In *Kristusfremstillinger. Foredrag holdt ved det 5. Nordiske symposium for ikonografiske studier på Fuglsang 29. aug.–3. sept. 1976*, ed. U. Haastrup, 103-116. Copenhagen 1980.

Haastrup, Ulla. "Zannermasken und -figuren im Profil und *en face*." In *Mein ganzer Körper ist Geschicht. Groteske Darstellungen in der europäischen Kunst und Literatur des Mittelalters*, ed. K. Kröll and H. Steger, 313-334. Freiburg im Breisgau, 1994.

Haastrup, Ulla. "Representations of Jews in Danish Medieval Art." In *Danish Jewish art – Jews in Danish art*, ed. M. Gelfer-Jørgensen, 111-167. Copenhagen, 1999.

Haastrup, Ulla and Robert Egevang and Eva Louise Lillie, eds. *Danske kalkmalerier.* 7 vols. Copenhagen, 1985-1992.

Heslop, T. A. "Romanesque Painting and Social Distinction: the Magi and the Shepherds." In *England in the Twelfth Century. Proceedings of the 1988 Harlaxton Symposium*, ed. D. Williams, 137-152. Woodbridge, 1990.

Lexikon der christlichen Ikonographie. 8 vols. Rome/Freiburg/Basel/Wien, 1968-1976.

Marienlexikon. 6 vols. St. Ottilien, 1988-1994.

Mellinkoff, Ruth. *Outcasts. Signs of Otherness in Northern European Art of the Late Middle Ages.* California Studies in the History of Art 32. Berkeley, 1993.

Moi, Toril. "What is a Woman? Sex, Gender and the Body in Feminist Theory." In idem, *What is a Woman? And Other Essays*, 3-120. Oxford, 1999.

Nørlund, Poul. *Gyldne Altre. Jysk Metalkunst fra Valdemarstiden.* Copenhagen, 1926.

Ott, Norbert H. "Der Körper als konkrete Hülle des Abstrakten. Zum Wandel der Rechtsgebärde im Spätmittelalter." In *Gepeinigt, begehrt, vergessen. Symbolik und Sozialbezug des Körpers im späten Mittelalter und in der frühen Neuzeit*, ed. K. Schreiner and N. Schnitzler, 223-241. Munich, 1992.

Panofsky, Erwin. "Iconography and Iconology: An Introduction to the Study of Renaissance Art." In idem, *Meaning in the Visual Arts*, 51-81. London, 1993 (1st. ed.

1955, orig. publ. in idem, *Studies in Iconology. Humanistic Themes in the Art of the Renaissance* 1939).

Réau, Louis. *Iconographie de l'art chrétien.* 3 vols. Paris, 1955-1959.

Ristow, Günter. *Die Geburt Christi in der frühchristlichen und byzantinisch–ostkirchlichen Kunst.* Recklinghausen, 1963.

Schapiro, Meyer. *Words and Pictures. On the Literal and the Symbolic in the Illustration of a Text.* Approaches to Semiotics 11. The Hague and Paris, 1973.

Schiller, Gertrud. *Ikonographie der christlichen Kunst.* 5 vols. Gütersloh, 1966-1990.

Schmitt, Jean-Claude. *La raison des gestes dans l'Occident médiéval.* Paris, 1990.

Notes

1 This article forms part of the interdisciplinary project "Costume in the Nordic countries during the Middle Ages," 2000-2002, Department of History, University of Gothenburg, Sweden. A longer version in Swedish is published in a monograph entitled *Den medeltida kroppen. Kroppens och könets ikonografi i nordisk medeltid* (*The Medieval Body. The Iconography of Body and Gender in Nordic Art during the Middle Ages*) (Lund, 2003).

2 Toril Moi, "What is a Woman? Sex, Gender and the Body in Feminist Theory," in idem, *What is a Woman? And Other Essays* (Oxford, 1999), 59-72.

3 Erwin Panofsky, "Iconography and Iconology: An Introduction to the Study of Renaissance Art," in idem, *Meaning in the Visual Arts* (London, 1993), 51-81.

4 Birgitte Buettner, *Boccaccio's* Des cleres et nobles femmes. *Systems of Signification in an Illuminated Manuscript* (Seattle and London, 1996), 2.

5 Poul Grinder-Hansen (text), Gérard Franceschi (photo), *Nordens gyldne billeder fra ældre middelalder* (Copenhagen, 1999), 36-39. The datings are to be taken as guidelines rather than definitive. For a detailed description of the frontal, see Poul Nørlund, *Gyldne Altre. Jysk Metalkunst fra Valdemarstiden* (Copenhagen, 1926), 131-140.

6 Today's placing of the scenes is not necessarily original, since they have been rearranged in connection with restorations in recent times without proper documentation.

7 There is also the possiblity that the meal scene is a shorthand version of the Last Supper, see Grinder-Hansen and Franceschi, *Nordens gyldne billeder*, 56. Because of the rearrangements of the scenes mentioned above, today's order cannot be used to reach a conclusion.

8 Norman Bryson, *Vision and Painting. The Logic of the Gaze* (Houndmills and London, 1983), 98-101.

9 François Garnier, *Le langage de l'image au Moyen Age* (Paris, 1982-1989), 1: 95-96, 244-246.

10 Jean-Claude Bonne, *L'art roman de face et de profil: Le tympan de Conques* (Paris, 1984), 146.

11 Moshe Barasch, *Gestures of Despair in Medieval and Early Renaissance Art* (New York, 1976), 57; Michael Camille, "The King's New Bodies: An Illustrated Mirror for Princes in the Morgan Library," in *Künstlerischer Austausch/Artistic Exchange*, Akten des XXVIII. Internationalen Kongresses für Kunstgeschichte (Berlin, 1993), 2: 394, 397-398; Ulla Haastrup et. al. eds., *Danske kalkmalerier* (Copenhagen, 1985-1992) 2: 29-30; Ulla Haastrup et. al. eds., *Danske kalkmalerier*, 4: 25-28; Garnier, *Le langage*, 1: 120; Jean-Claude Schmitt, *La raison des gestes dans l'Occident médiéval* (Paris, 1990), 140-142, 161.

12 Meyer Schapiro, *Words and Pictures. On the Literal and the Symbolic in the Illustration of a Text*, Approaches to Semiotics (The Hague and Paris, 1973), 11: 38.

13 Schapiro, *Words and Pictures*, 38-39. See also Schmitt, *La raison des gestes*, 29, and on the same feature in Danish mural painting Ulla Haastrup, "Kristus en face = Deus Majestatis," in *Kristusfremstillinger. Foredrag holdt ved det 5. Nordiske symposium for ikonografiske studier på Fuglsang 29. aug.–3. sept. 1976*, ed. U. Haastrup (Copenhagen, 1980).

14 Ulla Haastrup, "Zannermasken und -figuren im Profil und *en face*," in *Mein ganzer Körper ist Geschicht. Groteske Darstellungen in der europäischen Kunst und Literatur des Mittelalters*, ed. K. Kröll and H. Steger (Freiburg im Breisgau, 1994); Ulla Haastrup, "Representations of Jews in Danish Medieval Art," in *Danish Jewish art – Jews in Danish art*, ed. M. Gelfer-Jørgensen (Copenhagen, 1999), 132-133; Ruth Mellinkoff, *Outcasts. Signs of Otherness in Northern European Art of the Late Middle Ages*, California Studies in the History of Art 32 (Berkeley, 1993), 1: 211-220.

15 Gertrud Schiller, *Ikonographie der christlichen Kunst* (Gütersloh, 1966-1990), 1: fig. 177.

16 Garnier, *Le langage*, 1: 214.

17 Norbert H. Ott, "Der Körper als konkrete Hülle des Abstrakten. Zum Wandel der Rechtsgebärde im Spätmittelalter," in *Gepeinigt, begehrt, vergessen. Symbolik und Sozialbezug des Körpers im späten Mittelalter und in der frühen Neuzeit*, ed. K. Schreiner and N. Schnitzler (Munich, 1992), 224.

18 Karl von Amira, "Die Handgebärden in der Bilderhandschriften des Sachsenspiegels," *Abhandlungen der philosophisch-philologischen Klasse der königlich bayerischen Akademie der Wissenschaften* 23 (1905-1909): 234; Clifford Davidson, "Gestures in Medieval British Drama," in *Gesture in Medieval Drama and Art*, ed. C. Davidson, Early Drama, Art, and Music Monograph Series 28 (Kalamazoo, 2001), 82; Garnier, *Le langage*, 1: 184; Garnier, *Le langage*, 2: 120.

19 von Amira, "Die Handgebärden," 231-234; Garnier, *Le langage*, 1: 184, 198, 216-222; Garnier, *Le langage*, 2: 102, 120, 152; Lise Gotfredsen and Hans Jørgen Frederiksen, *Troens billeder. Romansk kunst i Danmark* (Herning, 1988), 74.

20 *Lexikon der christlichen Ikonographie* (Rome/Freiburg/Basel/Vienna, 1968-1976), 2: 92, 102; *Marienlexikon* (St. Ottilien, 1988-1994), 2: 600; Günter Ristow, *Die Geburt Christi in der frühchristlichen und byzantinisch–ostkirchlichen Kunst* (Recklinghausen, 1963), 31; Schiller, *Ikonographie der christlichen Kunst*, 1: 80, 82.

21 Garnier, *Le langage*, 1: 184; Louis Réau, *Iconographie de l'art chrétien* (Paris, 1955-1959), pt. 2; 2: 219; Ristow, *Die Geburt Christi*, 47; Schiller, *Ikonographie der christlichen Kunst*, 1: 73.

22 von Amira, "Die Handgebärden," 202-203, 212; Garnier, *Le langage*, 1: 167; Gotfredsen and Frederiksen, *Troens billeder*, 72; *Lexikon der christlichen Ikonographie*, 4: 145-146.

23 von Amira, "Die Handgebärden," 170-191; Garnier, *Le langage*, 1: 171-180; Gotfredsen and Frederiksen, *Troens billeder*, 73.

24 von Amira, "Die Handgebärden," 204; Garnier, *Le langage*, 1: 171.

25 Schmitt, *La raison des gestes*, 144-145. On the status of the shepherd in general during the Middle Ages, see Paul Freedman, *Images of the Medieval Peasant* (Stanford, 1999).

26 T. A. Heslop, "Romanesque Painting and Social Distinction: the Magi and the Shepherds," in *England in the Twelfth Century. Proceedings of the 1988 Harlaxton Symposium*, ed. D. Williams (Woodbridge, 1990).

27 Heslop, "Romanesque Painting and Social Distinction," fig. 7.

28 Buettner, *Boccaccio's Des cleres et nobles femmes*, 57-58, 99.

The Stadil Altar Frontal

A Johannine Interpretation of the Nativity of Christ and the Advent of Ecclesia

Harriet M. Sonne de Torrens

The single composition of the Nativity of Christ on the Stadil altar frontal, dated to 1200-1225, is a remarkable expression of the iconographical ingenuity that emerges in the Scandinavian imagery in the one-hundred year period from ca. 1150-1250 (Fig. 3).[1] Little known outside Scandinavia, this altar frontal, located in the Stadil parish church in the county of Ringkøbing in Jutland, Denmark, was like so many other works from this period part of a wide-spread, prodigious flowering of all the arts in the North. The twelfth-century unification of Church and State in Denmark under the reigns of Valdemar I (The Great, 1157-1182) and his sons, Knud VI (1182-1202) and Valdemar II (The Victorious, 1202-1241), firmly established a new regime that supported and promoted the Christian Church. Literally thousands of parish churches across the regions of medieval Denmark were constructed and ornamented with wall paintings, sculptural works and liturgical objects, such as fonts and altar frontals.[2] Often designated as being on the periphery of the Latin West, this incredible profusion of artistic creativity in the North deserves a closer scrutiny. In the design and ornamentation of these works, the artisans assimilated a wide range of diverse traditions that infiltrated the North from the East, West and South, and, in turn, created pictorial conventions that expressly suited their unique moment in history.

This paper focuses on the representation of the Nativity of Christ. The scene is one of five from Christ's infancy rendered on the tripartite altar frontal which, today, is enclosed in a Renaissance retable (Fig. 1). It is situated on the left panel in the lower left corner beneath the Adoration of the Magi on the upper register. On the right panel the Presentation in the Temple is placed in the lower right corner beneath the Annunciation and the Visitation scenes on the upper most register. These events are accompanied by representations of the twelve apostles standing in pairs on the central register across the left and right panels. The central panel is dedicated to a representation of Christ in Majesty. The figure of

Fig. 1. Golden frontal in Stadil Church, enclosed within a Renaissance retable. Photo: Søren Kaspersen.

Christ, bearded and wearing a crown bedecked with jewels, is surrounded by four angels, two of which swing censers, sanctifying the imagery.[3] Medallions illustrating the symbols of the four-evangelists ornament each corner. Discussion of the Stadil pictorial program and the other altar frontals, ensues only when it is relevant for creating a contextual understanding for the image. In what follows, I shall demonstrate that the unusual conflation of elements in the Nativity of Christ is rooted in Johannine eschatology; and, more importantly, that the image signifies not only a theological interpretation of Christ's birth, but, also, on an ecclesio-political level, the Advent of the New Law and Ecclesia in the North.

The Stadil altar frontal belongs to a group of forty-one Scandinavian altar frontals known as the "golden altars" produced from ca. 1150-1250.[4] It is made from gilded copper and measures 96.5 x 150 cm.[5] In the case of the Scandinavian golden altars, some were portable and others formed part of larger retables.[6] Of these, eleven are intact and seven of the eleven are ornamented with events from the childhood of Christ.[7] The seven altars which are ornamented with scenes from Christ's infancy are from parish churches in Stadil, Lisbjerg, Sindbjerg, Tamdrup, Ølst, Odder and Sahl in Denmark and Broddetorp in Västergötland, Sweden.[8] Ornamented with biblical and saintly figures these altar frontals were

dedicated to the liturgical seasons of Advent, Christmas, Easter, and, in some instances, the sanctoral feast days.

The representation of Christ's childhood on altar frontals

In the Latin West altar frontals, known also as *antependia*, were made first of stone and then later from metal or painted wood.[9] Most of them were placed in front of the altar on feast-days[10] and have been known in the West since early Christianity.[11] As in the case of Scandinavia's "golden altars," many of the twelfth- and thirteenth-century altar frontals follow a three-panel, hierarchial division of pictorial space, revealing a close affinity with how designers organized the pictorial spaces inside churces, in particular, areas like the apse and its relationship with the adjoining choir and nave spaces. Conventions, characteristic of monumental painting in Scandinavian churches, are evident in the design of the golden altars. The central panels on the altar frontals, usually with a theophanic message, are similar, for example, to the apse programs which have a central image of the Majestas Domini. The side panels on the altar frontals compliment their central theme and mirror the role of the linear narrative sequences on the nave walls.[12]

The representation of Christ's infancy on altar frontals is, however, a relatively infrequent occurrence compared to other motifs, which have adorned altar frontals since the sixth century.[13] The earliest known example is the altar of Angilbert's new church at St. Riquier (Centula) in northern France made between 791 and 799. It is believed to have had representations of Christ's Nativity in conjunction with scenes from the Passion, Ressurrection and Ascension.[14] Most of the surviving altar frontals, however, date from the eleventh to the thirteenth century and are mainly from Scandinavia, Italy, Germany, and northern Spain. The majority of these works are ornamented with representations of Christ in Majesty with references to saints' lives and the twelve apostles, not Christ's infancy.[15]

The altar frontals that are known to be ornamented with the childhood of Christ were made primarily during the late twelfth and first half of the thirteenth century.[16] The vast majority of these examples are found in Scandinavia as previously noted and in northern Spain, specifically Catalonia.[17] And yet, this genre of altar frontals is not an isolated development but belongs to a wider interest in the representation of the childhood of Christ on monumental works and liturgical objects that were created during this period. An example of this wider interest in ornamenting liturgical objects with events from Christ's infancy is seen in the numerous baptismal fonts that were made in Scandinavia and other regions of Western Europe.[18] Created from a number of ecclesiological and socio-political

Fig. 2. Joseph's First Dream'. Golden frontal from Ølst Church, detail. Copenhagen, National Museum. Photo: Gérard Franceschi, Silkeborg Museum of Art.

perspectives, the pictorial programs on these liturgical and monumental works belong to a distinct phase that sought to integrate an object's liturgical function with the theological principles associated with the events from Christ's infancy. Closely connected to this theme is the role of the Virgin Mary, as both the Mother of God and Ecclesia. As in the case of monumental works, the twelfth-century interest in the cult of the Virgin and her life in relation to Christ plays a prominent role in the representation of Christ's childhood on the altar frontals and other liturgical works from this period.[19]

Ornamentation of altar frontals in relation to the liturgy

The altar frontals were ornamented with themes related to the function of the object, that is, the celebration of the mass during the ecclesiastical year.[20] Central to our understanding of these pictorial programs were the assigned gospel read-

ings and sermons for each mass, which commemorated the feast days. [21] In the section of the mass known as the Liturgy of the Word, a selected passage from one of the four Gospels is read. [22] The theme of each mass reflects the events associated with the life of Christ for that feast day. From the time of Jerome and Leo the Great, the Church had gradually standardized the gospel readings for masses celebrated on Christmas, Epiphany and the Passiontide.[23] Even in the North where a wide range of liturgical traditions co-existed in the twelfth century, the selection of readings assigned in the Roman Lectionary were firmly established and remained canonical for the main feast days.

Events from the childhood of Christ stem from the canonical texts, the Gospels of Luke, Matthew and John.[24] Passages from these gospels were read during the seasons of Advent and Christmas. Four masses were celebrated at Christmas, each with a different selection of readings.[25] For the Vigil of Christmas, the mass readings are dedicated to the Gospel of Matthew (1: 18-25). These passages recount Joseph's First Dream and the genealogy of Christ. This accounts for why representations of Joseph's First Dream are sometimes depicted separate from Nativity scenes as on the Ølst altar frontal from Denmark (Fig. 2) or are given a prominence in some Nativity scenes, as in the case of the Catalan antependia: the Betesa frontal in the Museu d'Art de Catalunya (Barcelona) and the Sant Andreu de Sagàs frontal in the Museu Diocesà i Comarcal (Solsona), where representations of Joseph with the Angel are rendered adjacent to the birth scene.[26] On Christmas Day, the first two masses read the story of the Nativity of Christ and the Annunciation to the Shepherds according to Luke 2:1-4 and 15-20. The reading for the third mass is from the gospel of John 1:1-14, the account of the Incarnation of the Word and how John the Baptist was sent to bare witness to Christ's divinity.

The Nativity scene on the Stadil altar frontal

The artisan who designed the composition of the Stadil Nativity scene rejected the supremacy of a traditional formula and reduced the composition to only the most essential elements (Fig. 3). Yet, it remains all the more complex. By eliminating all extraneous elements, the image's simplicity is endowed with apotropaic powers, much as an icon.[27] The scene includes only the Virgin Mary, the Christ child and the two stable witnesses of the divine birth, the ass and the ox. Joseph is absent. He was not an essential participant in this composition. Two key attributes are rendered directly above the Child's head, a star and a dove, symbolizing the Holy Spirit. The visual power of these few elements is heightened in this minimal setting for every feature, gesture and pose have been carefully placed and designed to evoke specific ideas.

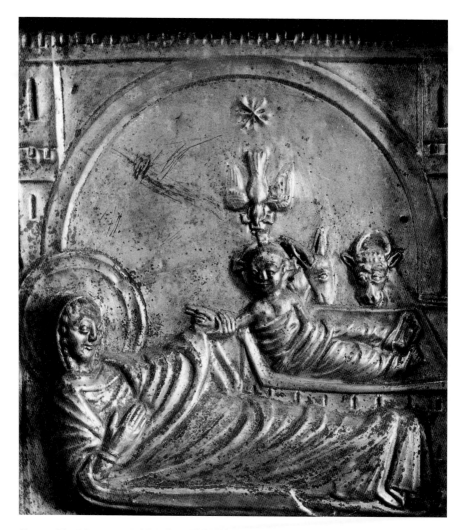

Fig. 3. The Nativity. Golden frontal in Stadil Church, detail. Photo: Gérard Franceschi, Silkeborg Museum of Art.

The tripartite combination of the Holy Spirit in the form of a dove and the star, positioned directly above the Child's head, is an unusual combination. Their combined presence in this minimal context signals a connection between the three. There is no known representation of the Nativity which combines both the star and the Holy Dove in the presence of the Child prior to the fourteenth century. The closest iconographical parallel is the Nativity scene painted by the Erfurt Master on one of the surviving wings of the former altar of the Church

Fig. 4. The Nativity by Erfurt Master, ca. 1350-1370. Wing from the former altar of the Church of Augustines. Erfurt, Angermuseum, Inv.- Nr. MA 82b. Photo: Dirk Urban.

of Augustines (Erfurt, Angermuseum) dated to ca. 1350-1370 (Fig. 4).[28] In this case, however, there is one star accompanied by seven doves, symbolizing the seven gifts of the Holy Spirit (Isa. 11:1). The image is accompanied by inscriptions referring to Isa.7:14 and John 1:14, a reference to the Word Incarnate.[29] The inclusion of the Johannine inscription indicates that there is a intended connection between these two symbols and the manifestation of the Word.

The Johannine reading for the third mass celebrated on Christmas Day, John 1:1-14, provides an entry point for our understanding of the Stadil Nativity scene; for as in the case of the Erfurt altar wing, it explains why Joseph is absent and why features normally associated with either the Epiphany or the Baptism of Christ, but usually not together, are conflated into one composition. Unlike the accounts in the Gospels of Luke and Matthew where a descriptive narration of the events surrounding Christ's birth occur, the Gospel of John is a spiritual and ecclesiological account of Christ's advent and deeds. The opening chapter is an account of the Incarnation of the Word and how the Word "…was made flesh and dwelt among us, and we beheld this glory, the glory as of the only begotten of the Father." (John 1:14). The Word signifies not only Christ but the four gospels, as exemplified by the symbols of the four evangelists on the central panel. The passages in the first chapter of John continue with an account of why John the Baptist was an important witness: "John testified to him and cried out, 'This was he of whom I said, 'He who comes after me ranks ahead of me because he was before me'." (John 1:15 and 1:30). Representations of John the Baptist baptizing Christ always depict the Holy Spirit, usually in the form of a dove, descending over the head of Christ. In like manner, the artist of the Stadil scene has introduced the presence of the dove above the Child to reinforce the idea that his was a divine conception as witnessed later by John the Baptist. The presence of the Holy Spirit at the time of Christ's baptism was the sign from God that Christ was his Son (Luke 3: 21-22). At the core of the Stadil representation of Christ's birth is the spiritual significance of the Incarnation of the Word as expressed in the opening passage of the Gospel of John.

In representations for the Epiphany and the Nativity, the star is a prominent feature. In the biblical texts, the star was understood as signifying both Christ's place of birth and divinity. The Gospel of Matthew tells us that the star leads the three kings to Bethlehem, Judea the place of David's birth and the Old Testament prophecy, the place of origin for the king Messiah (Micah 5:1-3). Indeed the star leads them to the very house where Christ is born. In Revelations 22:16, Christ is equated with the morning star. The star was considered the "heavenly" evidence of Christ's advent, just as John the Baptist at the time of Christ's baptism and the stable animals at Christ's birth were the "earthly" witnesses to the Christ's divinity. Augustine takes the biblical idea one step further in his sermons for the Epiphany and introduces an ecclesiological significance. He states that Christ's star was specifically created to give evidence that the Son of God had arrived.[30] More, importantly, Augustine wrote that "at His birth a new light was revealed in the star, and at His death the sun's ancient light wast veiled" thereby, signifying that the star also pronounced the arrival of the New Law as reiterated in the inscription found on the rim of the altar frontal.[31] By

portraying all three types of evidence together in one composition, the artist of the Stadil Nativity scene gives visual authority to Christ's divinity, Incarnation and advent of the New Law.

Twelfth-century texts can substantiate a more comprehensive view of the Augustianian connection between the New Law and the presence of the star at Christ's birth, and suggest why the Stadil composition also includes a reference to the Holy Dove. In his *Gemma Animae*, Honorius of Autun explains how the two motifs, the Star of Bethlehem and the Holy Spirit signified on one level the coming of Christ and on another the advent of the New Law, Christianity and the establishment of the sacraments.[32] Honorius of Autun reasons that it is only through God's divine intervention that the three Magi understood the profound significance of the star, for they were sent from the three parts of the universe to find the Christ child. It was, therefore, because of the star that the people of the world were converted to Christianity according to the holy scriptures. Consequently, as Honorius explains in the section, this resulted in the three reasons why Christ chose to be baptized. First, so that all could experience justice; second, so that John the Baptist could establish the ritual of baptism; and third, so that he could santify the baptismal waters for us. These are important liturgical connections that create an ecclesiological and sacramental context for the imagery in the Stadil Nativity scene and help to explain the next, unusual feature.

The manner in which the arms of the Madonna and Child are linked is a telling and decisive feature. It comprises several distinct and significant components. Under the grand sweep of a single arch, the Virgin Mary reclines across the full width of the ecclesiastical structure with the Child lying immediately above her. Her semi-seated figure mirrors, on a larger scale, the smaller, semi-seated figure of the Infant above her. Her left arm reaches toward the Child and her left hand clasps the wrist of the Child's outstretched, right arm, from underneath. The horizontal connection between the two figures is a visually prominent feature in the simple composition, emphasizing its importance in our understanding of the scene. The Virgin gazes not toward the Child, but at the viewer who thereby becomes directly engaged in this scene and its message.

In the Stadil composition, the veil wrapped around his body leaves his upper chest and two arms uncovered. The Child's exposed chest or, for that matter, any display of nakedness is a feature that is seldom seen in Nativity scenes before the fourteenth century.[33] When it does appear, the naked child is usually rendered in scenes emphasizing the Adoration of the Child.[34] The manner in which his mother raises his right arm revealing the left side of his rib cage, accentuates the significance of his exposed chest, immediately reminding the viewer of the bare-chested Christ in Passion scenes. The fact, that it is Christ's right arm that

Fig. 5. Deposition of Christ, ca. 1160-70. Typmpanum of south door, Cathedral of Ribe, Denmark. Photo: author.

is being raised and that he simultaneously extends a blessing toward his Mother is an important feature. First, it visually accentuates their relationship and bond in the composition. Second, the raised right arm signifies power.[35] In this case, it has the added meaning of transferring power.

The type of blessing-gesticulation used between the Stadil Virgin and Child is unusual. Most of the gestures used between Mother and Child in Nativity scenes from the ninth to the thirteenth century accentuate the maternal bond between mother and child. The Virgin Mary may stretch out her hands or arms toward the Infant, showing the viewer her Child;[36] she may simply rest her hand on the body of the sleeping Child as a gesture of tenderness and protection;[37] or she may raise the swaddled Child slightly from its manger, again, a form of endearment and motherly pride.[38] In the case of the Nativity scene on the former rood screen of Chartres Cathedral, the Virgin Mary gazes upon her Child and pulls the cloth away from his chin to see more clearly his face.[39] An early example of the Virgin Mary holding and nursing her Infant can be seen in the Nativity scene illuminated in the Gospels from Cologne, from about 1250 (Brussels, Bibliotheque Royale, MS. 9222, fol. 30b.).[40] The gesticulation between the

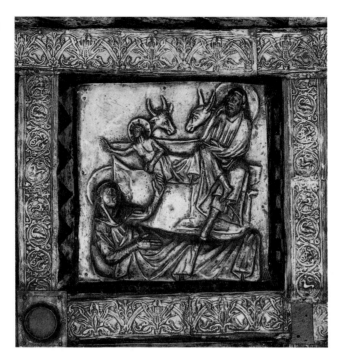

Fig. 6. The Nativity, ca. 1207-22. Golden frontal from Odder Church, detail. Copenhagen, National Museum. Photo: John Lee, National Museum, Copenhagen.

Virgin Mary and the Child in the Stadil Nativity knows no parallels in pre- or post-thirteenth-century Nativity scenes.

The manner in which the Virgin Mary grasps the Child's wrist and raises his right arm cannot be described as one that explicitly states a maternal bond, a spiritual union nor as one that simply serves a function, that is, to direct the Child's blessing gesture toward the Virgin. The only event which typically employs a similar type of gesture between the Virgin Mary and Christ are representations of the Deposition of Christ, where Mary will stand on the right side of Christ holding his right arm by his wrist, as in the case of the sculpture on the south door tympanum at the Cathedral of Ribe in Denmark (Fig. 5).[41] Sometimes she simply holds his hand, in other instances, she is shown resting it against her cheek. In these compositions, the gesture serves to express her sorrow. Christ's hand is never rendered in a blessing gesture, however, but, instead, falls limply indicating his death, explicitly negating any associations of power. When Christ is represented in scenes of his Deposition or Man of Sorrows, his chest is naked illustrating his wounds.[42] Clearly, the designer of the Stadil Nativity gesture was aware of these pictorial connections, for the combined features of the bare-chested Child and the way the Virgin Mary holds up the right arm of the Child only serve to amplify the pictorial links between these features and

Fig. 7. The Incredulity of Thomas, ca. 1200. Golden frontal from Ølst Church, detail. Copenhagen, National Museum. Photo: John Lee, National Museum, Copenhagen.

similar types in Passion narratives. A similar example of the bare chested Child with soteriological association is seen the Nativity scene rendered on the Odder frontal (Fig. 6).

This is not the only pictorial connection between his birth and death that would have been understood by contemporary viewers. The Virgin Mary's gesture is far from simple and points to two other pictorial connections for its origin and meaning. For example, Christ's right arm was also raised when Thomas the Apostle sought evidence of Christ's death and resurrection in representations of the Doubting Thomas, as recounted in the Gospel of John[43] and rendered on the Ølst altar frontal (Fig. 7). The fact that it is his Mother who raises his arm in the Stadil Nativity scene, immediately expresses not her doubts, as in representations of Doubting Thomas, but, instead, one of credulity. Her gesture is a sign of belief, affirmation rather than scepticism, a reminder to the viewer of the Christ's Passion. So, too was the ultimate consequence of Thomas' act. Despite the pictorial term acquired for the representation of Thomas' moment of disbelief in the Gospel of John, the story concludes with one of the most explicit expressions of faith found in the Gospels. The Virgin Mary's gesture recalls Thomas' statement to Christ and the latter's response: "Thomas answered him, 'My Lord and my God'. Jesus said to him, 'Have you believed because you have seen me? Blessed are those who have not seen and yet have come to believe'." (John 20: 28-29). Furthermore, the gesture recalls what Jesus told Thomas (John 14:6),

"I am the way, the truth, and the life: no man cometh unto the Father, but by me." Ultimately, it was the faith of Thomas the Apostle, after he had touched the wound of Christ, and that of the other disciples, which inspired them to preach to others the Word of God and upon which the foundation of the Christian Church was built. In a similar affirmation of faith and the Word of God, the designer of the Stadil altar has included the representation of the twelve apostles and symbols of the four evangelists.

The pictorial connections evident between Thomas' incredulity and Christ's birth in the Stadil Nativity scene are deliberate and appropriate from a number of soteriological and liturgical perspectives. First, they amplify the Virgin Mary's expression of faith, belief and humility. Second, the Paschal associations with this gesture and the bare-chested Child integrate the opening and closing passages and themes from the Gospel of John into one composition. Third, it reaffirms the soteriological connections between Christ's birth and death, and liturgically unifies the two seasons of Christmas and Easter, as John 20:19-29, is the designated reading for the mass celebrated on Low Sunday during the Paschal Season. The unusual gesture between Mother and Child, typologically, foretells Christ's eventual death and, apocalyptically, his Second Coming. The fact that the Child is shown lying not on an altar but in a sarcophagus type-of-manger only serves to emphasize the soterological symbolism in this scene. Lastly, the inclusion of a symbolic reference to Thomas the Apostle liturgically conflates the feast day of Thomas the Apostle which had been celebrated since the Middle Ages by the Roman Church on December 21st with December 25th, the Nativity of Christ, January 6th, the feast day which celebrates both the Epiphany and the Baptism of Christ.[44]

The Stadil artist's creation of this new gesture between Mary and Christ stems from another pictorial tradition that introduces an ecclesio-political component which was first mentioned in the opening section of this article. As previously noted, the fact that it is Christ's right hand that is raised and that he is simultaneously blessing the Virgin Mary, is a sign of power, and more, specifically, a transference of his power and authority. On the one hand, it signifies that she has his love and grace. On the other hand, it signals that she has received his favour, sanction and validation. The gesture depicted should be understood as a sacred ritual, a form of legal enactment that establishes the Virgin Mary as Ecclesia, because she is the Mother of God, and, which, in turn, endows her with jurisdictional power that is recognized by him.

This interpretation originates in the gesture's pictorial history, beginning with representations of Moses, the prefiguration of Christ. The manner in which the Virgin Mary holds Christ's wrist corresponds to the way Aaron and Hur held up Moses's tired arms at the battle of Amalek (Exodus 17: 9-13), a feature which

Fig. 8. Golden frontal in Lyngsjö Church, Scania, Sweden. Photo: Gérard Franceschi, Silkeborg Museum of Art.

Fig. 9. Madonna and Child. Golden frontal in Lyngsjö Church, detail. Photo: Gérard Franceschi, Silkeborg Museum of Art.

is repeated on the Lyngsjö frontal in Sweden (Fig. 8). This frontal does not il-
lustrate events from the Childhood of Christ but it does show the Virgin Mary
holding the Child's right arm up in the central depiction of the Madonna and
Child (Fig. 9). Like the Stadil representation the Child holds his right hand in
a blessing gesture but does not direct it at the Virgin Mary. To the right of the
Madonna and Child is a representation of Moses holding the tablets of the Old
Law. Clearly, the presence of Moses to the right of the holy pair and the manner
in which the Virgin raises Christ's right arm on the Lyngsjö altar is related to
the gesticulation between the Virgin and Christ in the Stadil representation, the
idea of the Old versus the New Law and, in turn, to the Moses gesture. From
the time of early Christian art, Moses' orant pose was understood as a prefigura-
tion of Christ on the cross, as seen in *De laudibus sanctae crucis* (Munich, Bayer-
ische Staatsbibliothek, clm 14159, fol. 2v.) and associated with Christ's Passion
(Fig. 10).[45] The orant pose symbolized the power of prayer known also from early
representations of Noah, Susanna and Daniel. The added feature of the two high
priests, Aaron and Hur, raising the arms of Moses introduces an alliance between
the three men, a type of pictorial gesture that is repeated through the centuries

Fig. 10. Moses' arms held up by Aaron and Hur. De laudibus sanctae crucis, ca. 1160-70. Munich, Bayerische Staatsbibliothek, Clm 14159, fol. 2v., detail. Photo: after Kruger & Runge (as in note 49).

in different contexts, for example, in two eleventh-century representations of the German kaiser, Henry II, one in a sacramentary (Munich, Bayerische Staatsbibliothek lat. ms. 4456, fol. 11) and the other in a pontifical (Bamberg, Staatliche Bibliothek, lit. 53, fol. 2v.).[46] The figures raising Henry II's arms wear episcopal dress. In these two instances, the alliance symbolizes the sacred authority of the ruler, a form of investiture as confirmed by the accompanying angels in the sacramentary where two angels above hand Henry II his lance and sword.

As discussed previously, the Virgin Mary's gesture is one of faith. The manner in which she holds up Christ's arm at the wrist is similar to the way Aaron and Hur hold Moses's wrists. In the case of Moses and Christ, there is a long tradition which connects these two figures. Moses, who signified the Old Law, was understood as a prefiguration of Christ, the New Law.[47] In fact, it is one of the primary analogies used to connect the Old Testament with the New Testament, theologically and pictorially.[48] Pictorially, representations use either one or two raised arms to make this association between the Old Law and the New Law, as in the case of the Stadil composition, where only the one arm of Christ is raised.[49]

In contrast to traditional representations of Moses, it is the Virgin Mary, the Mother of God, in the Stadil scene who holds up Christ's arm. In this role she assumes a similar position as the high priests who assisted Moses and the ecclesiastical figures who supported the arms of Henry II. In the Stadil composition she symbolizes Ecclesia, the personification of the Church, who supports and upholds the New Law as exemplified by the advent of Christ, her Child. Central to her portrayal as Ecclesia in the Stadil representation is her role as the Mother of God. For she is not crowned but veiled, her reclining role accentuates her maternal role and her bowed head speaks of her obedience and humility rather than regal stature. She is endowed with an overly large haloe and the blessing her Son bestows upon her, in conjunction with the way she holds up his right hand, emphasizes that it is due to her role as his Mother, that she was chosen as Ecclesia. Central to the idea of the New Law is the advent of Ecclesia. The artist of the Stadil composition has sucessfully adapted earlier Moses gestures from sovereign and sacred contexts to speak directly to the ecclesio-political authority of this representation of Ecclesia, signifying, in turn, the rise of the New Church in medieval Denmark.

Consequently, the Stadil representation of the Nativity of Christ is also a representation of the Nativity of Ecclesia. The Mother of God is designated as Ecclesia, the sponsa of Christ, the head of the Church. By 1240 a number of different pictorial representations of the advent of Ecclesia had surfaced. In the Bible Moralisée from ca. 1240 (Oxford, Bodleian Library Ms. 270b, fol. 6r) the birth of Ecclesia is rendered in relation to her predecessor, Eve. The figure of Ecclesia emerges from Christ's right side, under his raised arm on the Cross. Born from the right side of the Crucified Christ, the emerging figure of Ecclesia is rendered just below a parallel image of Eve emerging from the right side of Adam.[50] This allegorical representation is related to earlier representations of Ecclesia standing next to the Crucified Christ, collecting the blood of life in her chalice as it flows from his right side. As the renowned scholar, Anders Sunesen, archbishop of Lund (1201/1202-1224), explains in his *Hexaemeron*, the birth of Eve from the sleeping Adam was similar to the way his blood flowed from his side and came to signify Ecclesia, his spouse. [51]

The emphasis in the Stadil composition is on the Virgin Mary as the Sponsa-Ecclesia of Christ. The evocation of this theme serves to underscore the authority of Ecclesia as Christ's representative on earth. Like the Bible Moralisée representation, the Virgin Mary as Ecclesia reclines to the right side of the Christ child. Her advent, due to Christ's death on the cross, is suggested by the soteriological associations established between the Child's pose, recalling his eventual death, and her placement next to his right side, the place reserved for Maria-Ecclesia at his death on the cross.

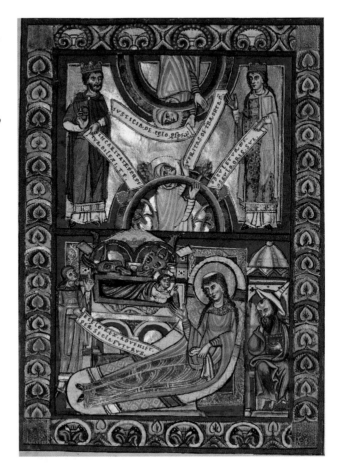

Fig. 11. The 'Nativity'. Kesselstadt Gospels, ca. 1170-90. Cleveland, Ohio, Museum of Art, J. H. Wade Fund, No. 33,445a. (single folio from the Gospels in Domschatz, Trier). Photo: Cleveland Museum of Art.

At first, this connection might be difficult to visualize but if we look at an earlier example of Christ's birth in the Kesselstadt Gospels, the visual parallels explored in these related themes become evident. In a two-tiered illumination for Psalm 85:11-12 on a single leaf from the Kesselstadt Gospels, ca. 1170-90, (Cleveland, Ohio, Museum of Art, J.H.Wade Fund No. 33,445a. [folio unknown]) (Fig. 11), Christ is shown in his manger. He turns back toward his Mother who stretches out her right hand to him. His right hand is raised and posed in a blessing gesture toward the Virgin Mary, as is seen in the Stadil composition. Watching this moment is Ecclesia, who shown as a separate figure standing to the right and pointing to the Child's action while holding an unrolled scroll that ends in the Virgin's bed. Directly above this lower scene, are King Solomon and Queen of Sheba who were understood to prefigure the idea of the holy Sponsus-Sponsa, Christ and Ecclesia. The idea that Christ's na-

tivity also signified the birth of Ecclesia was not a new concept in medieval art in Scandinavia nor was new to exegetical works. Christ's birth was frequently equated with the time of Ecclesia's advent. This theme can be traced back to the writings of Ambrose who wrote, "Behold the beginning of the Church now appearing, Christ is born…"[52] Honorius of Autun notes in his sermon for the Epiphany that it is the virginal bed from which Christ's sponsa, Ecclesia came[53] and in Pope Innocent III's sermon for Christmas he notes that the third Mass for Christmas symbolizes the Advent of Ecclesia.[54] Thus, the soteriological and apolcalyptic views of Christ's advent in the Stadil composition for the Nativity of Christ has the double meaning of also representing the advent of Ecclesia. By interweaving sacred history and the liturgical seasons into one purposeful image, the Stadil composition of the Nativity of Christ symbolically proclaims the advent of the Church in the North.

Frequently Cited Sources

Carelli, Peter. *En Kapitalistisk Anda. Kulturella förändringar i 1100-talets Denmark.* Lund Studies in Medieval Archaeology 26. Stockholm, 2001.

Folch i Torres, Joaquim. *La pintura romànica sobre fusta.* Monumenta Cataloniae; materials per a la història de l'art a Catalunya. 9 vols. Barcelona, 1956.

Honorius of Autun. *De eipiphania domini, Speculum Ecclesia.* PL 172: 843-850.

Honorius of Autun. *Gemma animae,* bk. 1, *De quinto officio et de pugna Christi* cap. xliv, PL 172: 557.

Nørlund, Poul. *Gyldne Altre. Jysk Metalkunst fra Valdemarstiden,* 2nd ed. Aarhus, 1968.

Schapiro, Meyer. *Words, Script, and Pictures: Semiotics of Visual Language.* New York, 1996.

Schiller, Gertrud. *Iconography of Christian Art.* 5 vols. Greenwich, Connecticut, 1971.

Sonne de Torrens, Harriet M. "*De fontibus salvatoris*: A Survey of Twelfth and Thirteenth-Century Baptismal Fonts Ornamented with Events from the *Childhood of Christ.*" In *Objects, Images and the Word: Art in the Service of the Liturgy,* ed. Colum Hourihane. Princeton, 2003.

Sonne de Torrens, Harriet M. "De fontibus salvatoris: A Liturgical and Ecclesiological Reading of the Representation of the Childhood of Christ on the Medieval Fonts from Scandinavia." Ph.D. diss. University of Copenhagen, 2003.

Notes

1 Literature on the Stadil altar frontal, as well as the subject of Christ's infancy on liturgical objects, is scarce. Several iconographical studies have been completed on Denmark's golden altars but, none of them specifically address the representation of the childhood of Christ.

The fundamental text on the golden altars from Denmark is by Poul Nørlund, *Gyldne Altre. Jysk Metalkunst fra Valdemarstiden*, 2nd ed. (Aarhus, 1968). He traces their development, the workshops, suggests approximate dates and outlines in detail the pictorial programs ornamenting ten of the eleven extant altars. Since then Harald Langberg, Otto Norn and Søren Skovgaard Jensen and other scholars have contributed to our understanding of these altars, see Jes Wienberg, "Gyldne altre, kirker og kritik," *Hikuin* 22 (1995): 59-76; Harald Langberg, *Gyldne billeder fra middelalderen* (Copenhagen, 1979); for a discussion of the similarities between the Spanish and Scandinavian altar frontals from the 12th and 13th centuries, see Eva de La Fuente Pedersen, "Majestas Mariae i Lisbjerg alterets ikonografi og motiviske forbilleder," *Den Iconographiske Post (ICO)* 2 (1988): 12-30; for an analysis of Mary and the Throne of Wisdom on the Sahl altar frontal see Otto Norn and Søren Skovgaard Jensen, *The House of Wisdom* (Copenhagen, 1990). Søren Bo Christensen examines the five medieval representations of St. Tecla, one of which appears on the golden altar of Lisbjerg, now in the National Museum of Copenhagen, see "Theklas Tympaner, Daniels Døre," *Den Iconographiske Post (ICO)* 2 (1991): 1-10. The relationship between Viking art and the borders ornamenting the golden altars is traced by Signe Horn Fuglesang, "Stylistic Groups in Late Viking and Early Romanesque Art," *Acta ad archaeologiam et artium historiam pertinentia* 1 (1981): 79-125.

2 Jes Wienberg's statistics, based on archeological evidence, shows 2492 parish churches existed in medieval Denmark. The boundaries of medieval Denmark included the southern Slesvig region of the Jutland peninsula, which is part of Holstein-Slesvig, Germany today and the provinces of Skåne, Blekinge and Halland in modern day Sweden; Jes Wienberg, *Den gotiske labyrint. Middelalderen og kirkerne i Danmark*, Lund Studies in Medieval Archaeology 11 (Stockholm, 1993), 19-21.

3 Around the rim of the altar frontal is an inscription which reads: + QUAM CERNIS FULUO TABULAM SPLENDORE NITENTE[M] PL(US) NITET YSTORIE COGNITIONE SACRE PANDIT ENIM CHR(IST)I MYSTERIA QUE SUP(ER) - AURUM IRRADIANT MUNDIS CORDE NITORE SUO ERGO FIDE MUNDES MENTE(M) SI CERNERE LUCIS GAUDIA DIVINE QUI LEGIS ISTA VELIS; Nørlund, *Gyldne Altre*, 186-187.

4 Of these forty-one altar frontals, thirty-two were from Denmark, five from Norway, three from Iceland and one from Sweden, see Peter Carelli, *En Kapitalistisk Anda. Kulturella förändringar i 1100-talets Denmark*, Lund Studies in Medieval Archaeology 26 (Stockholm, 2001), 303.

5 For the measurements see *Kunstschätze Jütlands, Fünen und Schleswegs aus der Zeit Waldemar des Siegers*, ed. Jesper Hjermind and Erik Levin Nielsen (Viborg, 1991), 25, no. 1.

6 See the various Danish types in Nørlund, *Gyldne Altre*, 1-24.

7 The other extant altar frontals with other holy figures and scenes are from Kværn in Denmark, Lyngsjö in Skåne, Sweden and Flåvär in Norway, see Wienberg, "Gyldne altre," 62; for recent photographs of the altar frontals and detailed views of the figures and scenes, see Poul Grinder-Hansen, Gérard Franceshi and Asger Jorn, *Die Goldenen Bilder des Nordens aus dem frühen Mittelalter* (Cologne, 1999); and for a list of all works see Carelli, *Kapitalistisk Anda*, 303.

8 For information on the Stadil workshop, see Nørlund, *Gyldne Altre*, 177-204.

9 Nørlund *Gyldne Altre*, 2.

10 Gertrud Schiller, *Iconography of Christian Art* (Greenwich, Connecticut, 1971), 1: 29 and n. 5.

11 For example, for a discussion of a 6th-century carved altar frontal in Parma see, Raffaella Farioli Campanati, "Un' inedita fronte d'altare paleocristiano e una nuova ipotesi sulla cattedrale di Parma," *Felix Ravenna* 127-130 (1984-1985): 201-215. A relief now in the narthex of the

modern church of S. Ambrogio alla Massina in Rome has been identified as an altar frontal
and associated with the donation of Pope Leo III (795-816) to the monastery in 807, see
Alberta Danti, "Una lastra a rilievo altomedievale dal monastero di Sant' Ambrogio alla Mas-
sina," *Bollettino dei Musei comunali di Roma* 6 (1992): 47-54; Rene Feuillebois reconstructs
the main altar frontal at the Carolingian abbey church of S. Benedict of Aniane, France, in
"Essai de restitution de l'autel erige par Saint-Benoît dans l'abbatiale d'Aniane," *Archeologie
du Midi Medieval* 3 (1985): 19-26.

12 Danish examples of similar types of pictorial programs in apses and naves can be found at
 Sæby, Væ, Skibby and Alsted. Many others are discussed in Søren Kaspersen, "Majestas Do-
 mini – Regnum et Sacerdotium," *Hafnia* 8 (1981): 83-146 and "Majestas Domini – Regnum
 et Sacerdotium (II)," *Hafnia* 10 (1985): 24-63.

13 For a few examples see footnote 7.

14 Anscher's Life of Angelbert describes these altars, see Jean Mabillon, *Acta Sanctorum Ordinis
 S. Benedicti*, Saeculum IV, Pars prima (Paris, 1677), 127.

15 For example, Thomas W. Lyman argues that the relief of Christ in Majesty and angels served
 as an altar frontal in "La table d'autel de Bernard Gilduin et son ambiance originelle," *Cahiers
 de Saint-Michel de Cuxa* 13 (1982): 53-73. See also Martin Blindheim, "St. Olav, ein skandi-
 navischer Oberheiliger. Einige Beispiele der Literatur under Bildkunst," *Acta Visbyensia Visby*
 6 (1981): 53-68; Joseph Brodsky, "Le groupe du triptyque de Stavelot, notes sur un atlier
 mosan et sur les rapports avec Saint-Denis," *Cahiers de Civilisation Medievale Poitiers* 21: 2
 (1978): 103-120. The Barnabas altarpiece (ca. 1250-1260) in the Kimbell Art Museum (USA)
 has been attributed as honouring Saint Louis (Louis IX of France), see J. Flechter, "The Barn-
 abas Altarpiece: A Possible Link with Southern France," *Antiquity Cambridge* 58:224 (1984):
 43-52. For a discussion of the 13th-century painted altar frontals in stave churches, see Roar
 Hauglid, "Kaupanger stavkirkes dekor og utstyr," *Arbok Foreningen tel Norske Fortidsminnes-
 merkers Bevaring* 130 (Oslo, 1975): 107-116.

16 Antonio Braca argues that a cycle of ivory relief panels (chiefly in the Museo del Duomo,
 Salerno but some fragments are now in other European and American collections) was pro-
 duced in the second quarter of the 12th century and were once possibly part of an altar fron-
 tal which had an extensive narrative cycle including scenes from the life of Christ, Apostles
 and donors, see Antonio Braca, *Gli avori medievali del Museum diocesano di Salerno* (Salerno,
 1994). Except for the comprehensive study by Robert P. Bergman, discussion has tended to
 focus on the original placement and arrangement of the ivory plaques, see Robert P. Berg-
 man, *The Salerno Ivories: Ars Sacra from Medieval Amalfi* (Cambridge, 1980). There is also
 known to have been an extensive altar frontal on the main altar in the Cathedral of Utrecht
 from the second quarter of the 12th century, see John M. A. van Cauteren, "De liturgische
 koordispositie van de romaanse Dom te Utrecht," in *Utrecht: kruispunt van de middeleeuwse
 kerk: voordrachten gehouden tijden het congres ter gelegenheid van tien jaar mediestiek, Faculteit
 der Letteren, Rijksuniversiteit te Utrecht, 25 tot en met 27 augustus 1988* (Zutphen, 1988), 63-
 84.

17 A distinction should be made between the Catalan altar frontals dedicated to the Virgin Mary
 as Mother of God and which include a representation of the Madonna and Child in the central
 panel and those which also include images of events from the childhood of Christ. The fol-
 lowing altar frontals are ornamented with events from the childhood of Christ: Avià, 13th c.
 dedicated to Mother of God (Barcelona, Museu d'Art de Catalunya); Bisbat de Vic, dedicated
 to Mother of God, 13th century (Vic, Museu Episcopal de Vic); Betesa, 13th century (Barce-
 lona, Museu d'Art de Catalunya); Lleida altar, dedicated to Virgin Mary (Barcelona, Museu

d'Art de Catalunya); see Joaquim Folch i Torres, *La pintura romànica sobre fusta*, Monumenta Cataloniae; materials per a la història de l'art a Catalunya (Barcelona, 1956): vol. 9. Other altar frontals with scenes from the childhood of Christ are known from Sant Andreu de Sagàs (Solsona, Museu Diocesá i Comarcal) see Joan Ainaud de Lasarte, *Catalan Painting: The Fascination of Romanesque* (New York, 1990). Others, which have no scenes from the childhood of Christ but, which include a central portrait of the Madonna and Child are from Esterri de Cardós, 12th century (Worcester, England, Art Museum of Worcester); Durro, 12th century (Barcelona, Museum d'Art de Catalunya); Alós, 12th century (Barcelona, Museum d'Art de Catalunya); Vic, 12th century (Vic, Museu Episcopal de Vic); Sant Hilari Sacalm, 13th century (Vic, Museu Episcopal de Vic). For images and discussion of these examples see Folch i Torres, *La pintura romànica sobre fusta*: vol. 9.

18 For an analysis of how the childhood of Christ was represented on baptismal fonts, see Harriet M. Sonne de Torrens, "*De fontibus salvatoris*: A Survey of Twelfth and Thirteenth-Century Baptismal Fonts Ornamented with Events from the *Childhood of Christ*," in *Objects, Images and the Word: Art in the Service of the Liturgy*, ed. Colum Hourihane (Princeton, 2003) and idem, "De fontibus salvatoris: A Liturgical and Ecclesiological Reading of the Representation of the Childhood of Christ on the Medieval Fonts from Scandinavia" (Ph.D. diss. University of Copenhagen, 2003).

19 In addition to the Catalan altar frontals, other frontals are known to have been dedicated to the Cult of the Virgin during this period, see Guy Barruol, "L'autel roman de l'ancienne cathedrale d'apt, Vaucluse," *Bulletin Monumental* 146: 3 (1988): 177-190; the 11th-century marble altar at Sainte-Foy (Conques) was dedicated to the Virgin, see Jean Claude Fau, "Les tables d'autel romanes de Sainte-Foy à Conques," *Bulletin Monumental* 134: 1 (1976): 49-52; M. Janssen discusses the iconography of the late 13th-century antependium's representation of the Death of the Virgin, "Das altar antependium aus Kloster Wennigsen," *Das Münster* 40:3 (1987): 238-240; Patrizia Angiolini Martinelli analyzes the Byzantine and western medieval elements of the portable triptych of the Madonna and Child and a related group of altars in "Note inmargine alle icone ravennati: il 'Maestro degli Altaroli' nella Pinacoteca di Ravenna," *Corso di cultura sull'arte ravennate e bizantina* 32 (1985): 151-171; Guy Barruol reconstructs a 12th-century altar with a sculpture of the Madonna and Child (Vaucluse, Cathedral of Apt) in "L'autel roman," 177-190; Marie M. Gauthier, "Le frontal d'emaux de San Miguel de Excelsis (Navarre)," *Bulletin de la Societe Nationale des Antiquaires de France* (Paris, 1982): 54-58.

20 For example, G. Krampe discusses the presentation of Christ's Passion and the eucharist symbolism of the *Agnus Dei* on the Westphalian retable-reliquary (1263-1272) commissioned by Volpert von Monchehof in, "Das Altarretabel der ehemaligen Stiftskirche in Wetter," *Kunst in Hessen und am Mittelrhein* 20 (Darmstadt, 1980), 9-19.

21 Liturgists have a fairly accurate idea of what the early medieval Roman arrangement for the Gospel readings were, see Joseph A. Jungmann, *The Mass of the Roman Rite: Its Origins and Development (Missarum Sollemnia)*(New York, 1950), 1: 401; and, for an outline of the various themes and readings for the ecclesiastical year, see Walter Howard Frere, *Studies in Early Roman Liturgy I-III*, Alcuin Club Collections no. 28, 30, 32 (Oxford, 1930, 1934 and 1935).

22 For a discussion on the liturgical cycles see Andrew Hughes, *Medieval Manuscripts for Mass and Office: A guide to their organization and terminology* (Toronto, 1982), 278.

23 For the specific development of these seasons see Stephan Beissel, *Entstehung der Perikopen* (Freiburg, 1907); Don Th. Maertens, "L'Advent. Genèse historique de ses thèmes biblioques et doctrinaux," *Mélanges de science religieuse* 18 (1961): 47-110, with tables of pericopes, their date and geographical origins.

24 The Gospel of Mark does not mention events from the childhood of Christ.

25 Three masses had been celebrated on Christmas Day since the time of Leo the Great, see Walter Howard Frere, *Early Roman Liturgy. The Roman Gospel-Lectionary, Studies in Early Roman Liturgy. Alcuin Club Collections* (London, 1930-1935), 2: 63.

26 For an illustration of the Ølst frontal, see pl. IV in Nørlund, *Gyldne Altre*; for an illustration of the Betesa frontal, see Pl. 46 in Folch i Torres, *Pintura*. For an illustration of the Sant Andreu de Sagàs frontal, see de Lasarte, *Catalan Painting*, 95.

27 For a fuller discussion of Christian images with apotropaic associations, see Sonne de Torrens, "De Fontibus Salvatoris," 91-93.

28 Schiller, *Iconography*, 1: fig. 183.

29 Gertrud Schiller equates the presence of the star with the text of Revelation 22: 16: "I am the root and offspring of David, and the bright and morning star." For an interpretation of this scene, see Schiller, *Iconography*, 1: 76.

30 See sermon numbers 18 (199) - 23 (204), *Saint Augustine: Sermons for Christmas and Epiphany*, The Works of the Fathers in Translation, ed. Johannes Quasten and Joseph C. Plumpe (Washington, D.C., The Catholic University of America, 1952), 154-178.

31 Augustine, "Epiphany: The error of astrology," Sermon number 18 (199), ed. Quasten and Plumpe, 158. For the inscription, see n. 3.

32 Honorius of Autun, *Gemma Animae. De magis*, Cap. XIX (19); PL 172: 648A: "Ideo hoc per stellam fieri voluit, quia per sacram Scripturam populum converti voluit, ideo in duodecimo die a nativitate sua hoc fieri voluit, quia per duodecim apostolos mundum attrahere voluit. Propter tres autem causas Dominus baptizari voluit: primo, ut omnem justitiam impleret: secundo, ut Joannis baptismum comprobaret: tertio, ut aquas nobis sanctificaret. Idcirco autem post triginta annos baptizari, et tunc praedicare voluit, quia nos adepta scientia in perfecta aetate populum docere voluit. Ideo vero a Joanne, non ab alio, baptizari voluit, quia ab illo testimonium ad populum habere voluit, quia videlicet populus Judaeorum illi, ut prophetae, credidit."

33 One of the few exceptions to this general trend is the example of the Nativity scene on the Odder frontal from Denmark, see Nørlund, *Gyldne Altre,* pl. III and Grinder-Hansen, *Goldenen Bilder*, fig. 130.

34 For a partially naked Child, see the manuscript illustration of the Nativity scene in initial D to the first Mass of Christmas, Gradual of Gisela von Kerssenbrook, [folio unknown] (Osnabrück, Gymnasium Carolinum, Library) see Schiller, *Iconography*, 1: fig. 185.

35 For more discussion about the raised right hand as a sign of power in ancient and Christian art see Hans Peter L'Orange, *Studies in the Iconography of Cosmic Kingship in the Ancient Word* (Oslo, 1953), 139ff. For discussion of the "brachium forte," see Agnellus, *Liber Pontificalis, vita Neonis*; PL 106: 519-520.

36 See the Nativity scene on the Odder frontal from Denmark in Nørlund, *Gyldne Altre*, pl. III; ivory relief, 9th century, diptych from the Collection of Count Harrach (Cologne, Schnütgen Museum) see Schiller, *Iconography*, 1: fig. 164; ivory relief, 12th-century plaque from altar (London, Victoria and Albert Museum) see Schiller, *Iconography*, 1: fig. 165.

37 See manuscript illumination, c. 1165, Bible of Floreffe, fol. 168 (London, British Museum, Add. 17733-8) see Schiller, *Iconography*, fig. 172.

38 See manuscript illumination, c.1235, Lower Saxony, Psalter, fol. 47v. (Donaueschingen, Fürstlich Fürstenbergische Hofbibliothek, Cod. 309), see Schiller, *Iconography*, fig. 175.

39 Schiller, *Iconography*, 1: fig. 181.

40 Schiller, *Iconography*, 1: fig. 179.

41 See manuscript illustration, 10th century, Byzantine Gospels (Florence, Biblioteca Lauren-ziana, Conv. soppr. 160, fol. 114b), see Schiller, *Iconography*, 2: fig. 550; wood relief of the Deposition, mid-11th century from the Rhine, central section of small altar (Berlin, Stiftung Preussischer Kulturebesitz, Staatliche Museem, Dept. of Sculpture), see Schiller, *Iconography*, 2: fig. 554; marble relief, 1178, Benedetto Antelami, former rood screen (Parma, Parma Ca-thedral), see Schiller, *Iconography*, 2: fig. 555.

42 A similar gesture is used between the two in later representations of the Man of Sorrows, as in the example of the 1430 wall painting by the Masters Friedrich and Johann von Villach, (Mariapfarr, near Tannsweg, Salzburg), see Schiller, *Iconography*, 2: fig. 774.

43 The Doubting Thomas is also shown on the golden altar frontal from Ølst, see Nørlund, *Gyldne Altre*, pl. III.

44 The feast of Thomas the Apostle appears in the Gregorian Calendar and in that of St. Peter in Rome in the 12th century, see Ildefonso Schuster, *The Sacramentary (Liber Sacrmentorum). Historical & Liturgical Notes on the Roman Missal* (London, 1927), 3: 319-320.

45 See the 5th-century mosaic representation of Moses in the nave of S. Maria Maggiore in Rome illustrated in Meyer Schapiro, *Words, Script, and Pictures: Semiotics of Visual Language* (New York, 1996), fig. 4.

46 For an analysis of these connections, see Schapiro, *Words*, 39, figs. 10-11.

47 As a sample of a few textual references to Moses as the prefiguration of Christ see Tertullian, *Adversus Judaeos* in *Opera: ad optimorum librarum fidem expresssa curante E. F. Leopold.* vol. 4 pars II. ed. Ernst Frederich Leopold (Leipzig, 1841), 317; Honorius of Autun, *Gemma animae*, bk. 1, *De quinto officio et de pugna Christi*, cap. xliv:557, PL 172: "Quintum officium alis cherubim velatur. In quo summi pontificis hostia et regis gloriae pugna repraesentatur. Hoc Moyses praefigurabat, quando in monte extensis manibus orabat, dum Josue, qui et Jesus, cum Amalech pugnabat, devicti regnum vastaba(r)bat, ac populum cum victoriae laeti-tia reducebat. (Exod. XVII). Sic Christus in monte crucis, extensisque manibus pro populo non credente et contradicente oravit, et victus, dux cum Amalech, id est cum diabolo, vexillo sanctae crucis pugnavit, devicti regnum vastavit, Dominus infernum superator maligno hoste spoliavit, populum de tenebris ereptum cum gloria victoriae ad coelestia revocavit."

48 Schapiro, *Words*, 26.

49 For an example of Moses in a similar pose and as a prefiguration of Christ on the tympanum of the portal of San Cassiano, see R. Silva, "*Dilexi decorem domus tuae*: il ruolo dell'episcopato nello sviluppo dell'architettura in Toscana dall'XI secolo alla prima metà del XII," *Arte me-dievale* 10.2 (1996): ill. 3; Moses using the same gesture, as a prefiguration of Christ in the *Hortus Deliciarum* (Munich, Bayerische Staatsbibliothek, Clm. 14159, fol. 2v), is illustrated in Annette Kruger and Gabriele Runge, "Lifting the Veil: Two Typological Diagrams in the *Hortus Deliciarum*," *Journal of the Warburg and Courtauld Institute* 60 (1998): 1–22. For an example of Christ using Moses' gesture, see the carved scene of Christ's baptism on the bap-tismal font in the Bjäresjö church in Skåne, Sweden, dated to ca. 1180 where John the Baptist stands on the right holding Christ's raised left arm up at the wrist. For a discussion and recent bibliography on this image, see Sonne de Torrens, "De Fontibus Salvatoris," diss., 285-292 and idem, "*De fontibus salvatoris*," ed. Hourihane, 126-129.

50 Ernst Guldan, *Eva and Maria. Eine Antithese als Bildmotiv* (Graz-Cologne, 1966), fig. 27.

51 "…Dum dormiret Adam, de costa produiit Eva: in cruce sopiti de Christi sanguine fuso per latus ecclesia fuit eius sponsa redempta; sicut Adam regere subiectam debuit Evam, sic regit ecclesiam Christus seruire paratam"; *Andreae Sunonis Filii Hexaemeron*, ed. Sten Ebbesen and Lars Boethius Mortensen (Copenhagen, 1985), 1: 133.

52 Ambrose, "The Beginning of the Church," CSEL, iv, 69-71 and as translated in Thomas Aquinas, *Catena Aurea. The Sunday Sermons of the Great Fathers [Patristic homilies on the Gospels].* trans. and ed. Martin Francis Toal (Chicago, 1957- 1963) 1: 117.

53 Honorius of Autun, *De eipiphania domini, Speculum Ecclesia*; PL 172: 843-850.

54 Pope Innocent III, *Opera Omnia Innocentii III*; PL 217: 459C: "De tribus Christi nativitatibus, quas in missis tribus in festo nati Domini repraesentat Ecclesia; et de sex Christi nominibus, et cur non sint plura aut pauciora. Puer natus est nobis et filius datus est nobis, et vocabitur nomen ejus Admirabilis, Consiliarius, Deus, Fortis, Pater futuri saeculi, Princeps pacis (Isa. IX). Sicut tres in Christo substantias fides catholica confitetur, divinitatem, carnem, et spiritum; ita tres in ipso nativitates Scriptura sacra testatur, divinam ex Patre, carnalem ex matre, spiritualem in mente."